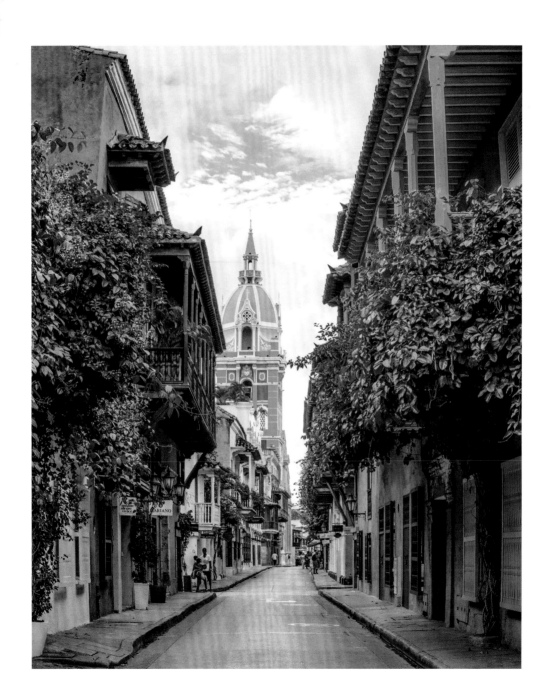

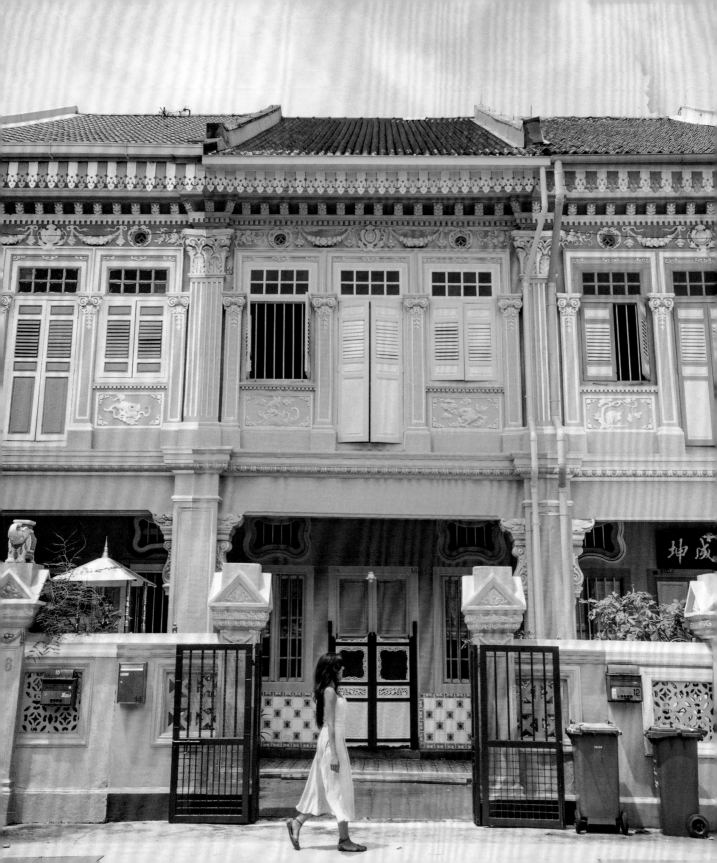

dame

TRAVELER

LIVE THE SPIRIT OF ADVENTURE

NASTASIA YAKOUB

TEN SPEED PRESS
California | New York

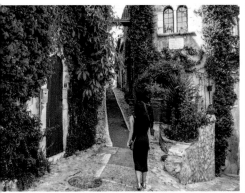
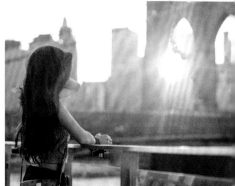
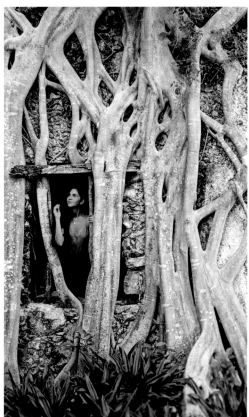

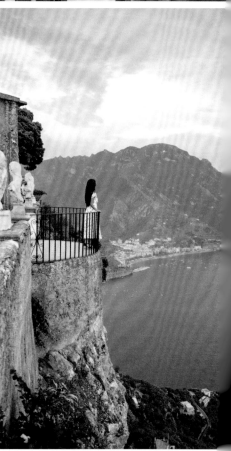
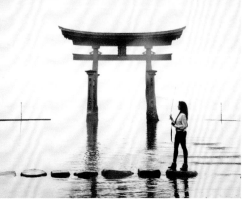

This book is dedicated to my mother, Niran.
Thank you for being my favorite travel partner,
for softly cheering me on from the sidelines,
and for breathing life into me.

I hope I make you proud.

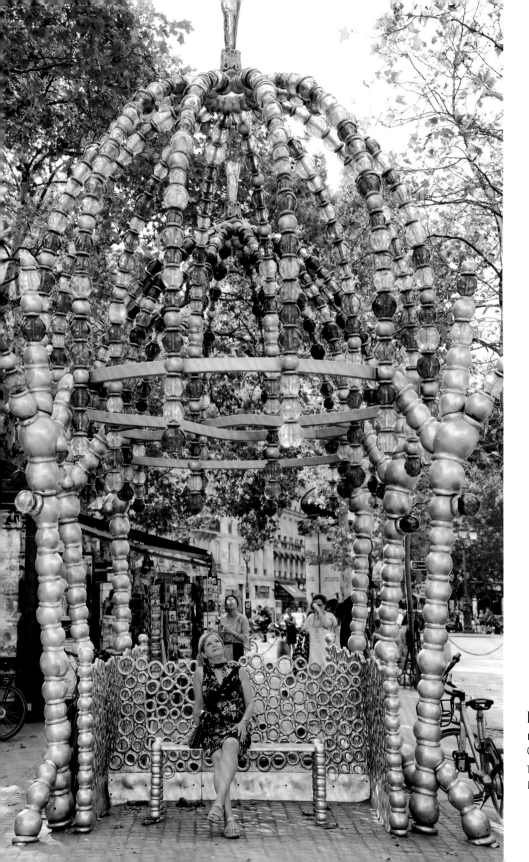

Paris, France

NASTASIA YAKOUB
@NASTASIASPASSPORT

The Palais Royal–Musée du Louvre metro.

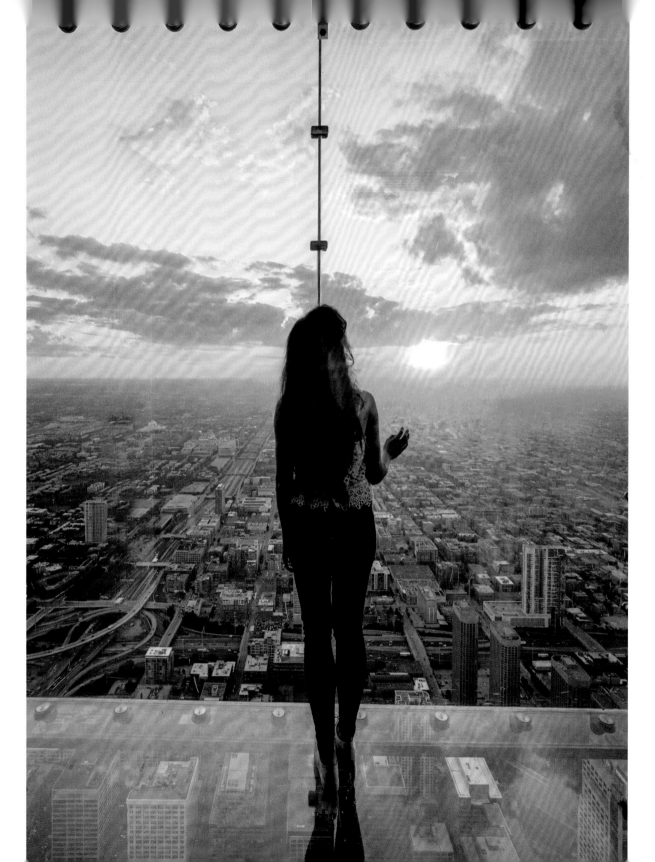

introduction

"Once in a while it really hits people that they don't have to experience the world in the way they have been told to."

—ALAN KEIGHTLEY

For as long as I can remember, I have felt out of place. Growing up in a strict Middle Eastern community in Michigan, I found myself constantly questioning the status quo. "Why am I being forced into this mold of a woman that I don't identify with? Why should marriage and raising children at a young age be my only priority? Why am I not enough?" These questions constantly haunted me.

With cultural barriers and different perspectives on how life should be lived, the type of expectations placed on many girls and women in my community just didn't align with the vision I had for my life. By the age of twenty, I had had enough. I knew in my heart of hearts that there was something more for me outside of the bubble I was born into . . . and I was going to find it. I didn't know where my life was heading, but I promised myself that I wasn't going to settle by taking the traditional path.

During this time, I began volunteering at a local hospital and became inspired by the dedication and selflessness of the nurses that I assisted, which led me to start taking prerequisite classes for nursing school. As I progressed in my studies, I knew that I needed to get out of Michigan, but, at the time, I didn't believe I had the confidence to be accepted into universities; and then I woke up at 4 a.m. one morning, and something called me to give it a shot and to impulsively send my applications to nursing schools in major cities like New York City and Chicago. Ever since I first caught a glimpse of the glimmering skyline on our family trips to Chicago, living in a big city had become a far-fetched dream of mine, and this late night wake-up call was my attempt at making it a reality.

After pressing send, I never imagined I would hear back from universities. But a month later, I received an acceptance letter from Loyola University in Chicago. I sat in a café as I ate lunch, opening my mail, and caught a glimpse of the envelope. At first glance, I thought it was just a brochure and was about to throw it away. But then I noticed the word *congratulations* on the bottom. I cried happy tears in public that day as the reality set in that my life was about to drastically change.

Achieving such a huge step was a feat, and life in my new city became harder and harder with each passing day. I was on my own emotionally, mentally, and financially in a place where I didn't know a single soul, and was quietly fighting criticism from my community

back in Michigan because it wasn't common for women like me to leave their families before getting married. But I persisted.

During this intense phase of my life, I made another impulsive decision and booked a flight to Cape Town, South Africa, to volunteer at an orphanage. Tired of waiting on indecisive friends to join me, I embarked on my first solo trip *ever* in 2011. I still remember crying on the flight, asking myself if I had made a huge mistake . . . but after successfully spending three weeks in Cape Town on my own, making new friends, and feeling empowered, I discovered my love for solo travel and for the world. This trip helped to build my confidence, and I wanted more of that feeling. Little did I know at the time that more of it was just around the corner.

I graduated from nursing school in 2013 and built a life of my own in Chicago. The more it felt like home, the more the city became my safe haven. I snagged a job as a labor and delivery nurse shortly after. But of course, just as I thought everything was going smoothly . . . life had other plans.

Let's rewind to when I was twelve and had an 80-degree scoliosis curvature that required immediate spinal fusion surgery. It was a bother during nursing school, but the chronic pain was just something I learned to live with until I suffered a major injury while on the job, drastically changing my life yet again. After going to "break the bed" to slide a patient onto a stretcher, I underestimated its weight and lost control of the metal, crushing my back, and fell into bed rest for six months. My floor nursing career was over due to its physical intensity.

Luckily, this curve ball was not my first rodeo–I like to think that every time a door closes, my unwavering faith leads me to discover a new one to open.

Growing up, photography was always a therapeutic outlet for me. I was known as the family photographer at every wedding, capturing candid moments of my friends and family. This hobby continued into nursing school, where I used it as a creative outlet from my studies and would lock myself in the photography darkroom for hours. And as I went on to travel solo, I began capturing the world through my eyes and lens.

Bored, uninspired, and at a loss while frantically searching for nonphysical nursing jobs that I couldn't see myself doing, I realized I needed a passion project while I was on bed rest to distract myself. It was during this downtime that I would catch myself dreaming of faraway places. I wanted a way to live vicariously through other solo female travelers, and that led me to notice a lack of a female travel community in 2013, on the newly popular photography app, Instagram. I created Dame Traveler as a way to celebrate brave women making bold decisions, both in travel and in their lives. When it came time to give this newborn passion project a name, I searched through my *Merriam-Webster* dictionary and I found "Dame: A woman of rank, station, or authority."

I chose the name *Dame Traveler* because I wanted to exemplify strength, fearlessness, and courage. When a woman travels solo, she throws fear to the wind and trusts the universe to protect her while she uses her instincts to make smart decisions. Coming from a community where many women live under a microscope, I wanted to create a space that exists to break those barriers and to empower women to be brave with their lives.

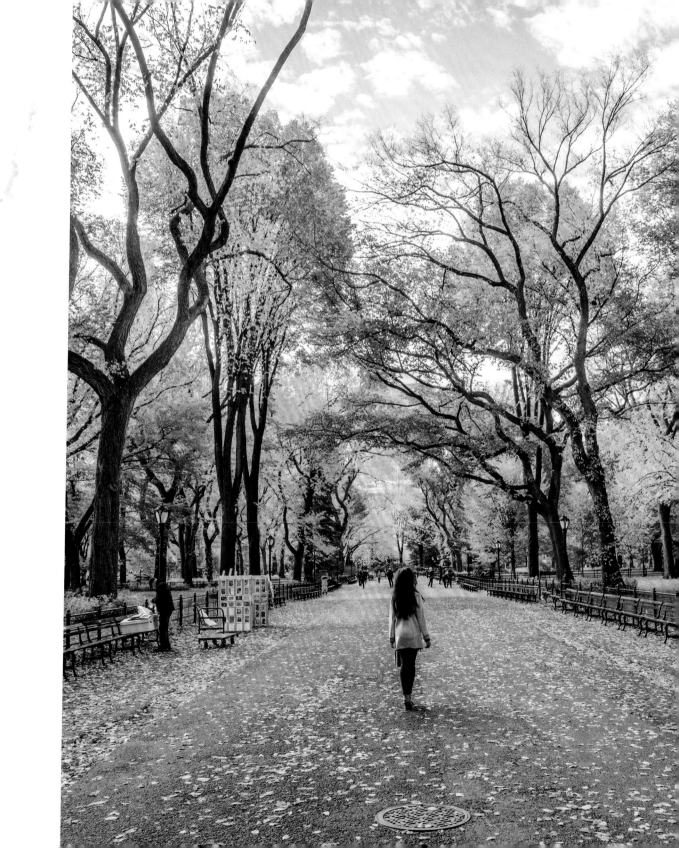

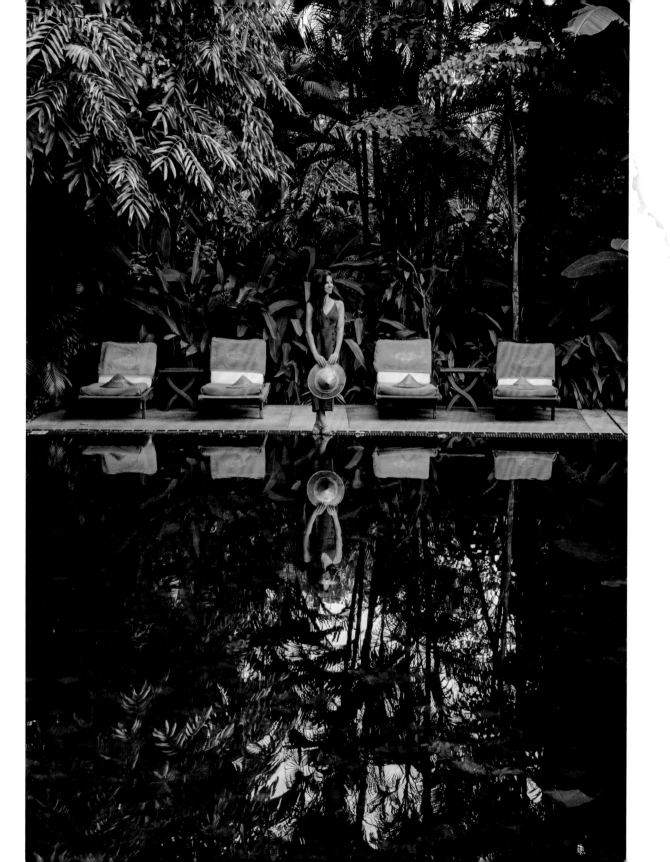

So a Dame Traveler is any woman who aspires to lead a life of courage, curiosity, and compassion.

Looking back, I'm in awe of the universe's serendipitous ways. These challenging yet important phases of my life led me to where I am today. Maybe, if I hadn't woken up at 4 a.m. and impulsively applied to schools outside of Michigan, I would never have had the chance to expand my mind and grow as a woman. Maybe if I didn't chase my dreams of being a city girl, I wouldn't have ended up calling the city of dreams, New York City, my forever home. Maybe if I hadn't injured myself on the job, I would never have had the chance to see the world. Maybe, just maybe, if I hadn't broken away and started a new chapter for myself so long ago, I would have allowed fear to dictate my life, and it would have led me in a totally different direction. Who would have thought that after all of that, my parents would eventually become my greatest supporters?

And so, whatever it is that you desire to do . . . whether it's to travel, to move to a new city, to go against the grain, or to defy the expectations that others have set for you–do it. The scarier it may seem, the better. It will be difficult at first, but the struggles will pass eventually and, no matter the outcome, you'll be proud that you tried.

This community is more than an Instagram account filled with dream-inducing pictures of women gazing toward far-off places. We are more than a hashtag categorizing women's travels. Our mission is a movement that inspires and empowers women to *travel more, experience more, and be more.* We strive to offer female travelers the encouragement and resources to explore all that is waiting for them in the world.

From backpackers in Peru to artists in Berlin to storytellers in Morocco, we believe in celebrating the diversity and bravery of women from around the world who are not afraid to think (and live) outside the box. Dame Travelers exemplify the spirit of true adventurers. Our curated collection of stories from the road and illustrative, empowering photography allows any woman to travel the world and share every snapshot. Our mission is not to portray an unimaginable fantasy, but to share real-life examples of female travelers who made their dreams a reality.

We believe in the incredible power that travel lends to those who go for it. *Dame Traveler* is yours. It's your place, it's your community.

It's my hope that this collection of Dame Travelers' photos, stories, and insights from their experiences will fill you with enthusiasm for–and the desire to explore– this fascinating world we call home. Organized by the main anchors of destinations around the world–architecture, water, culture, and nature–each section of the book will feature everything from safety alerts and destination-specific tips to quotes from Dame Travelers about their takeaways and discoveries that are scattered between each beautiful moment captured during their adventures.

Yangon, Myanmar
NASTASIA YAKOUB
@NASTASIASPASSPORT

Reflecting at the Belmond Governor's Residence.

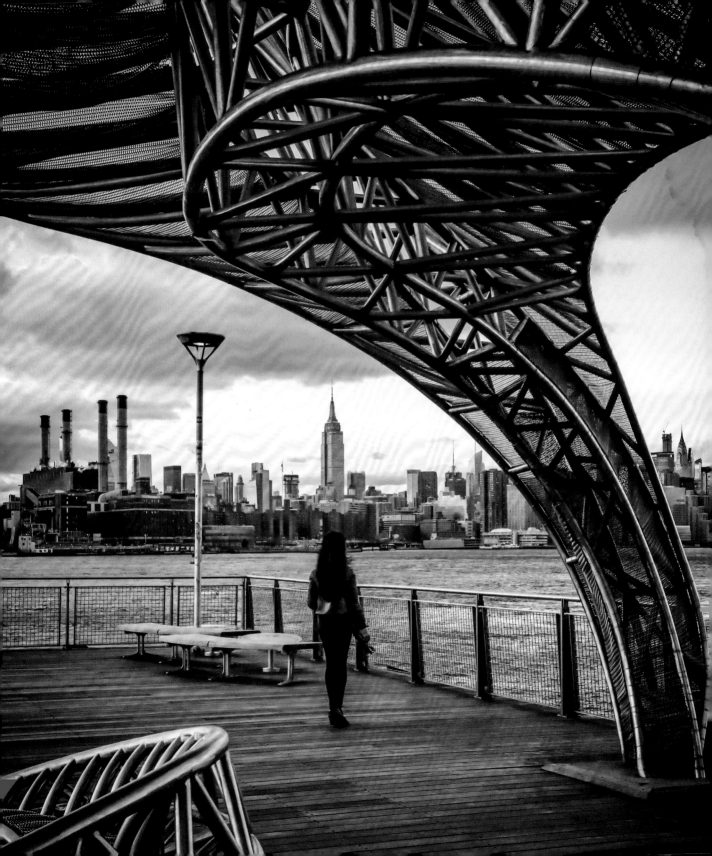

safety tips

Being prepared, educated, and safe are the three main cornerstones of exploring as a woman. Women should be *nothing* but encouraged to explore the world. However, the unfortunate circumstance of our world requires us to keep our safety and security in mind. Simply put—exercise intelligent caution and always stick to the safety tips that follow.

- Stay at hotels, homestays, and hostels that have lots of reviews. This seems obvious, but don't let your budget dictate your safety.

- If possible, stay with female hosts. Look into verified hosts who not only have sparkling reviews but also are women.

- Visit a travel clinic before departing. Find out about the vaccinations or prescriptions you'll need to get.

- Research common scams for your destination. A simple web search will bring up tons of circumstances described by past visitors.

- Take pictures of all your documents and save them digitally. If you lose your passport, ID, or itinerary information . . . you'll always have a digital backup.

CONTINUED ON PAGE 8

Brooklyn, New York, United States

NASTASIA YAKOUB | @NASTASIASPASSPORT

The view from Williamsburg's pier on North Fifth Street is stunning during the golden hour.

"The world is often a scary place for women. Whether we're traveling to another country—or even just another state, for that matter—or we're walking down the street or watching TV alone in our apartments, we are at risk of gender violence. So, if there's so much danger, why should women travel? Why should they explore the world instead of hiding out in a remote doomsday bunker? Because fear shouldn't stop us from living our lives fully. I spent most of my life living in fear—fear of other people, of being vulnerable, of being harmed, of being disappointed—and it kept me in hiding and from doing so many things I wanted to do. It kept me from being an active, main character in my life experiences. But what did it not keep me from? Being hurt, being taken advantage of, and being let down. Fear shouldn't stop women who seek to explore the world. Travel allows women to connect with others, to nourish themselves, to be seen, to be heard, and to ask for more. The opinions, roles, and goals of women are changing, and the more they move throughout the world, the more it will force the world to shift with them."

MICHELLE JUERGEN (@MEESHULL)

- Have hard copies of your itinerary and important phone numbers with you at all times. Identification is fine, but having an address and emergency contact list is one excellent way to be safe.

- Always mention that you're meeting someone. Just a quick "Yeah, I'm meeting my friend" will immediately stop a troublemaker.

- Communicate your itinerary with someone at home. In fact, print out an itinerary so that they'll have a copy on hand.

- Register your trip with the US Department of State. This is a great resource to turn to for safety information and for help if the country you're in is in a state of emergency.

- Learn a few key phrases in the local language. Know "Hello" and "Thank you," but also "Stop" and "Help."

- Walk relatively close to a couple or a family after dark. There's safety in numbers.

- Schedule a regular check-in with someone back home. Whether it's a daily text to share what you're up to or a FaceTime date with someone you can count on, have a regular time to communicate.

- Pop into the nearest restaurant, store, or hotel if you feel uncomfortable with someone near you. If you're feeling watched or followed, ducking into a store with other people makes it look like you're meeting up with someone.

- Pack an external phone charger. In this day and age, losing power to your phone pretty much takes you off the radar. As nice as that may sound, it also heightens your risk.

- Grab the business card for (or ask the front desk/concierge to write down, in their language) the name, address, and phone number of your accommodation. If you're staying with a host, ask them to provide the same, just in case.

- Ask female flight attendants and concierge staff about their feelings about safety. Ask the women you encounter throughout your travels for their honest opinions. They'll tell you what to look out for or if they've had any scary incidents in the area where you're staying.

- Never, ever use an unmarked taxi. You may be tempted by a cheaper, less stressful ride . . . *but don't do it.* Unmarked taxis are completely unmonitored and unregulated, leaving you unprotected in a potentially horrible situation.

- Know your destination's emergency phone numbers. Saving your foreign emergency phone numbers in your phone could save your life!

- Take note of sunrise and sunset. If you know you'll need to be navigating by foot (hiking, taking a long walk when there's no public transportation) in an unknown area, you'll know when you need to be on your way.

- Hang your "do not disturb" sign even when you aren't in the room. Call downstairs and ask for your room to be cleaned while you are there rather than making your room a potential robber's easy target.

- Be aware of your purse at all times. Keep it on your lap in cafés, with your hands resting on the top zipper while you maneuver through busy streets, and on your body when you use the bathroom.

- Take your bag with you to the bathroom every time, even on buses and trains. Never, and I mean *never*, leave behind your valuables when going to the bathroom, even if it's for a quick break.

- Don't keep all your money in one place. If you're bringing a purse to carry around in the daytime, place your money scattered throughout it (for example, in your wallet, in your side pocket, and inside a tampon applicator).

- Pack a day bag with all your important items and don't let it leave your side. Your most prized items should be glued to your hip, stowed away in your locked suitcase, or in the hotel safe.

- Walk confidently with your head up and make eye contact. Attackers looking to cause harm to a woman search for signals that a woman won't fight or cause a scene. Do the opposite.

- If you're listening to music, only wear one earbud. Many people use headphones as a signal that they would rather not be interrupted, but others may see this as a distraction that makes it easier to take advantage of you.

- Always go in a train car that has other people in it; avoid the ones that don't. New Yorkers know this tip very well.

- Don't feel guilty about saying no to anything. You *do* have the right to say no to anything.

- Exercise caution when posting your vacation pics. Sharing your photos on social media is a signal to robbers back home that you aren't there (leaving them with an abandoned home from which to shop).

- Be careful about tagging specific locations, including the hotels where you are staying. Post later if you must.

- Last but not least, *never doubt your intuition.* Trust your gut.

TO THE MEN WHO ARE READING THIS . . .
We want to thank you. Just by opening the pages of this book you show your interest in supporting women who travel. We need more male allies like you! We'd love to impart some ways you can support our passion for travel out there in the world.

- *Be the guy who amplifies our stories.* We need more women to know that they shouldn't be afraid to go it alone. You can help us.

- *We might be afraid of you–please don't take it personally.* Given the number of horror stories we hear, understand that we might be fearful of the men we encounter in public. Our fight-or-flight senses may be on high alert when we see you on a street.

- *Be the guy who steps in.* Harassment (and the fear of harassment) is a real thing. If you see something, say something. We need more men who are vocal and able to step in and stop unsafe behaviors that men often display toward women.

- *We're good, we promise.* When we say that we've got things under control, trust us! It can be difficult to express our need to be left alone, whether it's for our own safety or for some quiet time.

- *Understand what we put up with.* To understand our plight is to be our ally. We need more compassionate men to support us.

- *We're not being rude–we're being private.* When you ask us where we're from, where we're staying, how long we'll be in town– understand that we might not be comfortable telling you our private information. Our guard may be up.

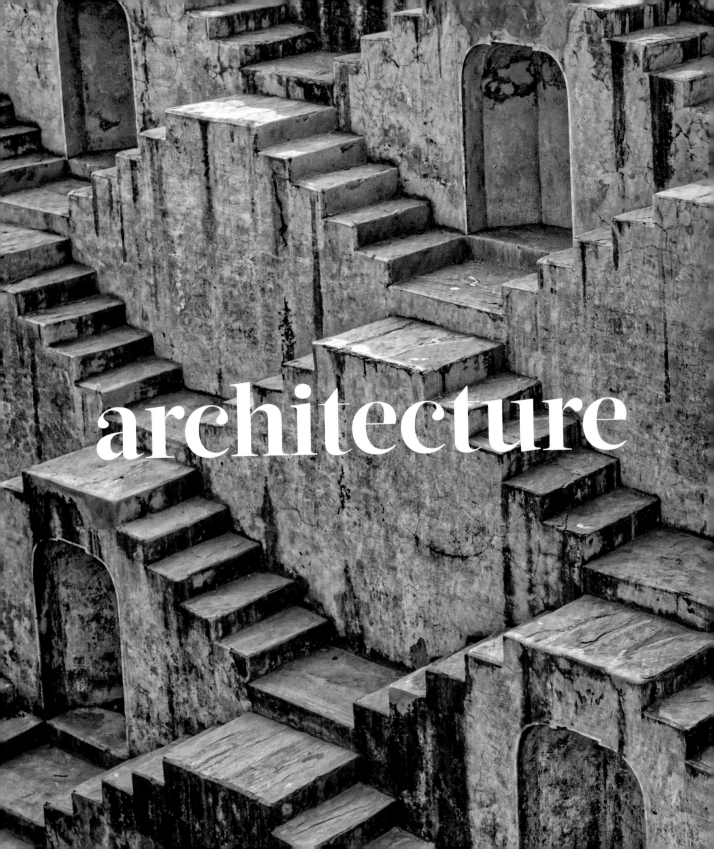

architecture

From the breathtaking cathedrals of France and Italy to the intricate, *zellige*-tiled Moroccan *riads* (homes or palaces) to the towering skyscrapers of Dubai, traveling through the architectural wonders of the world has a way of teleporting you back in time and offering a glimpse of our future. Physically standing within these places breathes life into the monumental moments of history that have occurred there, making everything feel more real than if you were to just read about them in books.

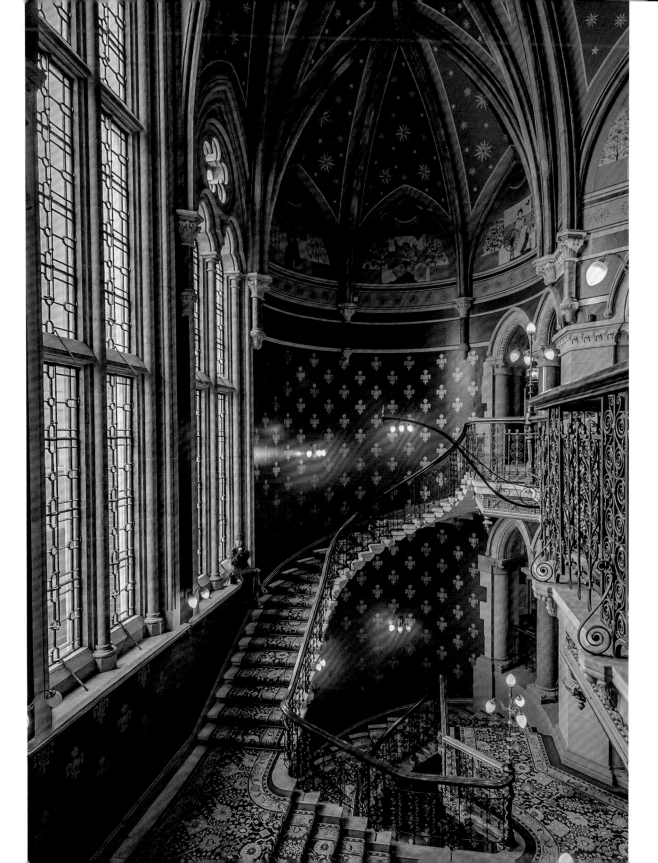

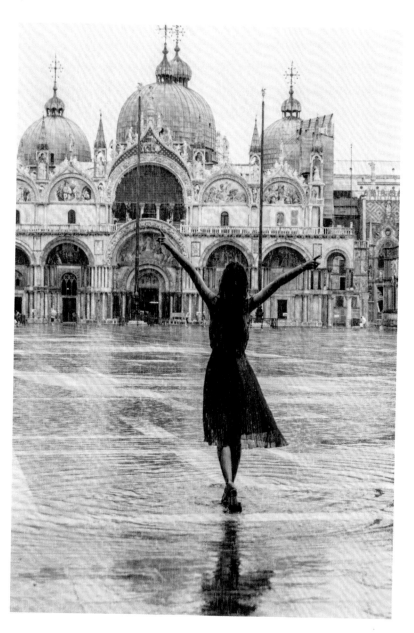

London, England

SHARON YAP | @SHARONYWS

(Opposite) "The grand double staircase of St. Pancras Renaissance Hotel, a historic hotel in London, is quite a sight to behold. It was a trip down memory lane to learn that the iconic staircase was where the Spice Girls filmed the music video of their hit track 'Wannabe'! The St. Pancras Renaissance Hotel has direct access to the high-speed Eurostar and tube service of London St. Pancras International Train Station. Since the staircase can only be accessed by guests staying at the hotel, book a tour to learn about the history of the railway station and hotel. The tour comes with refreshments too!"

Venice, Italy

АЙГУЛЬ ВИШНЯ | @VI66NYA

(Left) The iconic Saint Mark's Basilica is a must-see destination when in Venice, but be sure to arrive early in the morning to beat the cruise ship crowds that flood the square. For a lesser-known experience, head over to the Acqua Alta Bookshop on Campo Santa Maria Formosa.

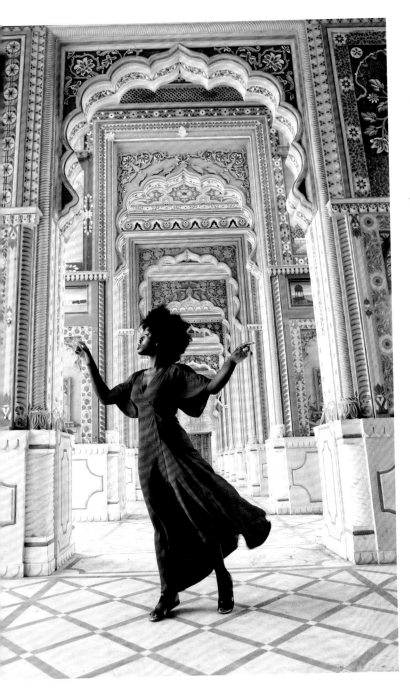

Jaipur, Rajasthan, India

SHADE BAKARE | @FOLA.SHADE

(Left) The stunning Patrika Gate is the entrance to the circular garden of Jawahar Circle, located a short distance outside of India's Pink City, Jaipur.

"Most cities I ventured to in India were so drastically different from my home that there was an initial culture shock from the sheer overwhelm of it all. In a space so unpredictable, you can neither focus on the past nor predict the future. Your sense of self in the present heightens, and you're forced to live in the moment."

Admont, Austria

KELSEY HAMEL | @KELSEYHAMEL

(Opposite) "The library at Stift Admont (Admont Abbey) in Admont, Austria, is the largest monastic library in the world, which houses texts dating back to the eighth century AD. We made a detour here on a road trip from Salzburg to Vienna, adding an hour and a half of driving through beautiful landscapes to the trip–so worth it! What surprised me was how spiritual the library felt, thanks in part to the incredible frescoes painted by Bartolomeo Altomonte (who was eighty years old at the time!) in the eighteenth century. They depict an interconnectedness of religion, art, and science and their relationship to the path of enlightenment."

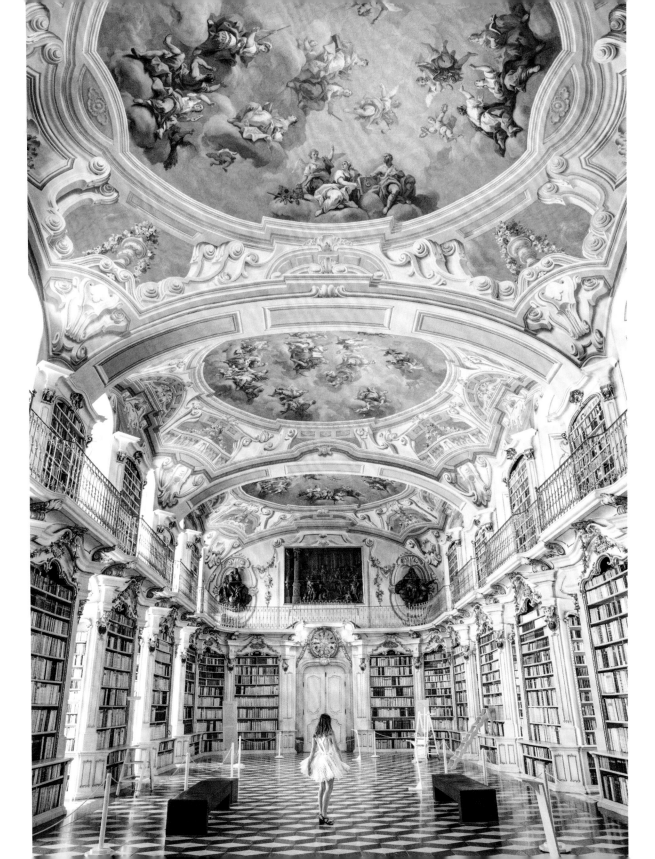

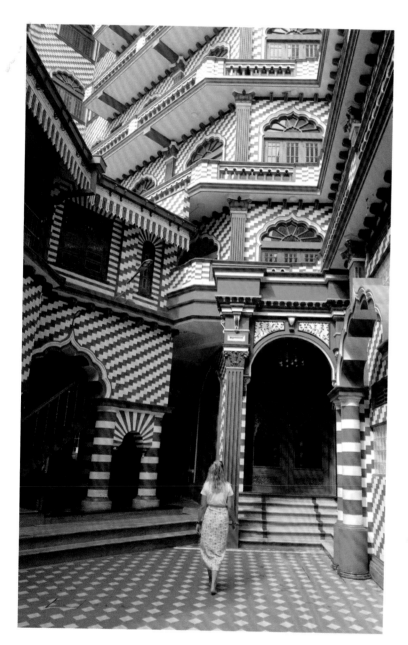

Guía de Isora, Tenerife, Spain

CAMILLA MOUNT | @CAMILLAMOUNT

(Opposite) "The Moorish inspired Ritz Carlton Abama Hotel is set on a clifftop in the Canary Islands. The property is a mix of Marrakech and Santorini, washed in dusty pink, surrounded by mountains and the ocean. The hotel has a very laid-back, relaxed atmosphere, making it the ideal place away from all the hustle and bustle of the rest of the island. Be sure to visit the nearby town of Playa San Juan for a seafood lunch by the sea and a stroll through the colorful streets."

Colombo, Sri Lanka

KIM VAN WEERING | @KIMVANWEERING

(Left) The candy-striped Jami Ul-Alfar Mosque is located in Colombo, the capital of Sri Lanka. The mosque is within walking distance from the lively Pettah Market, which is worth exploring as well. Ask your tuk tuk driver to park at the edge of the market and then you can weave through the maze. It's best to have the driver or a friend walk with you through the market, as it can get very crowded and hectic.

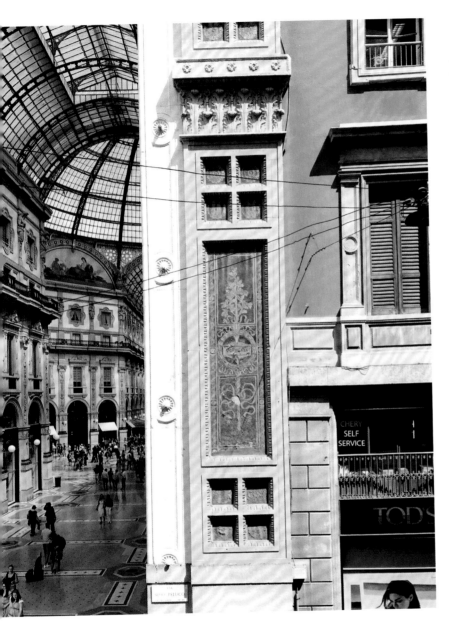

Milan, Italy

MICHELLE CATHERINE
@CRAZYCATLADYLDN

(Left) Galleria Vittorio Emanuele II is a four-story double arcade and is one of Milan's most photographed spots, but this unique perspective can be found from the Park Hyatt Hotel.

DAME TRAVELER PRO TIP

After you've gotten your fill of the touristy sites like Galleria Vittorio Emanuele II and the Duomo, spend time in Milano, hanging with the locals in one of the city's many hip neighborhoods like the fashionable Zona Tortona, the city's former city gates at Porta Romana and Porta Venezia, hip-yet-cozy Isola, and the chic cafés in Brera.

Copenhagen, Denmark

CONNIE CAO | @CONNIEANDLUNA

(Opposite) Is Copenhagen the cozy capital of the world? We sure think so. The Danish tradition of *hygge* (pronounced "hoo-gah") celebrates coziness of the soul. Experience it for yourself by nestling on the terrace of a café along Nyhavn 1, enjoying a slow day strolling through Copenhagen's quiet back alleys full of character, and disconnecting from your phone to enjoy the present moment while you explore this welcoming city.

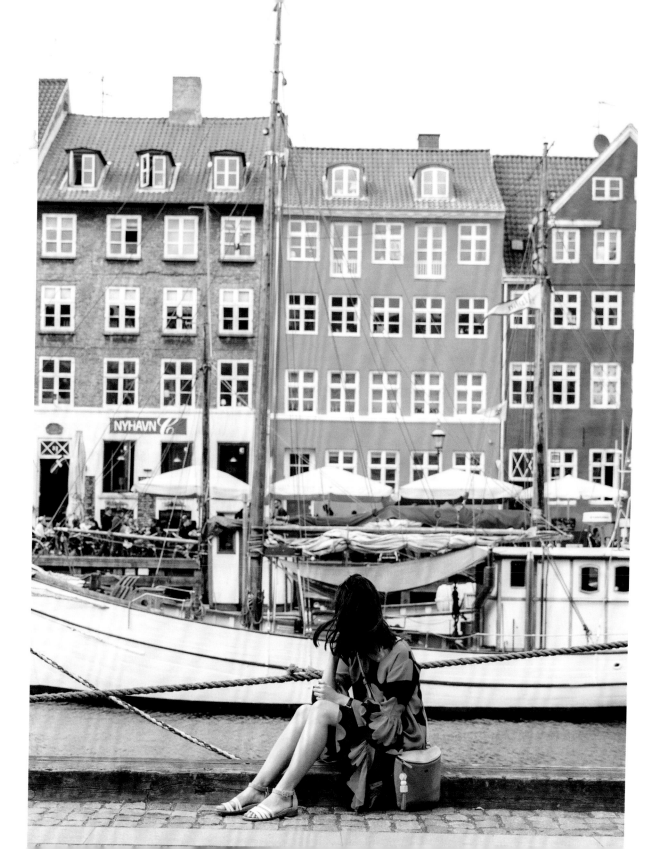

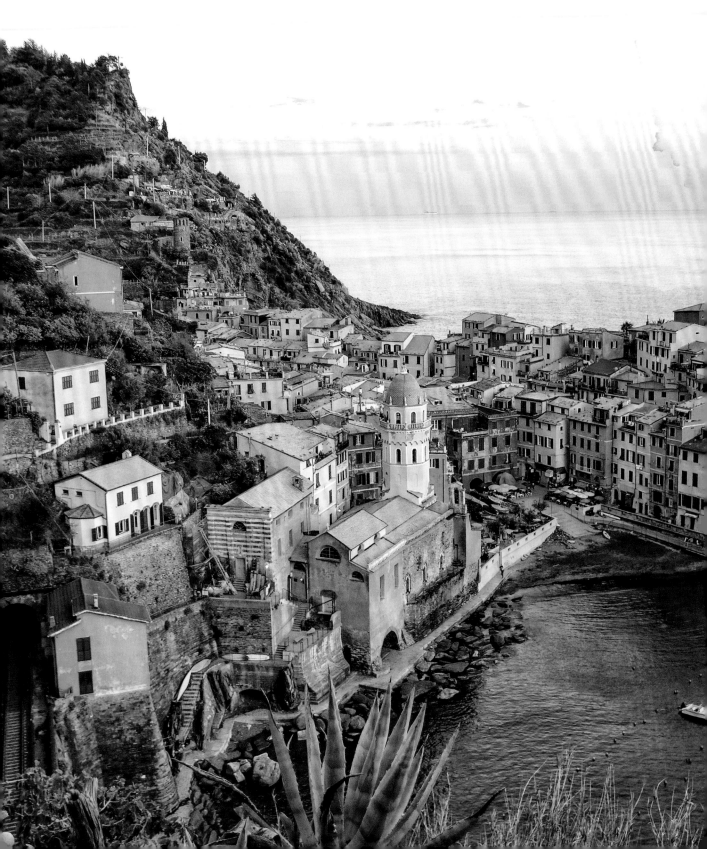

Vernazza, Cinque Terre, Italy

NATALIE RAYMOND | @MYGREATESCAPES

(Opposite) Cinque Terre ("The Five Lands") comprises five villages: Monterosso al Mare, Vernazza, Corniglia, Manarola, and Riomaggiore. During the warmer seasons, you can set out to hike from one village to another, making for a super scenic adventure. Some of the hiking paths take two to three hours, and the average time spent to hike the whole of Cinque Terre is approximately six to seven hours. You can also opt for traveling from village to village by local train or ferry boat.

George Town, Penang, Malaysia

ANNETTE RICHMOND
@FROMANNETTEWITHLOVE

(Right) In Malaysia's George Town, the five-foot way at Kek Chuan Road is a colorful sheltered walkway and corridor that's open to the public and lined with colonial shophouses.

"Bringing attention to an underrepresented community has shown me that fear of the unknown is the biggest factor keeping people from traveling. As a fat person, I have things to consider that a straight-size person doesn't. For example, Will I need a seat belt extender on the plane? Will I need to purchase two seats? Does the zip line have a weight limit? Does the scuba trip company have a wetsuit in my size? Not knowing the answers to these questions and not knowing who to contact to get the answers is a major deterrent for plus size travelers. By sharing my story and my travels, I'm able to shine a light on the importance of transparency and create content that answers them in order to help people in my community feel less self-conscious and more brave to get out there. It is imperative to celebrate women and people of all sizes, because variety is the spice of life!"

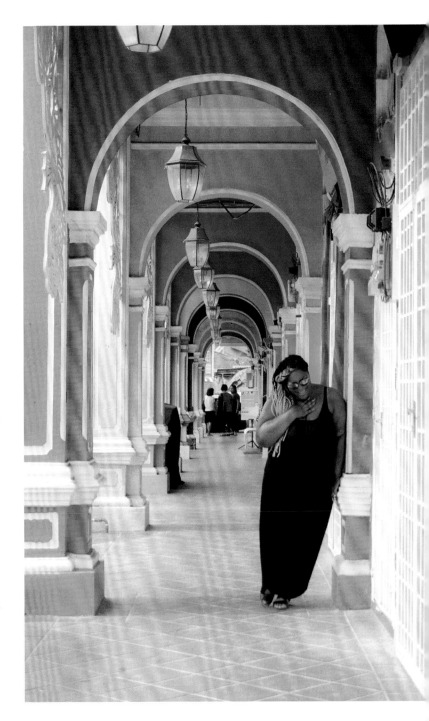

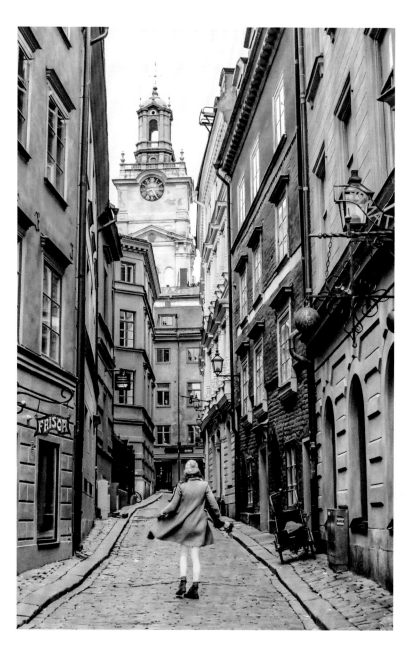

Stockholm, Sweden

HELENA BRADBURY
@HELENABRADBURY

(Left) The historic district of Gamla stan of Stockholm, with its mustard color palette, has charming corners at every turn—like this particular street on the corner of Stora Gråmunkegränd and Stora Nygatan, facing east.

Düsseldorf, Germany

TEZZA BARTON | @TEZZA

(Opposite) Schloss Benrath is the castle your childhood dreams are made of. This opulent Baroque-style summer mansion with pink exterior is the perfect day trip from Germany's beloved city of Düsseldorf. Explore its three wings and learn all about its past soirées! And be sure to explore its extremely well-kept gardens just outside of its wide windows.

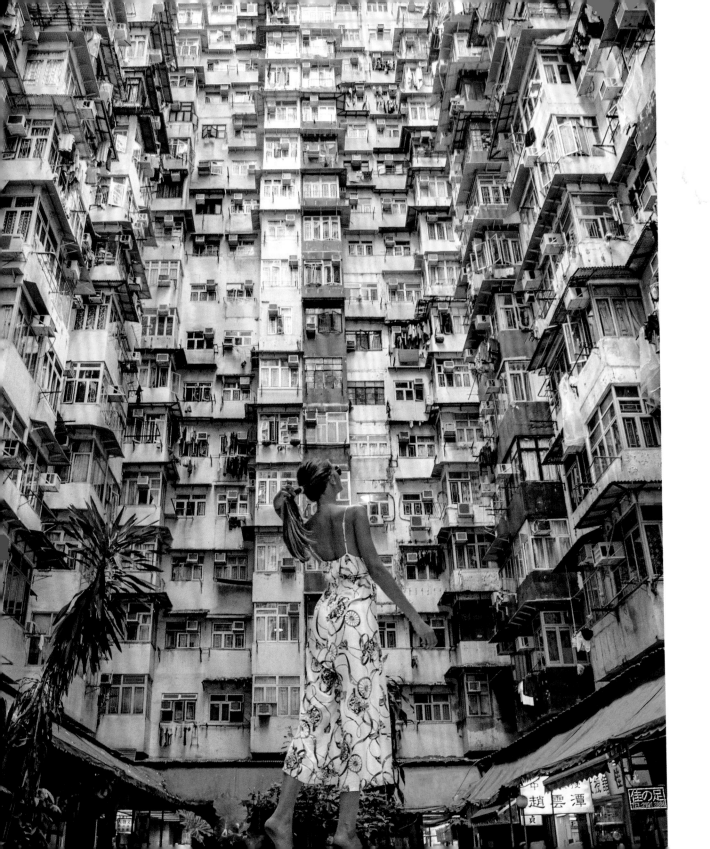

Hong Kong

NATHALIE ARON | @VOYAGEFOX_

(Opposite) Quarry Bay is a less touristy side of Hong Kong. It offers tons of great restaurants frequented by locals, art galleries, and awesome architectural complexes, like the Yick Cheong Building, that make for great photo opportunities.

DAME TRAVELER PRO TIP

Since it's a bit hard to find, plug the exact address into your navigation: 1046 Kings Road, Quarry Bay, Hong Kong. Also, take a break at the nearby chic and minimal East Hong Kong's rooftop bar, Sugar, to catch unique views from the thirty-second floor.

Venice, Italy

LUCIANA TERRONI | @LUCIANATERRONI

(Right) The Antica Locanda Sturion Hotel boasts views of the Grand Canal as well as the iconic Venetian site: the Rialto Bridge.

DAME TRAVELER PRO TIP

One of the best ways to experience simple, slow moments in Venice is to have a picnic along the canal. Pick up some bread, cheese, and wine at the Mercati di Rialto, just north of the Rialto Bridge and take in the beauty of this enchanting city.

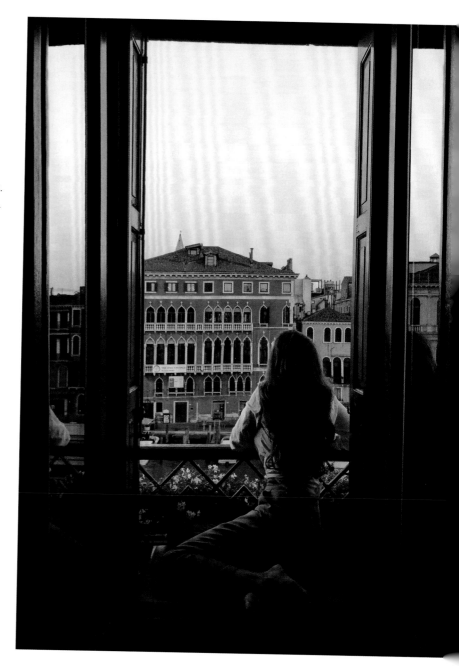

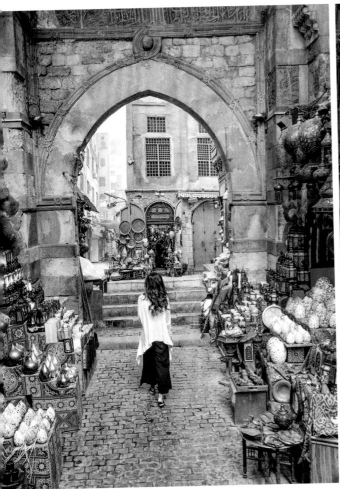

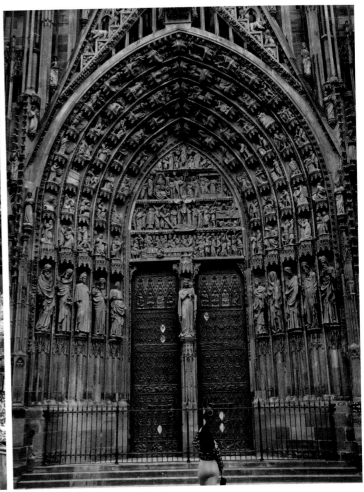

Cairo, Egypt

JO HYUN | @SHESATRAILBLAZER

"Traveling has taught me the beauty of living simply. I was overwhelmed by the thought of consolidating my apartment into a suitcase and getting rid of the majority of my possessions. Almost a year later, I don't miss a single item. You realize the happiest moments are often free or cost very little–watching a sunset over a remote desert, eating some amazing handmade ice cream, connecting with locals over a shared meal, or walking through a massive market like Khan el-Khalili market, without the need to buy a thing, just appreciating its beauty and all of the colors and moments happening."

Strasbourg, France

SASHA SHAFFOU | @SASHASHAFFOU
BY @NASTASIASPASSPORT

Strasbourg is the perfect blend of French and German cultures in one city. The city's Gothic cathedral is more than a thousand years old and its intricate details are a real marvel. Don't miss the church's astronomical clock that shows the exact positions of the sun and moon according to the planetary calendar.

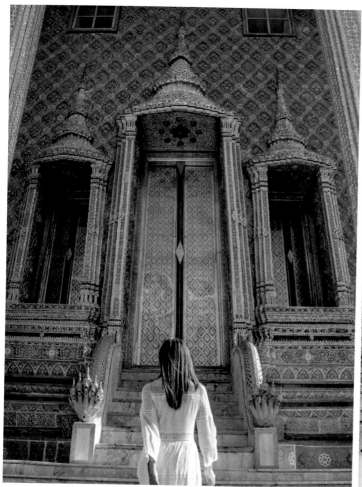

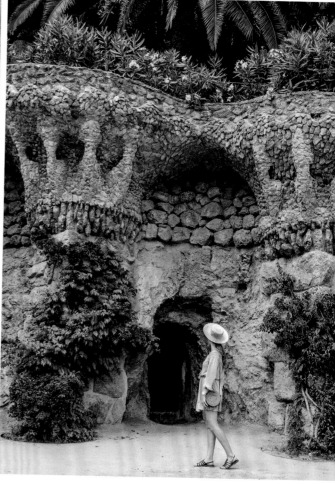

Bangkok, Thailand

TIFFANY WYNNS | @PINCABOO

"The Grand Palace is one of the most popular tourist destinations in Thailand, so it can get a bit hectic. Visit closer to closing time when the tours start to leave, and you have a better chance of experiencing quieter moments in this special place."

DAME TRAVELER PRO TIP

Be prepared for the palace's strict dress code. A shawl alone may not be deemed acceptable. It's better to be covered conservatively from head to toe, otherwise you may be turned away.

Barcelona, Spain

OPHÉLIE MORIS | @LABENGALE

With the help of long siestas, art, beaches, history, markets, and sangrias, the people of Spain definitely know how to live. Barcelona is a destination for travelers craving a break from the hustle and bustle of work life. Spend an afternoon strolling and people watching in Antoni Gaudí's eccentric and well-loved architecture in Park Güell around golden hour, when the crowds have cleared and the light is magic.

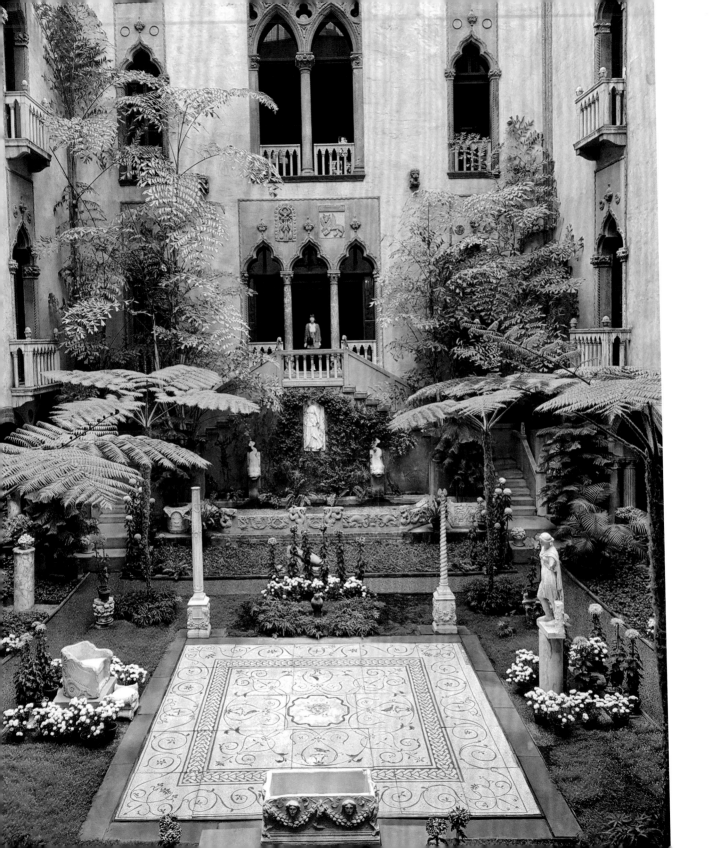

Boston, Massachusetts, United States

FEDERICA DI NARDO | @FEDERICADINARDO_

(Opposite) The Isabella Stewart Gardner Museum is so much more than a gallery filled with over two thousand artifacts. Isabella's story tells a tale to which many women who travel can feel a kinship. After discovering that she would not be able to have children again, Isabella Stewart Gardner fell into a deep depression and even isolated herself from the world for two years. It was only after a trip across Europe that her spirit was lifted. That journey sparked an unrelenting desire for collecting objects from foreign lands, which catapulted her into more travels. After gathering enough artifacts to fill multiple warehouses, she decided to showcase her collection to the public.

Mexico City, Mexico

MELISSA MALE | @MELISSAMALE

(Right) The Four Seasons Hotel in the heart of the hustle and bustle of Mexico City is an absolute urban oasis and an institution for both chic locals and travelers alike. It's also home to one of The World's 50 Best Bars, Fifty Mils.

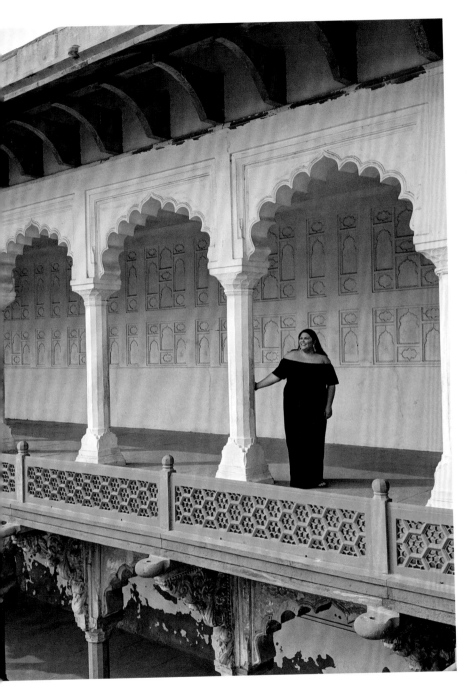

Agra, India

CALLIE THORPE | @CALLIETHORPE

(Left) Agra Fort has housed many important emperors throughout India's history. Should you find yourself here, be sure to check out its many secret, interconnected tunnels and underground apartments and pathways.

Lisbon, Portugal

ONYI MOSS | @MOSSONYI

(Opposite) The best way to describe the Jerónimos Monastery would be that it's quintessential "Portuguese Gothic." The monastery's intricate design and lavish cloisters with fascinating stories behind them will take your breath away. Built along the Tagus River, this UNESCO World Heritage Site in Lisbon's Belém district is also close to the famous Pastéis de Belém, where you can try Portugal's famous Portuguese egg tarts and explore the beautiful Belém Tower.

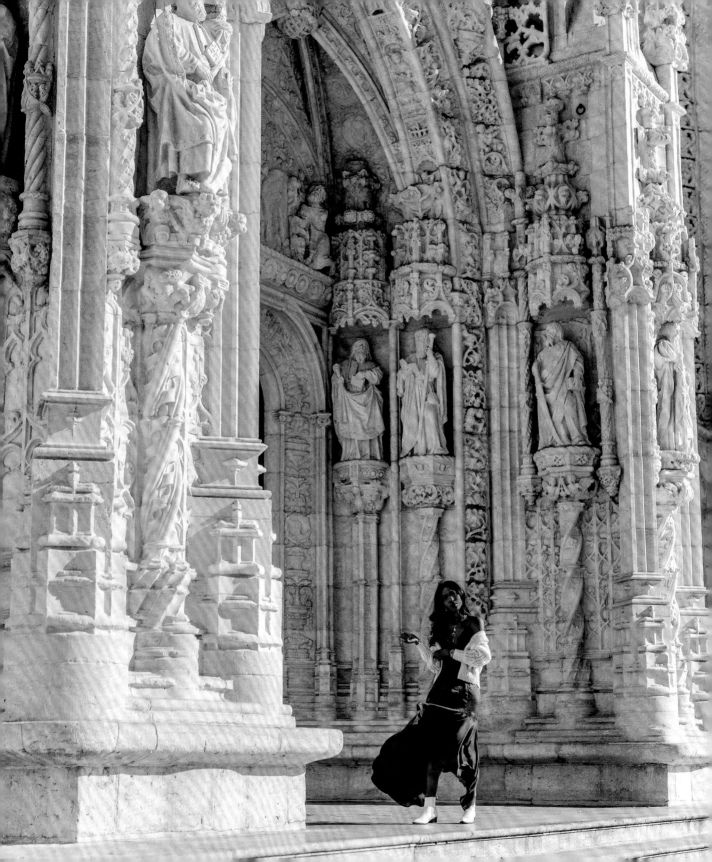

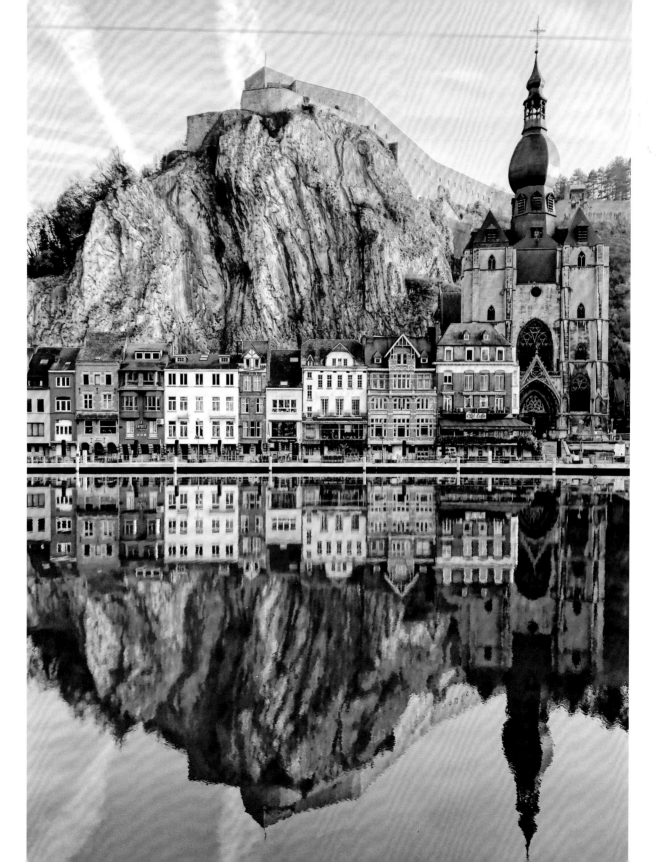

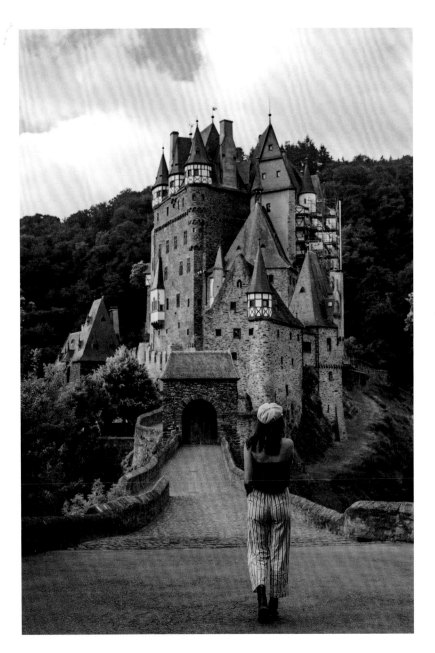

Dinant, Belgium

AGATA WAGEMAKER
@WINDMILLDREAMS

(Opposite) Should you find yourself in Dinant, Belgium, go up to the Citadel: a medieval fortress with gorgeous views over the whole city. Music lovers will enjoy a visit to the Saxophone Museum. Turns out, the inventor of the jazz instrument was born in Dinant, and his home is now an interactive exhibit in which visitors can play and learn about the saxophone's development. Entry is free, and it's a great way to spend a few hours in town.

Wierschem, Germany

LAURA FLEISCHER
@GET.LOST.IN.PARADISE

(Left) The Eltz Castle is just one of the magnificent castles sitting above the Moselle and Rhine Rivers in Germany. This particular one looks like a scene right from *Sleeping Beauty*. Nestled between Koblenz and the university city of Trier in a dense forest, the hiking paths around Eltz Castle are the best vantage point for seeing its turrets and medieval structure . . . but walking right up to it is not a bad sight to see either!

DAME TRAVELER PRO TIP
Book a river cruise that sails along the Rhine River and try the region's incredibly delicious Riesling.

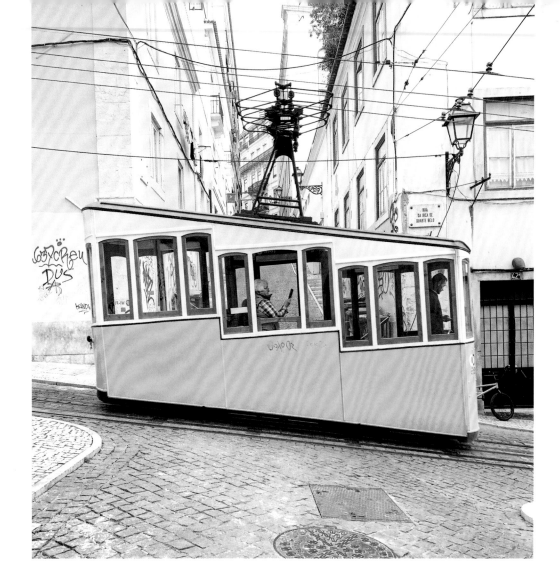

Lisbon, Portugal

TERESA MIRANDA | @ALFACINHASTORIES

(Above) From the weathered and traditional Alfama to the modern and grand Baixa, one of the best ways to explore Lisbon is by riding the Tram 28. When sitting down to plan the logistics of any city trip, be sure to research the public transportation available in the destination you're visiting. You'd be surprised how simple and cost-effective using public transport is. Here are some things to consider: Is it reliable? What are the hours they operate? Will you need to rely on taxis? Are there any tourist-specific offers for shorter stays? Being informed before you go allows you to budget for transportation costs but also gives you peace of mind and will have you feeling like a local in no time!

Chiang Rai, Thailand

NOELLA EHIKWE | @OGONOELZISM

(Right) "A beautiful work of art in Chiang Rai–the Wat Rong Khun Temple is a hidden gem. Some of Thailand's most famous artists worked and resided here. Take your time and be sure to read about the temples before visiting them so that you can truly experience what message the artists were trying to create with their imagery."

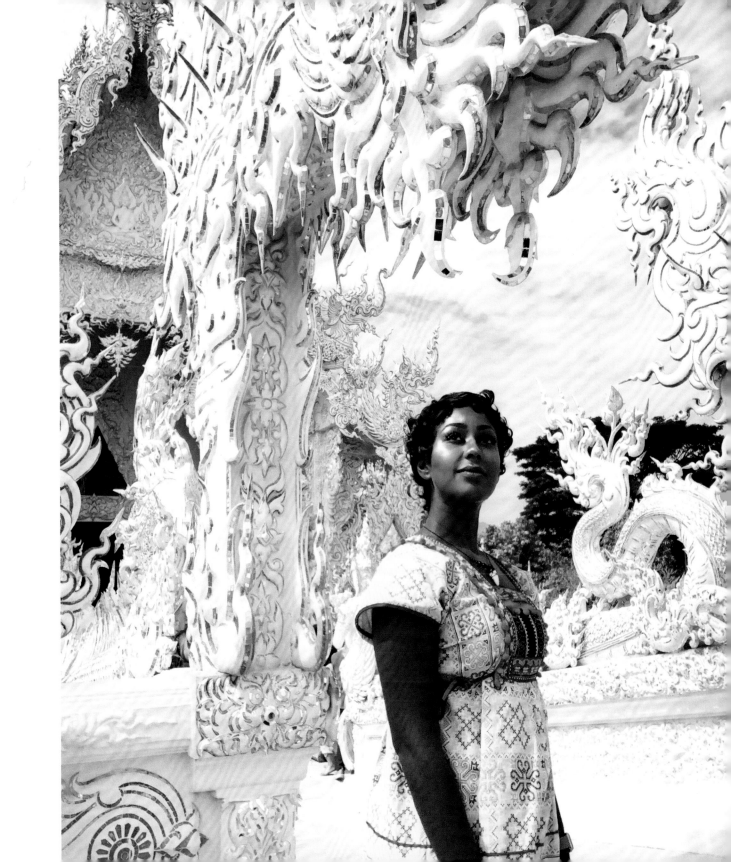

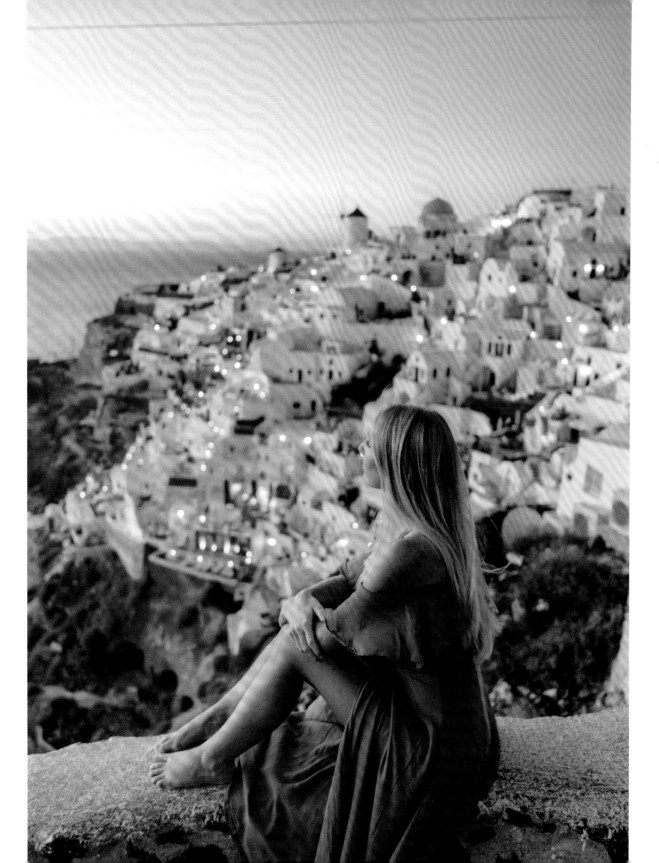

Santorini, Greece

CHIARA BARRASSO | @CHIARABARRASSO

(Opposite) The one-of-a-kind island of Santorini is accessible by ferry or a short thirty-minute flight from Athens. There are three main towns on the island: Fira, Imerovigli, and Oia. Fira, the capital, is definitely the liveliest town out of the three, with tons of nightlife and restaurants. Imerovigli is sandwiched in between the two. And Oia, pictured here, arguably has the most photo-worthy views. Its well-loved white buildings with blue rooftops are iconic, and you can watch what is considered "the most romantic sunset in the world" from the Oia's Castle vantage point.

Medellín, Colombia

ALEXANDRA ROZHKOVA | @ALEXANDRINE_AR

(Right) This sweeping view of the sprawling city of Medellín can be seen from the eighteenth floor terrace of the Charlee Hotel in the hip and very green district of El Poblado. This neighborhood is dotted with up-and-coming cafés, restaurants, and unique local boutiques.

DAME TRAVELER PRO TIP

Medellín is rumored to be dangerous due to its rough past (Comuna 13 used to be one of the most dangerous neighborhoods in the world), but the speed with which this city recovered after the civil and cartel war and the resilience of its locals have truly transformed the city. Comuna 13 is now home to one of the most vibrant communities, where you'll find the best street art in the city.

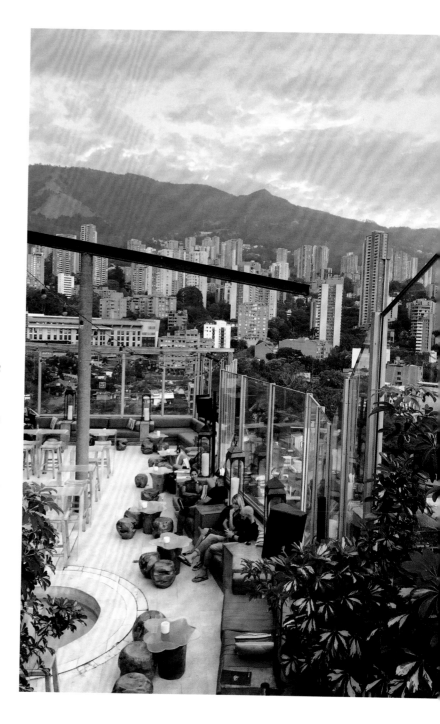

Singapore

GRASELLA DAYOT | **@DOITFORICECREAM**

(Right) As much of an architectural wonder as Singapore is (case in point, the Marina Bay Sands Hotel framed by the Helix Bridge, pictured here), you might be surprised to discover that it's also a major culinary destination. Foodies will love diving into Singapore's many markets and the incredible variety of foods, Michelin-starred restaurants, and unique local dishes. Nature lovers will also adore the city's commitment to creating many green spaces throughout the city and even vertical gardens alongside the skyscrapers.

DAME TRAVELER PRO TIP

The Helix Bridge is accessible via train and bus, and it's walking distance from Marina Bay Station.

Marrakech, Morocco

LINH TRAN | **@LINHBAYBONG**

(Opposite) With hundreds of hotels and guesthouses (known as *riads*) in Marrakech, how will you ever choose where to stay? The centrally located Royal Mansour Hotel, with the airy calming atmosphere of a spa, is the perfect hideaway from the bustling medina outside its doors. It's best known for its intricate architectural breezeway, so bring your camera and prepare to be in awe of its beauty.

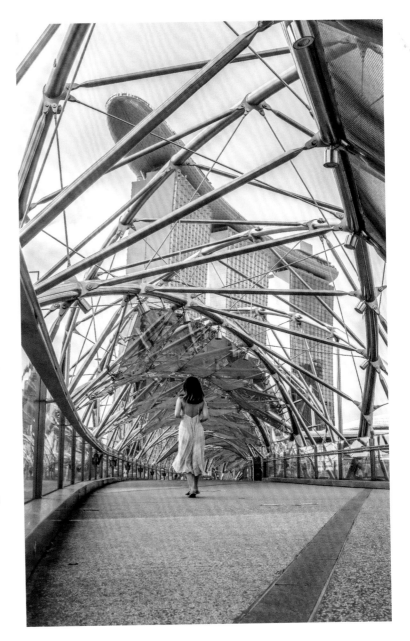

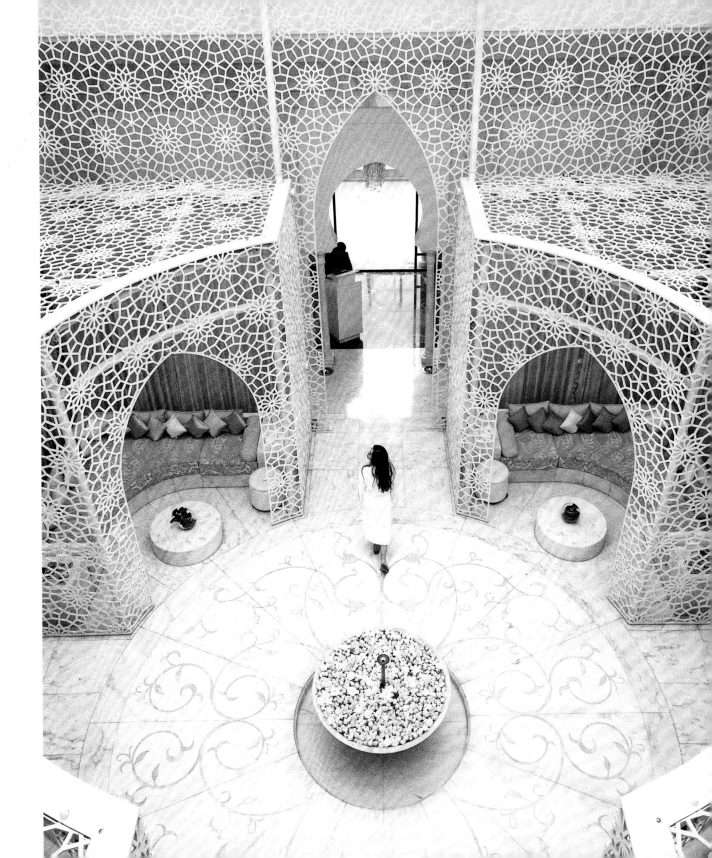

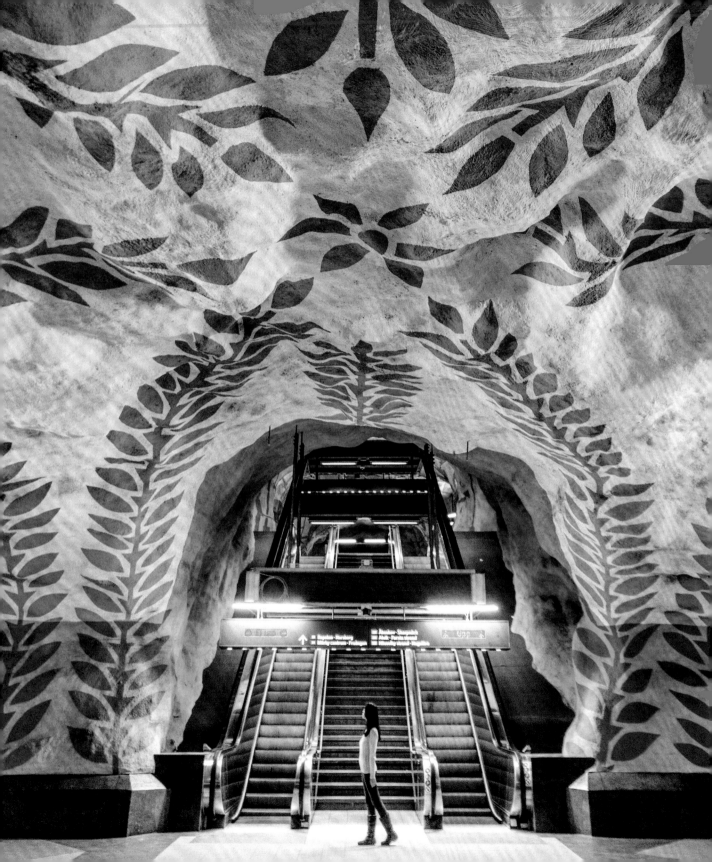

Stockholm, Sweden

JIAYI WANG | @THEDIARYOFANOMAD

(Opposite) "Spend at least half a day exploring Stockholm's different metro stations. There are over ninety stations in this city that have been decorated with paintings, installations, mosaics, and sculptures by 150 artists. Each has a unique vibe. The artists painted this specific station blue because this color inspires a sense of serenity and peacefulness, perfect for a place where people are often in a rush."

DAME TRAVELER PRO TIP

Out of the ninety stations, these are the must-see ones to add to your list: T-Centralen (pictured), the rainbow-themed station T-Bana, historical murals at Kungsträdgården, the pixelated art at the Thorildsplan Station, and the red- and orange-hued Rådhuset.

Frigiliana, Spain

JELENA BOGICEVIC | @HELENLOVESTULIPS

(Right) "On a road trip from the city of Málaga, we drove into the hills above Nerja, to find the gorgeous gem of a town, Frigiliana. It's a picturesque little spot in Andalusia, and its white alleys full of flowers, splashes of aqua blue, and doors painted an array of pastel colors filled me with energy and delight. You can find lovely views of the surrounding countryside and the coast below, but if you walk all the way up the hill you'll be rewarded with the most magnificent view of this whitewashed town and the sea for as far as your eyes can reach."

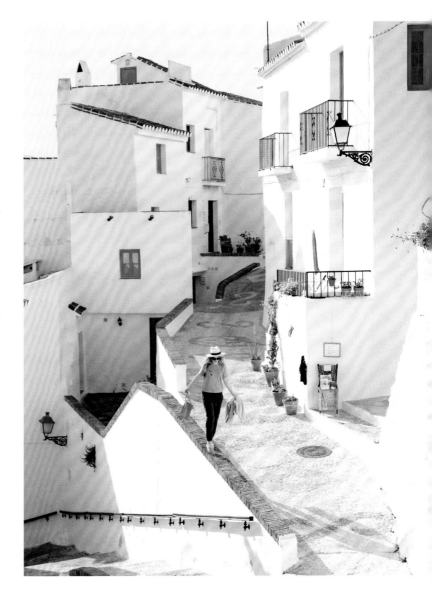

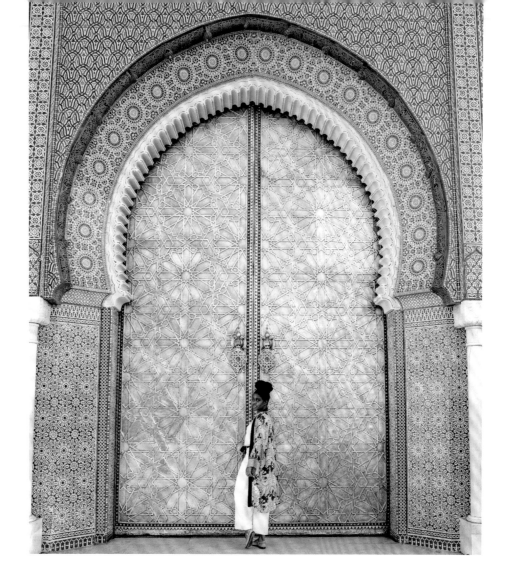

Fès, Morocco

TY ALLEN | @THATGRLTY
BY @SMALL.PERFECTIONS

(Above) Although Dar al-Makhzen is not open to the public, the stunning brass gate exterior of the royal residence of the King of Morocco is a compelling reason to visit.

"We as women are living in one of the greatest eras of humankind. We have so many opportunities that are available to us, and now is the time to seize every experience we can. Traveling gives us the freedom to take part in the rite of passage that was not always afforded to women and, in many parts of the world, is a luxury some can only dream of."

Sydney, Australia

LISA MICHELE BURNS
@THE_WANDERINGLENS

(Opposite) "Appearing like a ship floating on the harbor, the Sydney Opera House is a photogenic marvel. With structured, shell-like sails forming a skyline that's unlike anywhere else in the world, this UNESCO World Heritage Site is somewhere I always visit when I'm in Sydney."

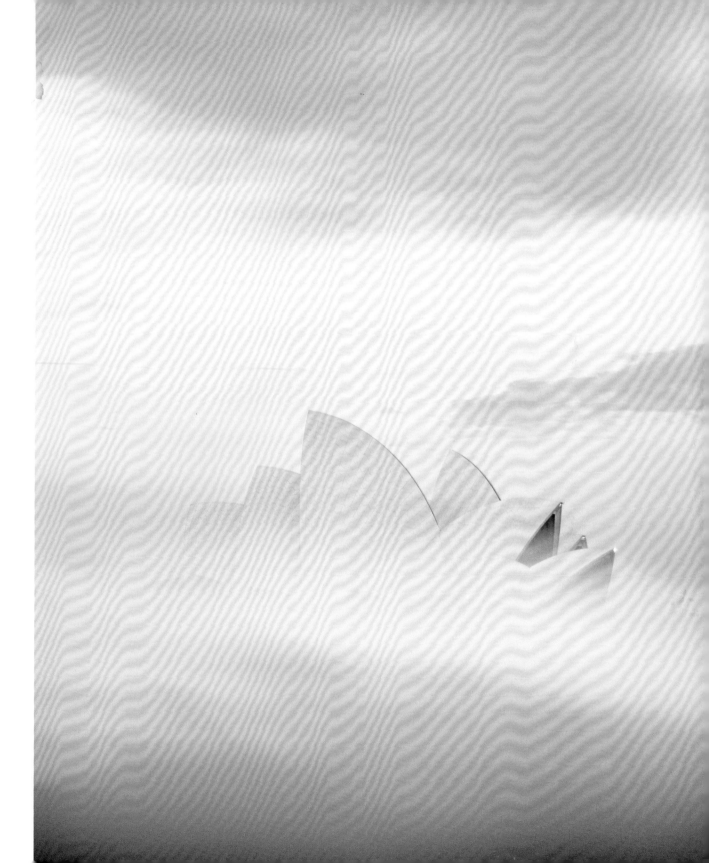

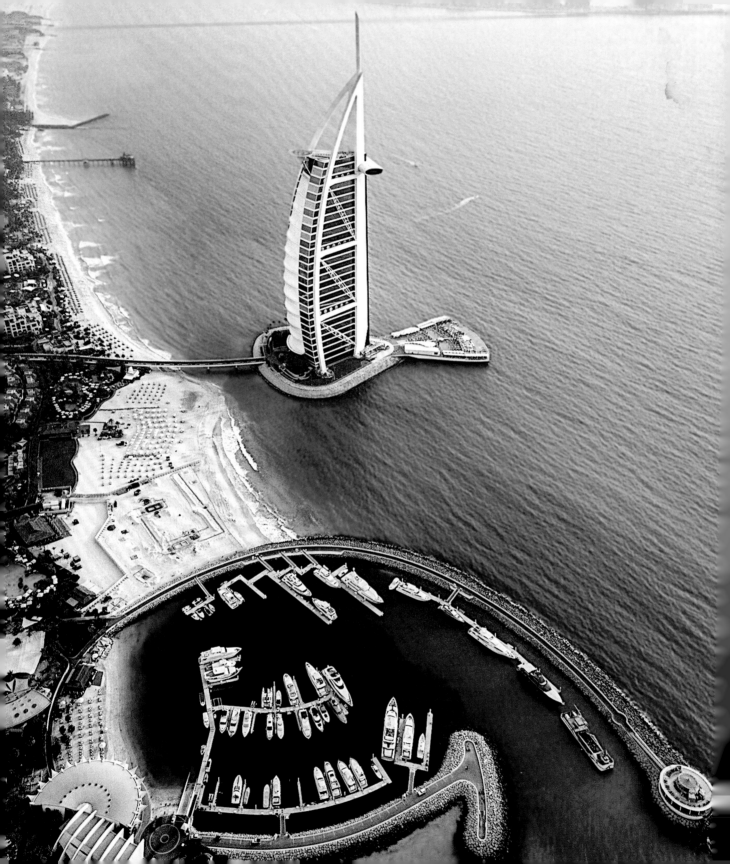

Dubai, United Arab Emirates

HUDA BIN REDHA | @HUDABINR

(Opposite) Dubai is the most incredible mix of awe-inspiring architecture and a diverse population of people from all over the world, chasing opportunity. The city's young skyline seemingly changes every day. From the modern structures soaring sky high to beachfront views and traditional mosques, Dubai is a quilt of curiosities. There's no better way to ensure you'll catch every breathtaking view of this futuristic place than from a helicopter ride. You'll get a bird's eye view of iconic places like the Burj Al Arab Jumeirah Hotel and the human-made island, the Palm Jumeirah, in all of their glory.

Paris, France

AMELIE GIADA | @AMELIEGIADA

(Right) Every perspective of the Louvre is breathtaking, but there's really something special about the framing of the tunnel at the entrance on Rue de Rivoli right outside the Palais Royal–Musée du Louvre metro station.

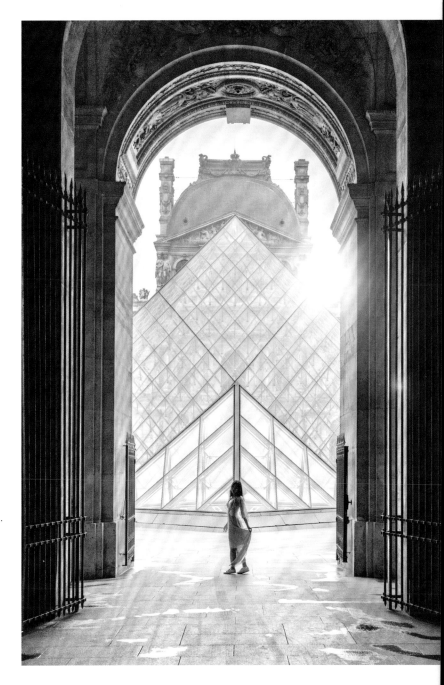

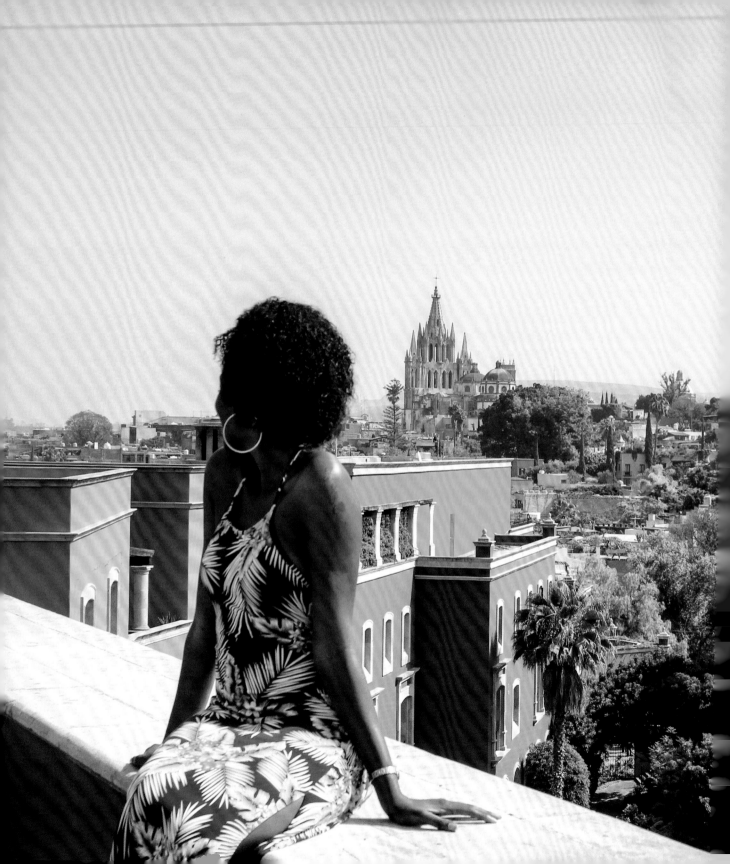

San Miguel de Allende, Mexico

DANA GIVENS | @AUTHORVMONET

The colonial city of San Miguel de Allende is best known for its intricate Spanish architecture and its many cultural festivals. Explore its cobblestoned streets and be sure to visit Parroquia de San Miguel Arcangel's tall, pink towers in the main square.

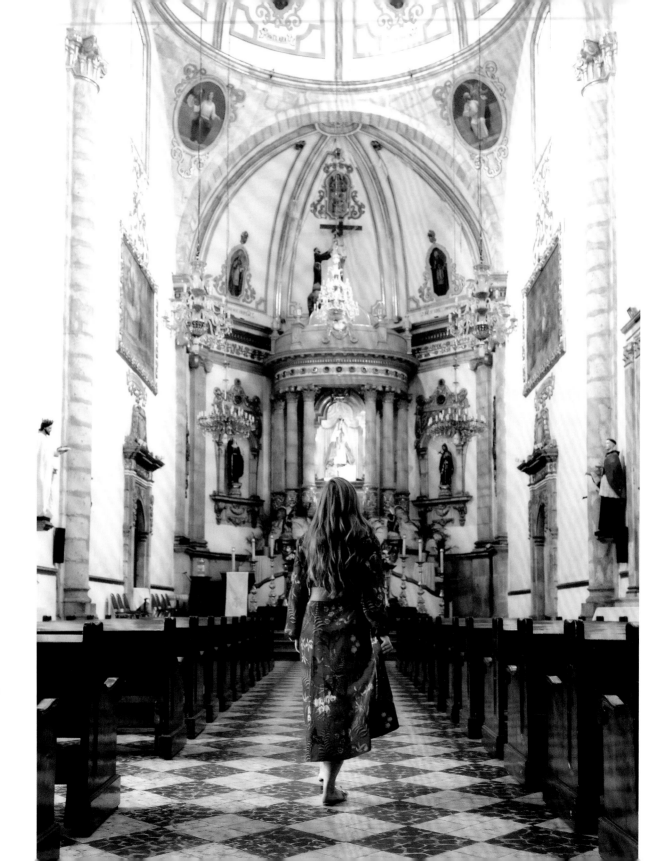

Morelia, Mexico

ASHLEY HUTCHINSON | @MUSHROOMSTEW

(Opposite) Mexico has thirty-four UNESCO World Heritage Sites and the hidden gem of Morelia is one of them. The city has yet to be inundated with an influx of foreign tourists, which means you can have the city and beautiful churches like Iglesia San Francisco all to yourself.

Cartagena, Colombia

MARISSA ANWAR | @MARISSA.ANWAR

(Right) The key to safety and reducing fear while traveling solo in places like Colombia is proper preparation. Always thoroughly research your destination. Try to find out what some of the local areas you'll be exploring are like. Is there a hospital or a medical center nearby? What is the crime rate of the neighborhood your hotel is located in? Are there any warnings from the United States about the country you are traveling to? What about typical tourist traps or tricks to keep your eye out for? These questions should be addressed before making your booking and confirming your itinerary. Not only will you be more informed, but knowing what to expect will give you much more peace of mind.

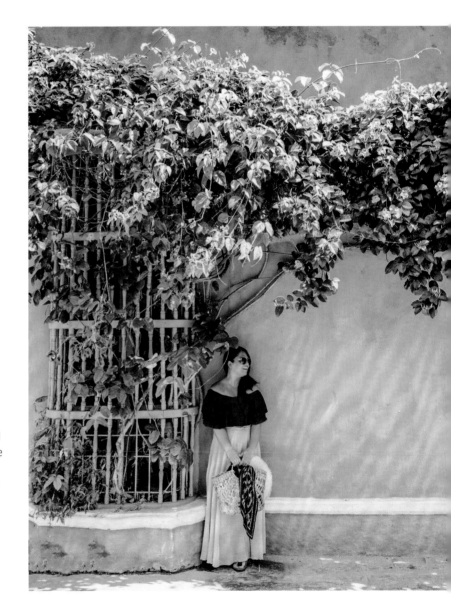

Brooklyn, New York, United States

CARLA VIANNA | @BYCARLAVIANNA

(Left) "Travel has humbled me in the best way possible. Growing up in a first-world country, I've gotten used to a certain level of comfort that simply isn't realistic in many parts of the world. Traveling through villages around the globe has shown me that there's more to happiness than 'comfort' and that just because I'm accustomed to a certain way of life doesn't mean I'm entitled to anything."

DAME TRAVELER PRO TIP

Brooklyn has some of the best views of the Manhattan skyline from outside the concrete jungle. Some of the most impressive are from the Brooklyn Bridge Park in Dumbo and the Ideas rooftop bar in Williamsburg.

New Orleans, Louisiana, United States

LEYLA TRAN | @SECONDCITYMOM

(Opposite) "New Orleans is such a fun city with so many beautiful neighborhoods to explore. You could get lost in the French Quarter for days, but I tend to like the Garden District because it gives you the chance to feel like a local. The area is so charming and filled with beautiful, historical homes with lovely facades like the carriage house at the Carroll-Crawford House."

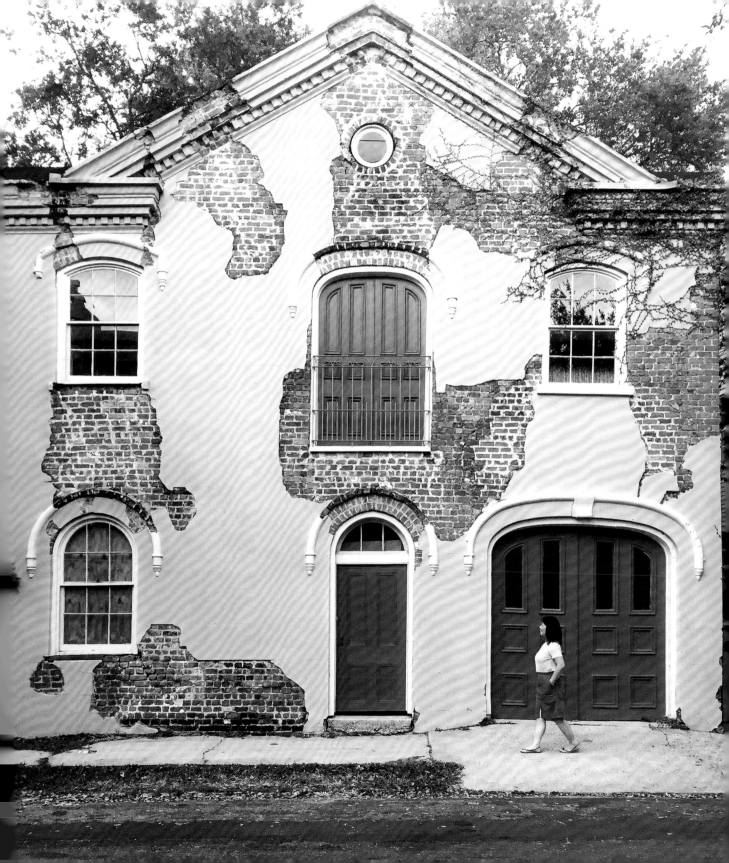

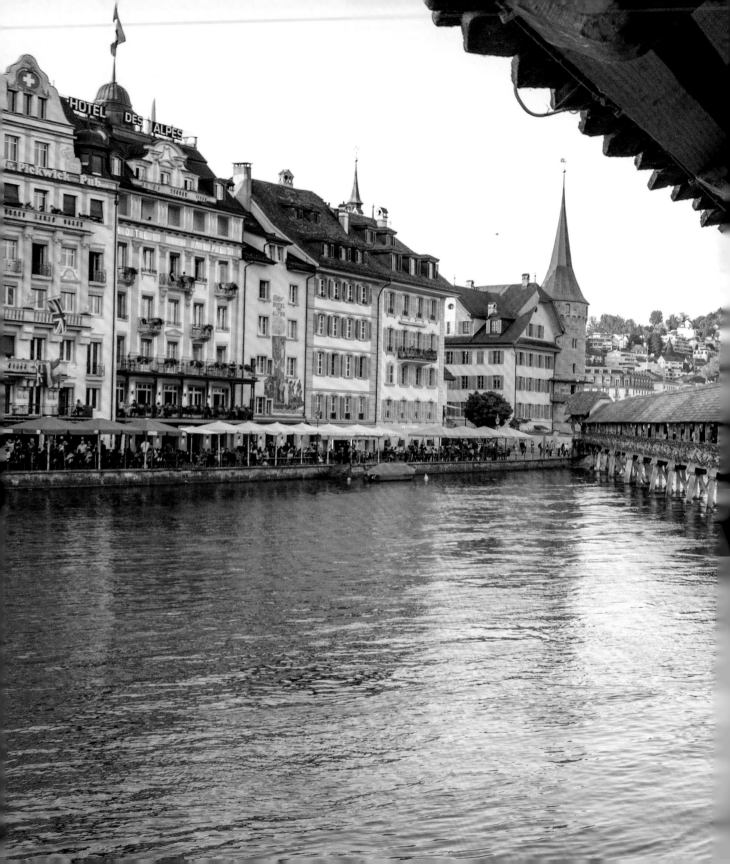

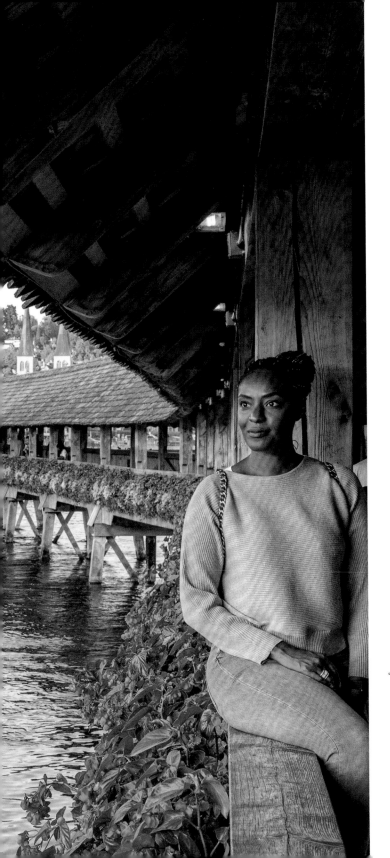

Lucerne, Switzerland

SHAIKHA ALKHAYYAL | @SHAIKHAYYAL

"Some of my favorite views of Lucerne are seen from the Musegg Wall and Gütsch hill. The views (encountered during a scenic boat trip on the lake) of the surrounding mountains and villages are not to be missed. Have lunch or an afternoon tea at the Château Gütsch restaurant, housed in a historic castle, and enjoy sweeping views of the gorgeous city below."

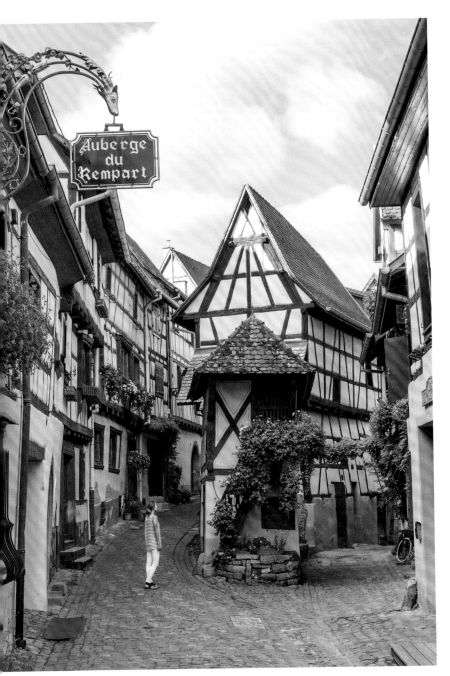

Eguisheim, France

DEVON COSTANTINE | **@DEVSTINATIONS**

(Left) "The town of Eguisheim is a quaint medieval village built in a huge circle of medieval houses. It's the kind of place where you can get lost in time, as you step around the same corner that travelers have wandered for centuries."

DAME TRAVELER PRO TIP

Rent a car and head to the Alsace region starting in Strasbourg with stops in Riquewihr, Colmar, and Eguisheim. Between the cobblestoned medieval towns and the vineyards just outside them, this area makes for the perfect European road trip.

Prague, Czech Republic

DAVINA TAN | **@HEYDAVINA**

(Opposite) Visit the Old Town Hall Tower located in the Old Town Square and purchase tickets at the base. The elevator takes you up to one of the most picturesque views in Prague. Some other photogenic opportunities in Prague include exploring the John Lennon Wall, visiting the Vrtba Garden, and climbing the steps to the top of the Charles Bridge tower at sunset.

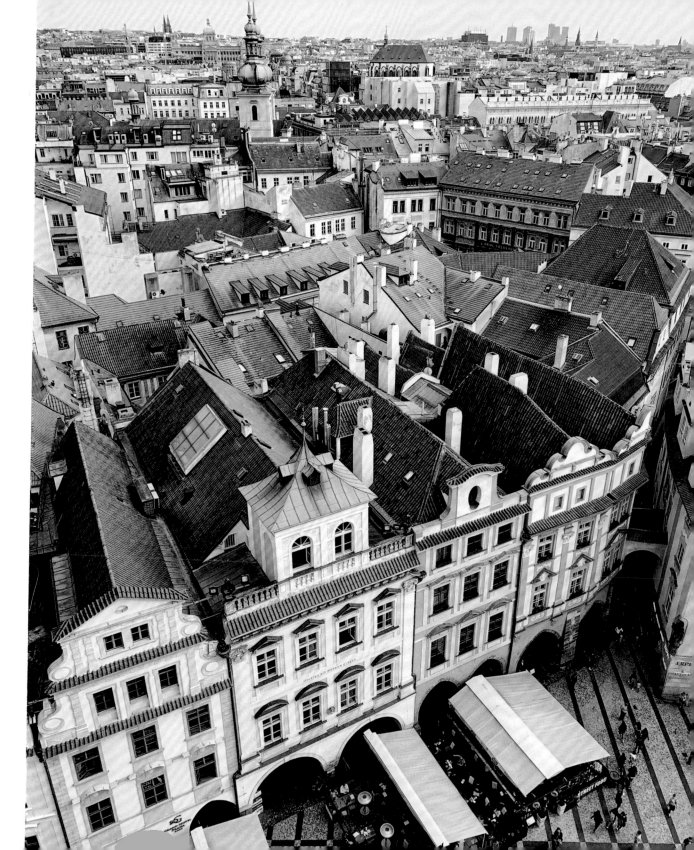

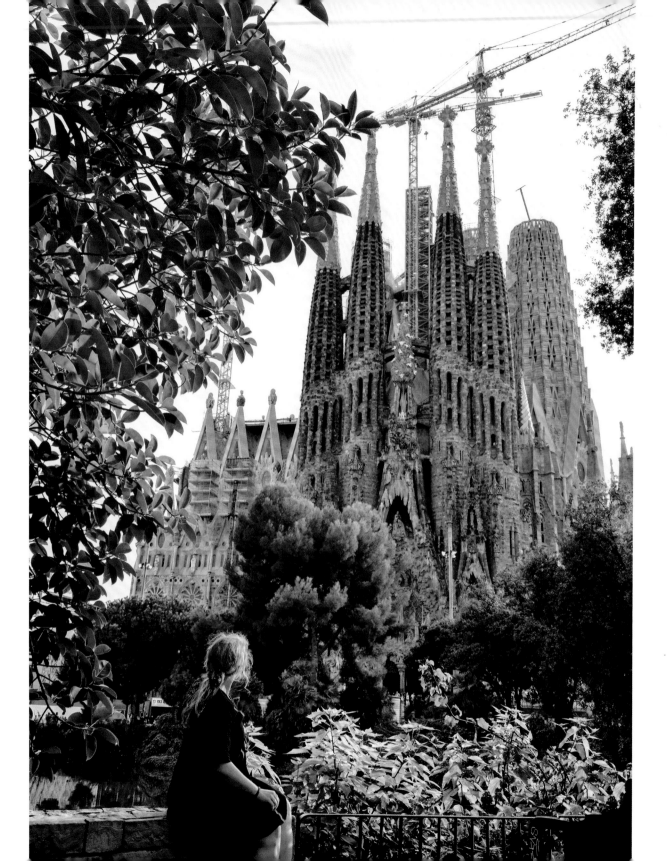

Barcelona, Spain

HELENE SULA | @HELENEINBETWEEN

(Opposite) "Bustling and buzzing, Sagrada Familia is always a maze of people. From those working on the last real cathedral of Europe to others standing in awe, people are always astonished by this masterpiece of art and religion. Antoni Gaudí envisioned Sagrada Familia almost as a musical instrument. The holes in the towers pipe out the music and make the bells ring throughout the city. Inside, it's designed like a forest, and above, the columns spread out like branches."

DAME TRAVELER PRO TIP

The iconic cathedral can be seen from so many different unique perspectives, but our favorite is from the Plaça de Gaudí where the gardens and pond perfectly frame the stunning cathedral.

Palermo, Sicily, Italy

PIPPA MARFFY | @WANDER_PIP

(Right) Gritty, eclectic, diverse, and full of energy, Palermo is a complete surprise, especially to those who have traveled much of Italy. If you'd like to see Palermo from above, pop by a rooftop bar like the terrace at the Hotel Ambasciatori di Palermo, Obicà Mozzarella Bar, and Kursaal Kalhesa.

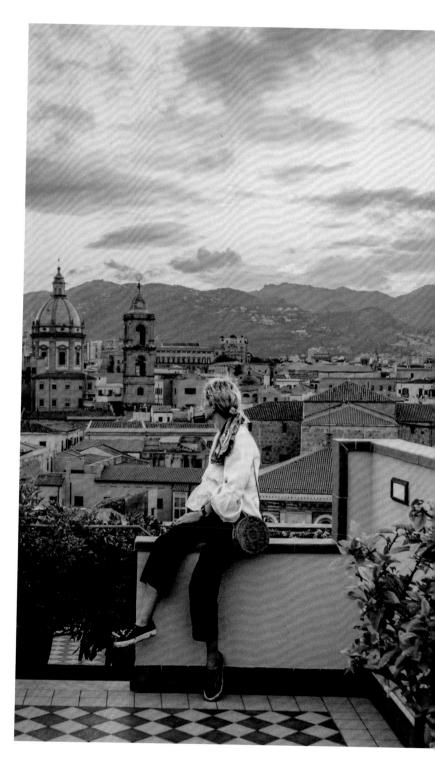

Manhattan, New York, United States

MENDY WAITS | @ANGRYBAKER

New York City is often considered an acquired taste. But if it's for you, there's no place in the world that can compare. If the touristy sites are high on your list (think Times Square, Broadway, Madison Square Garden, or Rockefeller Center), then staying in Midtown is your best bet. But if you've been there, done that, stay in a place with the feel of a neighborhood, like the West Village. It's quiet and charming and offers a side of New York City that most visitors don't see. Wander through the smaller streets of the West Village (Grove Street, Waverly Place, and Christopher Street are favorites) and then walk to Soho via Prince Street. You'll be taking photos on every block!

Hanoi, Vietnam

CIARA JOHNSON | @HEY_CIARA

Deciding to explore a location that pushes you—whether that's pushing yourself to go to a remote, rural retreat as a city-loving gal or an adventurous romp around a country you're unfamiliar with—expands your ability to overcome predetermined ideas. Hanoi is the perfect retreat for a traveler who typically seeks out luxurious relaxing vacations. The city has an irreplaceable, traditional feel that's brimming with spirit and authenticity.

San Francisco, California, United States

ANNA HAMMERSCHMIDT | @COMEJOINMYJOURNEY_

To truly understand a place, you must experience it through the eyes of those who live there. Connecting with locals while traveling allows you to gain a deeper knowledge of a place. If you're staying in one city for a few days, like on Lombard Street in San Francisco, find a local spot and make it yours, like a great café near your hotel to stop in every morning! Finding your "spot" and repeating the visit daily is a great way to ground yourself, but it also opens the door to connecting with locals.

Paris, France

SIERRA DEHMLER | @PASSPORTVOYAGER

An unexpected, cobblestoned back alley hidden in the twelfth arrondissement of Paris, Rue Cremieux is full of colorful shutters and quaint details . . . much different than the uniform, opulent French architecture Paris is known for. This rainbow-colored neighborhood gem should definitely go on your itinerary, especially if you crave charming architecture.

Munich, Germany

LEYLA KAZIM | @THECUTLERYCHRONICLES

(Opposite) "The Munich Residence served as the primary residence and seat of government of the Bavarian monarchy for over four hundred years. Today, it's a labyrinth of ornate rooms and collections through the ages, such as the Schatzkammer's bounty of jewels from yesteryear, from golden toothpicks to finely crafted swords. Do not miss the truly spectacular and fresco-covered Antiquarium banqueting hall and the lavish bedrooms!"

Paris, France

ANASTASIA EZHOVA | @CURLINGTHEWORLD

(Right) Rue Saint Dominique in the seventh arrondissement of Paris is the perfect place to catch a unique perspective of the City of Light's iconic Eiffel Tower. The street spans the whole width of the neighborhood, from the west end's Champ de Mars and Eiffel Tower (which you can see peeking above the rooftops as you walk) to the east end's Napoleon's Tomb and the Musée Rodin . . . but the perfect place to capture a moment like this is on the corner of Boulevard de la Tour-Maubourg and Rue Saint Dominique.

water

About 71 percent of the Earth's surface is covered in water, and it's incredible to witness just how many fascinating forms it comes in. From the deep sinkholes of Mexico to the pink-hued bodies of water in Indonesia, Australia, and Bolivia to the multicolored Grand Prismatic hot spring of Wyoming, the world is home to so many stunning bodies of water in almost every shade of the rainbow, not just blue!

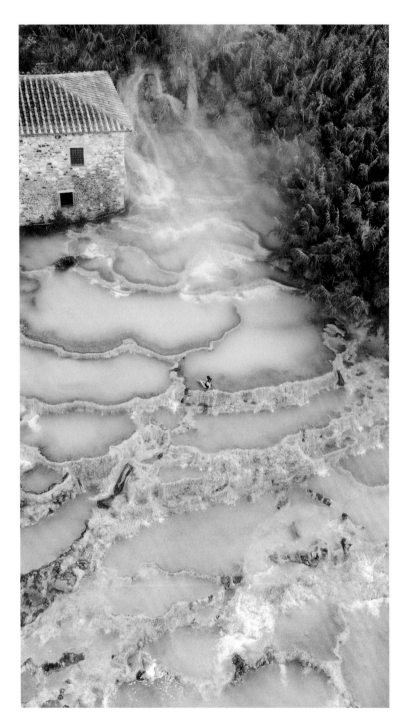

Saturnia, Tuscany, Italy

TAYLOR O'SULLIVAN | @TAYLOROSULLIVAN

(Left) "The Saturnia Thermal Baths have long been a hotspot for Italians. Some locals visit the springs on a daily basis, claiming that it's their key to health and longevity. The hot springs get crowded during the day, so my friends and I wanted to be there before sunrise. The night before our visit, we camped nearby (so close that we could smell the sulfur and hear the babbling of water on the rocks as we fell asleep). Then the next morning we woke up around 5:00 a.m. and hurried over to the hot springs to hop into its glorious warmth."

DAME TRAVELER PRO TIP

There are a ton of (almost microscopic) red worms in the water. They don't bite or bother you, but they will stick to your body as you float. They might freak you out at first, but just remember that the natural hot spring is their home, not ours!

La Digue Island, Seychelles

MICHELLE TEUSCHER | @LAMICHELLE__

(Opposite) Seychelles is not just your average beach destination. La Digue Island is situated in the Indian Ocean right off of East Africa and is known for its granite boulders that tumble into its clear blue waters and isolated, quiet beaches . . . some of them accessible only on foot! Head to Anse Source d'Argent Beach. It's a tranquil and shallow section of Seychelles' famous beaches as it is sheltered by a reef just beyond its granite boulders.

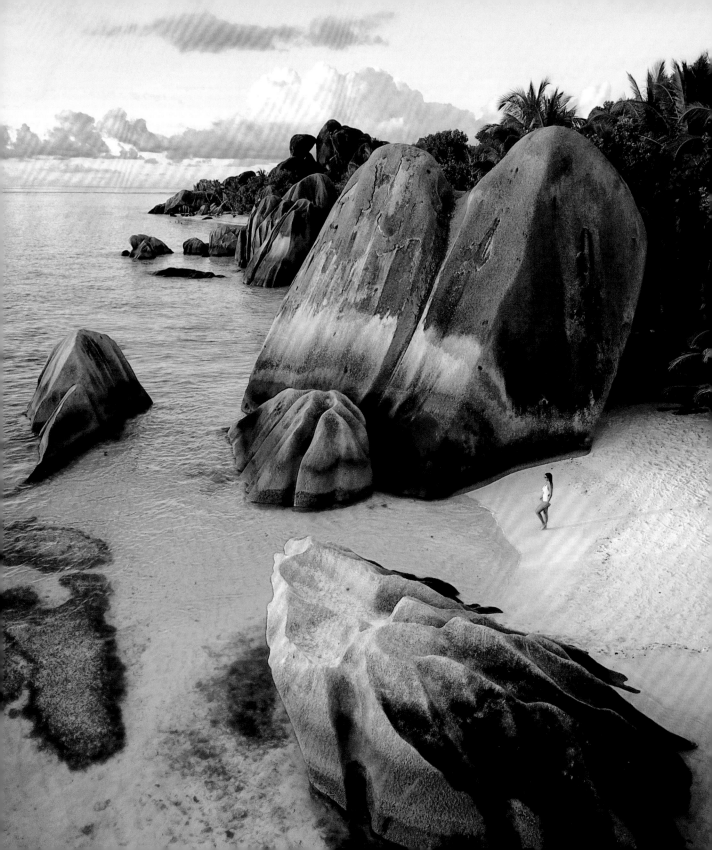

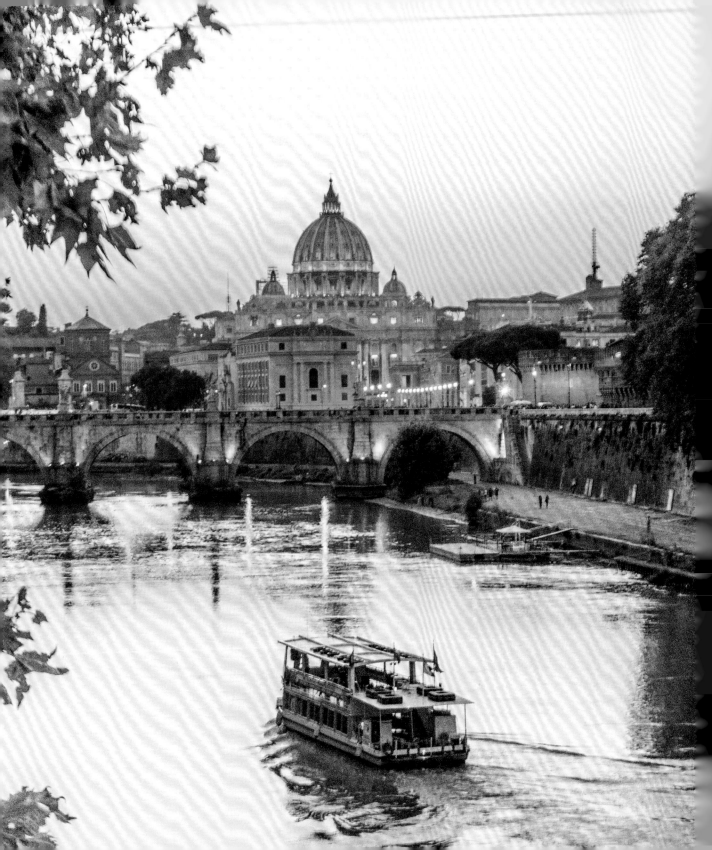

Vatican City, Rome, Italy

DIANA DE LORENZI | @DIANADELORENZI

(Opposite) "As the sun sets over the horizon with the San Pietro skyline, catch this view from the Ponte Umberto I Bridge and feel the warmth of Italy as you stroll along the Lungotevere. The Tiber River is truly the vein of the city that ties it all together."

DAME TRAVELER PRO TIP

Other sights to see from the Lungotevere (especially at sunset) are the Sant'Angelo Castle, the Church of the Sacred Heart of Suffrage, and the Palace of Justice. Be sure to take a detour to explore the charming creamsicle-hued Trastevere neighborhood as well!

Kuala Lumpur, Malaysia

ANGELA GIAKAS | @THESUNDAYCHAPTER

(Right) Kuala Lumpur is often a gateway city to other destinations in Southeast Asia, but the pool view from Face Suites is just one reason to extend your stay in the city a bit longer.

DAME TRAVELER PRO TIP

If you're hoping to sharpen your travel photography skills, start to pay attention to how you can manipulate and capture light. No matter if you're shooting on a fancy DSLR or your smartphone, take advantage of sunlight—not artificial light or flash. If you're indoors, try to shoot near the window. Sunrise and sunset are dreamy lighting conditions (called "the golden hour") and often result in less tourist-packed photographs.

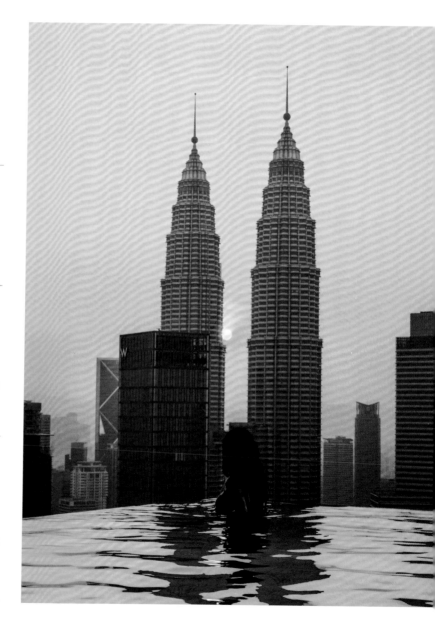

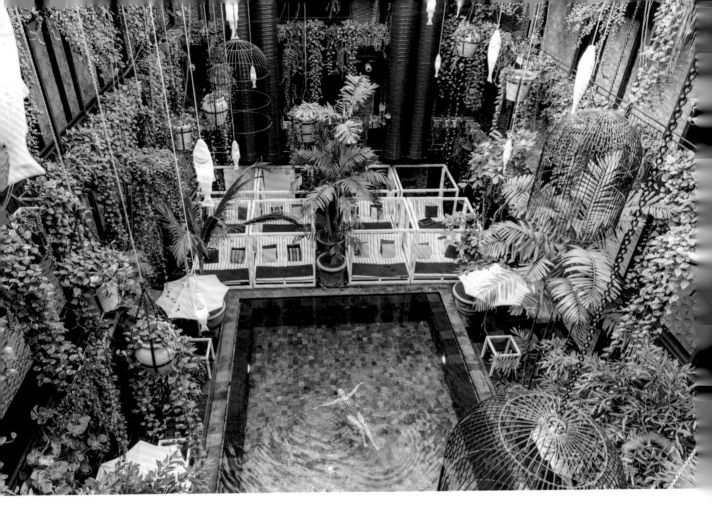

Copenhagen, Denmark

MARI BAREKSTEN | @MARIBAREKSTEN

(Above) "Manon les Suites' scent is like a botanical garden and is Copenhagen's greenest boutique hotel, with a lush swimming pool just outside your hotel room. The hotel's sustainable restaurant is 98.6 percent organic and has the motto 'love food, hate waste.' Plus, it has many green initiatives such as offering tap water only and using recycled paper. Manon les Suites is located in the hip district of Nørrebro, within walking distance to Torvehallerne food hall, Rødder og Vin natural wine shop, and the gourmet 'smørrebrød' restaurant, Aamanns 1921."

Singapore

CYNTHIA ANDREW | @SIMPLYCYN

(Opposite) The Cloud Forest is home to one of the world's largest indoor waterfalls, towering almost one hundred feet above the ground. It is just one of many beautiful features of the futuristic Gardens by the Bay.

"Why should women travel? Because you can't understand something you don't see. As a woman of color, a black woman and an African woman, I know it is important to show many that look like me what is possible, not just for others to do the same . . . but also for people in countries that I visit. It's just as important for them to get an opportunity to meet someone like me to change their perception and understanding of other women of color who so often go unseen."

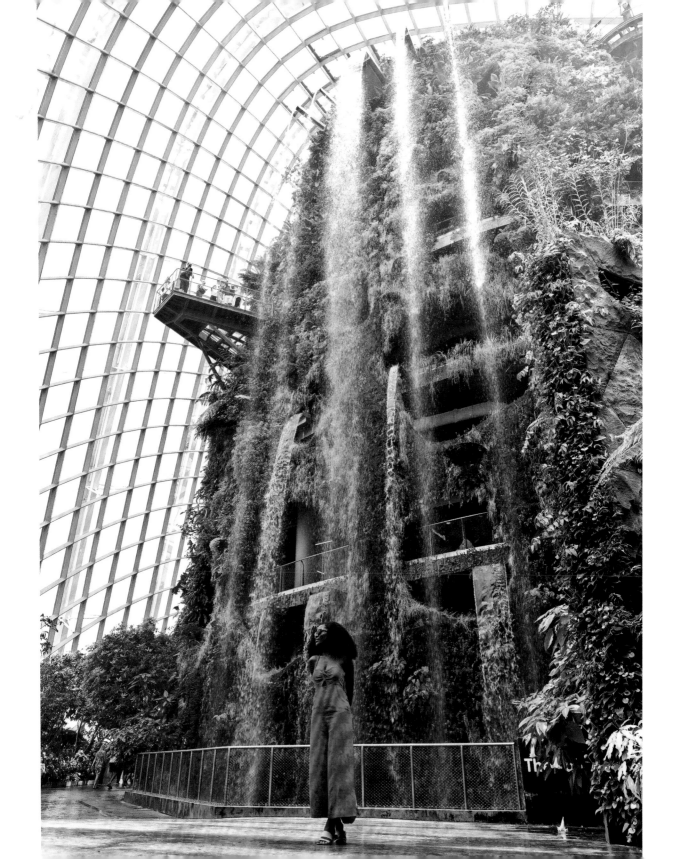

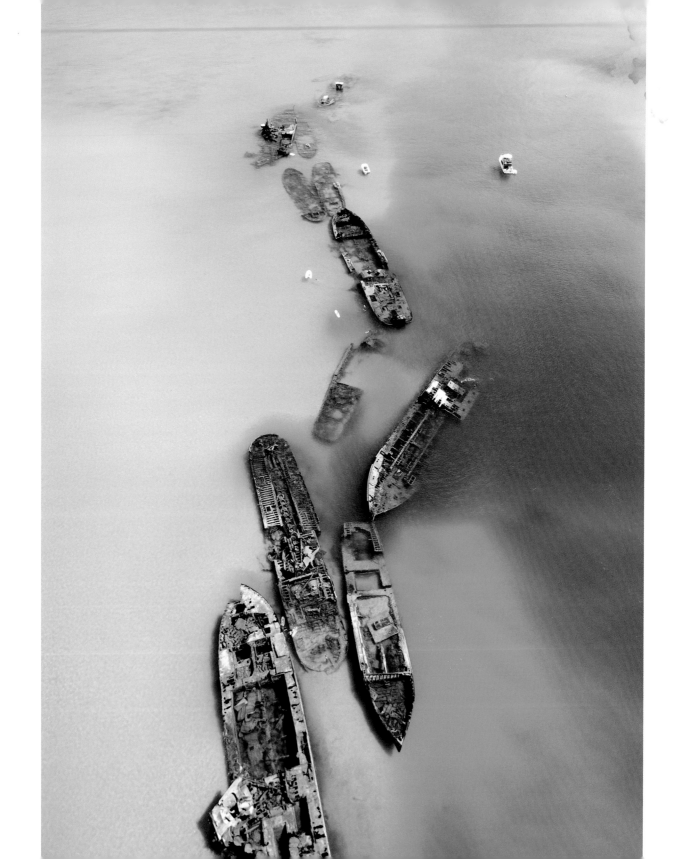

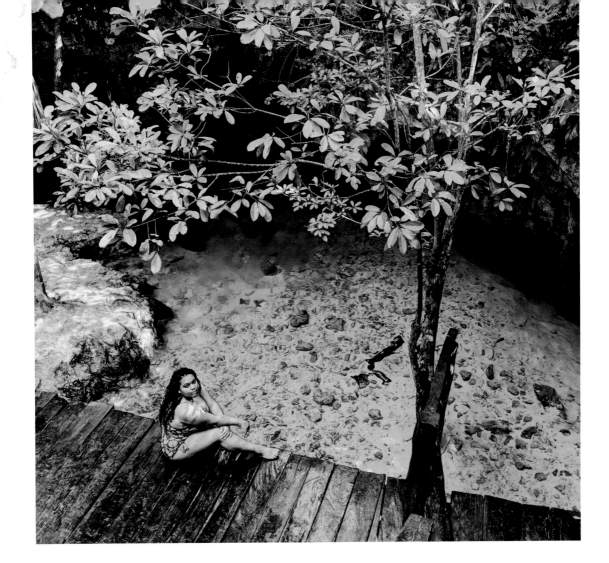

Moreton Island, Australia

JENNY FENG | @JENNYSWORLDTOUR

(Opposite) "Moreton Island is a small island with only one resort, making it a destination for travelers hoping to reconnect with nature. It can get a little busy during the day with tourists; however, it's a beautiful, pristine island with crystal clear blue water and plenty of tropical marine life including dolphins and humpback whales in winter (which is June to August in Australia). A day is enough to experience everything this island has to offer . . . however, it's a perfect escape for those that wish to stay longer and relax."

Tulum, Mexico

SAMANTHA O'BROCHTA | @CALLMEADVENTUROUS

(Above) The Yucatan Peninsula of Mexico is known for its over six thousand cenotes (sinkholes). The Gran Cenote, located in Tulum, is one of the most picturesque. Travelers can swim through its underwater cave system and water channels.

"It hasn't been long in the history of the world that women, specifically women of color, were able to travel without major fears or laws in their way to do so. I travel so I can do what my ancestors could not. Those women who were never given that chance motivate me to go out and see the world."

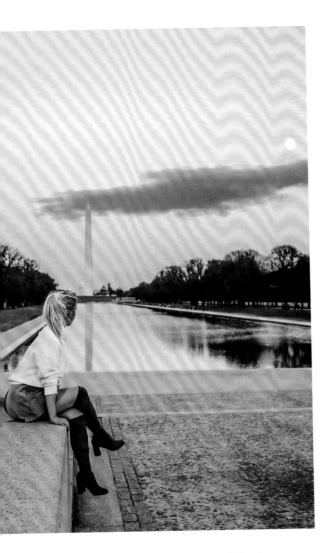

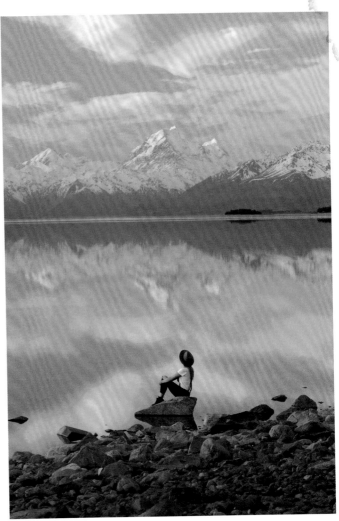

Washington, DC, United States

KELLY NEILL | @KELLYNEILL

The Lincoln Memorial Reflecting Pool in the heart of the United States capital, Washington, DC, is best viewed at sunrise. When visiting Washington, DC, try to book your accommodation in Georgetown so you can have easy access to all the city has to offer while nestled in a quaint and charming neighborhood.

South Canterbury, New Zealand

VIKTORIA STEINHAUS | @VIKTORIAWANDERS

"On a clear day, the views of Lake Pukaki are mesmerizing. The lake is quiet, serene, and an absolute dream to experience. This was actually my fourth time to this scenic spot, but it was the first time I had a clear view of Mount Cook, New Zealand's tallest mountain. I'd never seen a photo of the mountains reflected onto the lake, so when I turned the corner to this view, I ran down to the water's edge to watch the magic unfold."

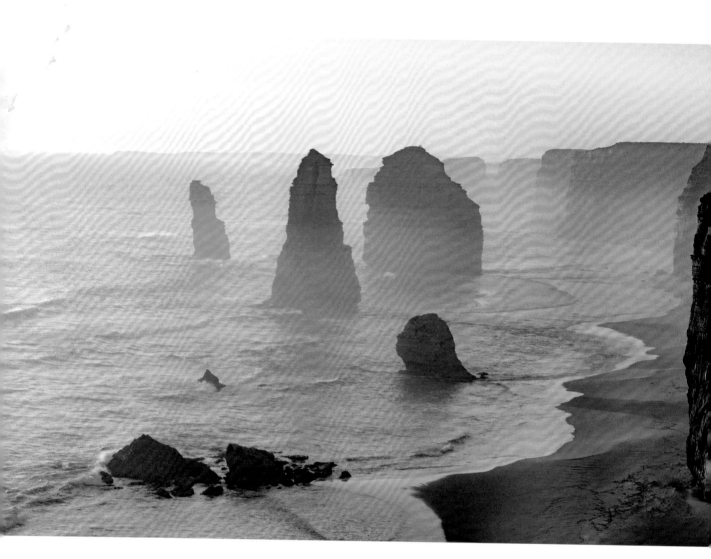

Victoria, Australia

CARLEY RUDD | @CARLEYSCAMERA

A road trip from Melbourne along the Great Ocean Road is an Australian classic. This 150-mile stretch is filled with stunning views that will make you want to stop every other minute! This viewing platform is a perfect photo stop that overlooks one of the most well-known and well-loved highlights of this road trip, the Twelve Apostles.

"My home has been on the road for the last two years now, so travel is an extension of my daily life. That said, I do still get the same jittery excitement in my stomach when visiting a new place. For me, new experiences, places, and people fuel my creativity."

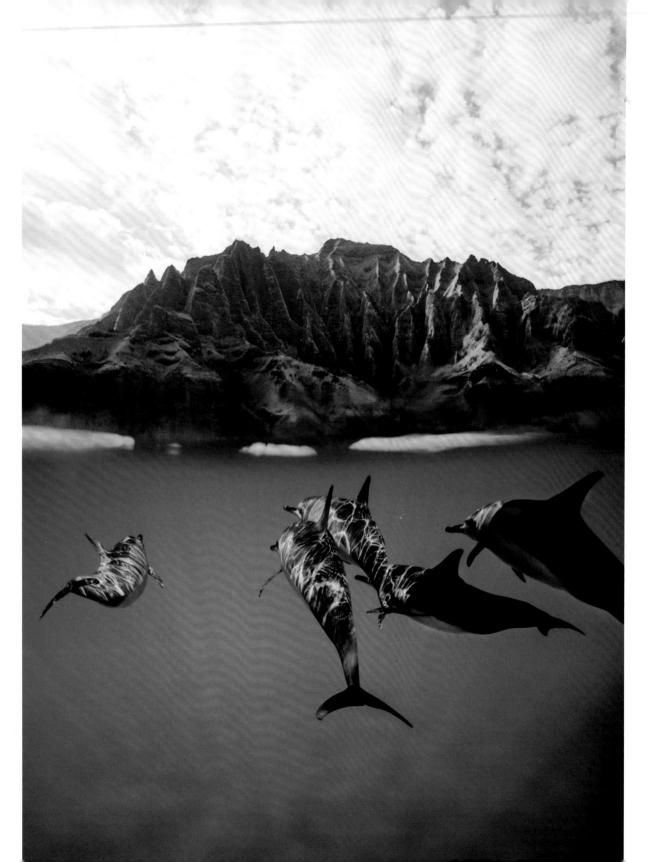

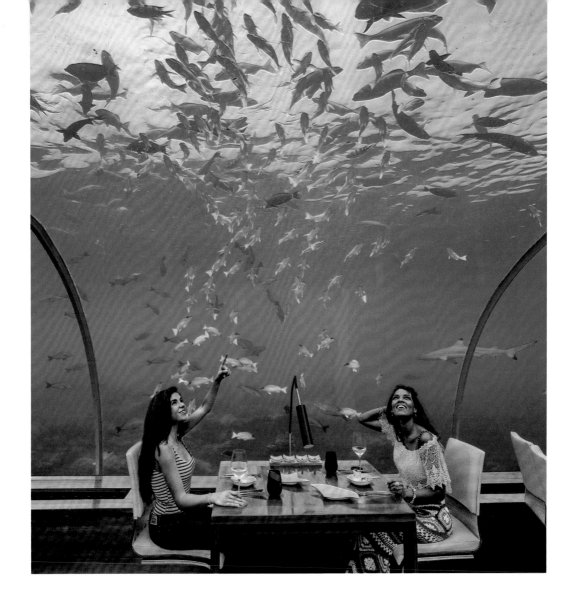

Kauai, Hawaii, United States

MEAGAN BOURNE | @MLBOURNE

(Opposite) The Pacific Ocean's unspoiled Nā Pali Coast State Wilderness Park is a great place to see dolphins, especially in the harbors and along the coastline from Port Allen onward up the shoreline.

"I know my favorite places in the world are living day to day without me there, and just knowing that makes me want to get back and be a part of it as soon as I can."

South Ari Atoll, Maldives

**NASTASIA YAKOUB AND
ROSANNA CORDOBA HUTCHINSON**

**@NASTASIASPASSPORT, @ROSANNA_CORDOBA
WITH @LAURAGRIERTRAVEL**

(Above) Made up of over a thousand coral islands, the Maldives is one of the most unique destinations in the world. It's also home to the world's first underwater restaurant, Ithaa, located sixteen feet below sea level at the Conrad Maldives Rangali Island resort.

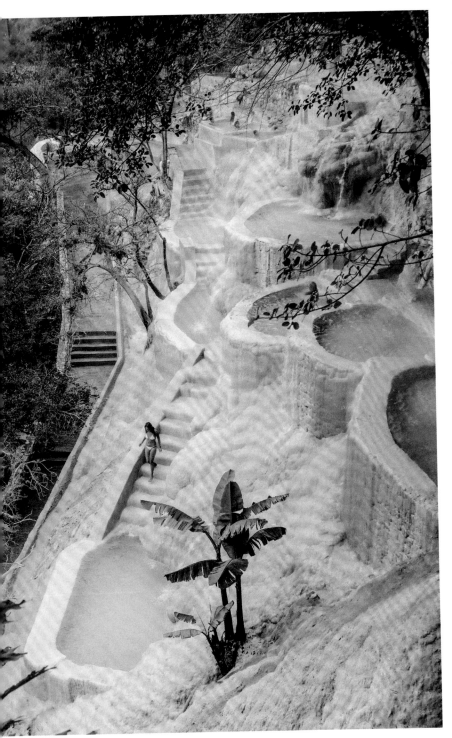

Hidalgo, Mexico

ANNA GALU | @ANNAGALU

(Left) The Grutas de Tolantongo is a national park and a rather hidden gem in Mexico. Located about four hours north of Mexico City, the area features a resort and tons of opportunities to connect with nature. But the highlight of the park is experiencing the Las Pozas thermal natural pools covered in limestone.

DAME TRAVELER PRO TIP

Try to get to Hidalgo early in the day, since there's virtually no internet access and hotels can't be booked online in advance. Look for the hidden tunnel, containing hot springs, at the end of the canyon and under a long suspension bridge.

Labadee, Haiti

JENNY CHECO | @JENNYCHECO

(Opposite) Ile des Amoureux, or "Lovers Little Isle," is a sandbar in north Haiti's Labadee Bay near the city of Cap-Haitien.

"As a Dominican woman, visiting Haiti is a difficult endeavor, as we have a tenuous history between our two countries that share the same island. Most of my friends and family were shocked and disturbed that I would even consider traveling there in the first place because all they had ever known were negative stories. My entire mind-set was transformed upon connecting with the great Haitian people I met along my journey. Since then, I have dedicated my efforts to improve relations between Dominicans and Haitians through sustainable tourism."

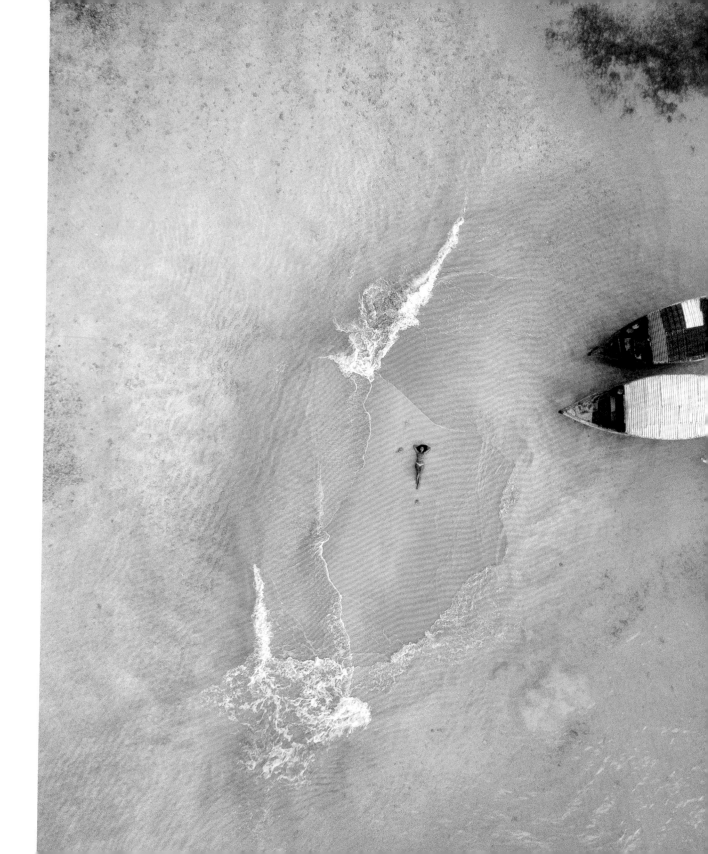

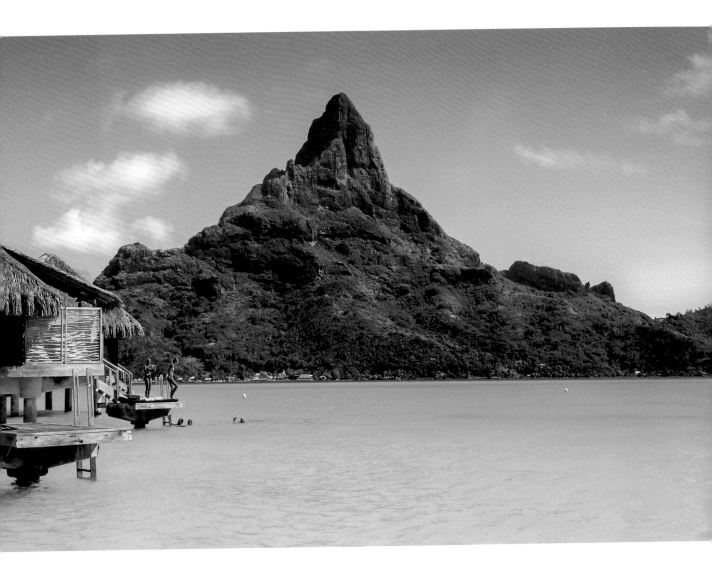

Bora Bora, French Polynesia

DANIELLE GREENTREE | @TRAVEL_A_LITTLE_LUXE

Bora Bora's turquoise waters have become quite notoriously sought after by luxury vacationers. After all, how often does one get a chance to stay in a water villa over some of the purest blue waters? Although this special experience costs a pretty penny, it is absolutely worth saving for.

"My passion for travel began the moment I jumped on a plane by myself for a four-month journey through Europe. Having no plans and no idea where or what I would be doing was the most liberating feeling in the world. My life hasn't always been luxury villas and turquoise waters though, and I do not take my traveling fortunes for granted. I want to always earn the right to accept the opportunities that come my way."

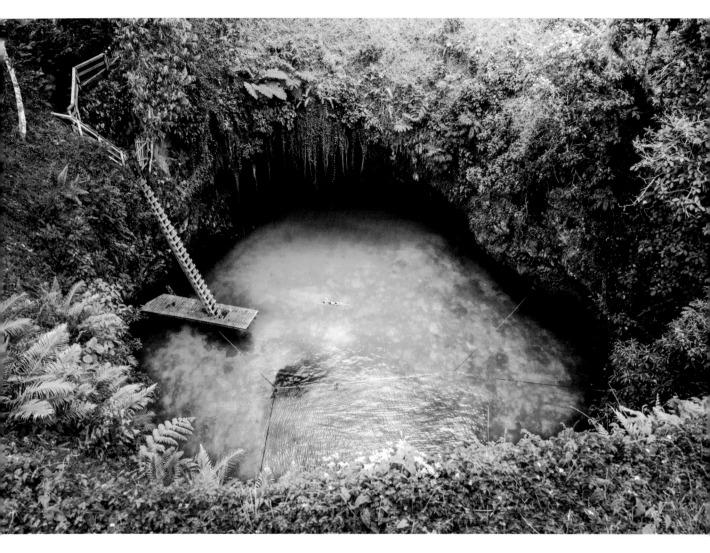

Upolu, Samoa

RADHA ENGLING | @GLOBALADMIRER

"The Sua Trench on Samoa's main island of Upolu is a natural treasure, two million years in the making. It is part of an ancient lava tube that collapsed to create a massive hole that connects to the ocean. Today, the trench is a perfectly formed circle, deep in the ground. To get down there is a nerve-wracking climb down a twenty-six-step ladder, but it's totally worth it. At the bottom is an emerald pool that looks like you've just stumbled onto the world's most beautiful volcano crater, lined with tropical vines and flowers."

Alajuela Province, Costa Rica

DULCE RUBY | @DULCERUBY

(Above) "The first solo trip is an important one. Remember your intentions with this trip. Whether you're looking for a fresh perspective on things, visiting your dream location, or even seeking to venture on a spiritual journey—we all give a purpose to our travels. Always remember that every interaction relies on intention and consent—whether it is someone intruding in your space, or another's opinion about your journey—it is all about your reaction toward one's actions. Hold space for those you wish to hold space for, and hold sacred that which you do not wish to share."

Udon Thani, Thailand

BETTINA HALAS | @BETTINA___H

(Opposite) Slow travel is centered around prolonged, in-depth travel experiences. The focus is on quality over quantity of "bucket list" items and prioritizing having extended time in one place. Take the time to enjoy the simple things along your journey. Should you book a longer stay in Udon Thani, Thailand, explore the Red Lotus Sea's layers of lily pads and pink lotus flowers. Just be sure to arrive at sunrise so that you can watch the flowers opening as the day begins.

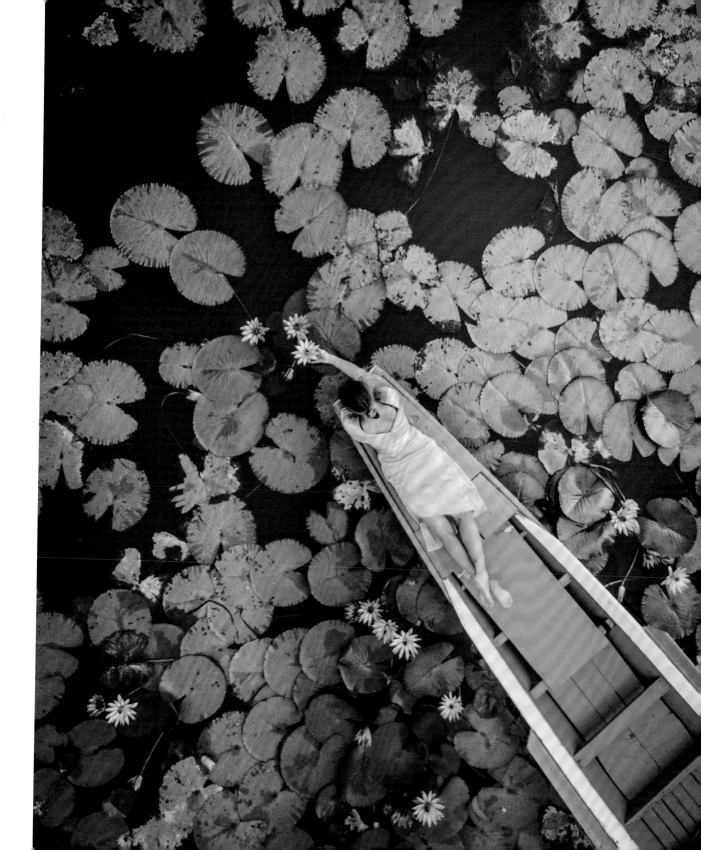

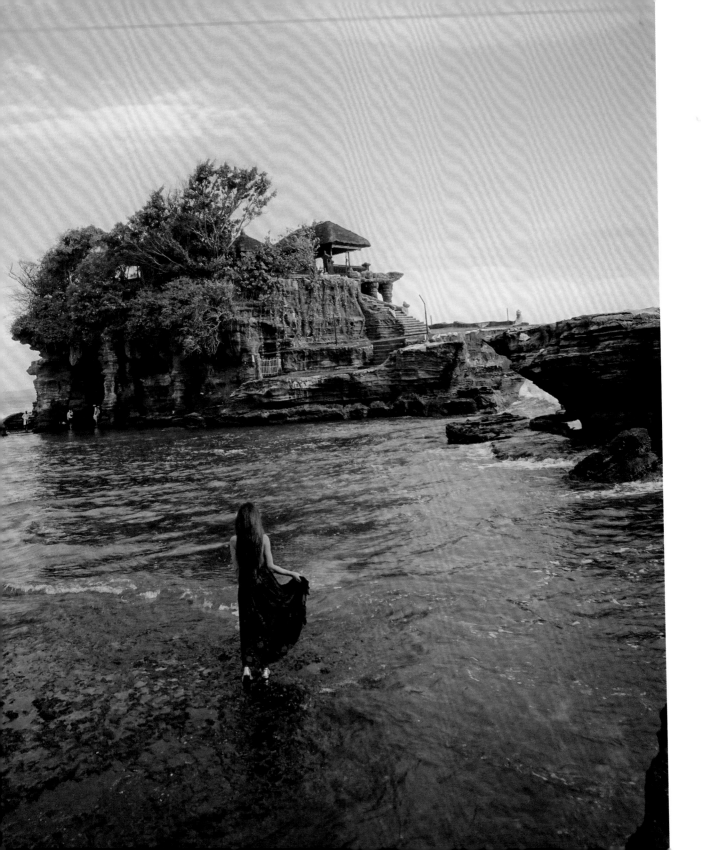

Bali, Indonesia

NASTASIA YAKOUB | **@NASTASIASPASSPORT**

(Opposite) Perched on the edge of the island on a rocky outcrop, Tanah Lot is one of Bali's most scenic sea temples. The beautiful rock-formation setting mixed with the mythological lore of the temple will leave you absolutely awestruck.

DAME TRAVELER PRO TIP

Non-Balinese people are not allowed to enter the temple proper, but it's possible to walk across to the temple grounds at low tide.

Bavaria, Germany

JANA BOGENA | **@ALOHAA_JANA**

(Right) If you're in Munich and need a respite from the hustle and bustle of the city, take a day trip to Lake Eibsee in Germany's Bavaria to experience the crystal turquoise waters at the base of the Zugspitze Mountain, the highest peak in Germany.

DAME TRAVELER PRO TIP

To catch the most picturesque, unshaded views of Zugspitze on the two-mile walking path around the lake, walk the path counterclockwise! You can also take the Eibsee Cable Car to the top of Zugspitze for a different perspective.

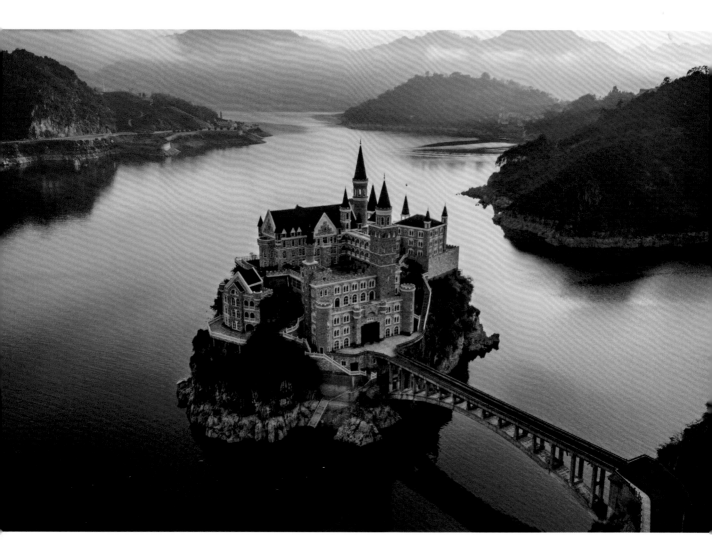

Guizhou, China

STELLA YAN | @ST_ELLA

(Above) Floating on a lake in China's Guizhou Province, the Jilong Castle Country Club looks like a slice of Europe in the center of the Middle Kingdom.

"The day I took this picture, I got up early and saw this incredible beauty in the light of the dawn. Guizhou's castle was floating in the sky. At that moment, I was completely shocked by the unexpected peace I felt. With the sunrise, the veil of fog lifted. I clicked the shutter."

Vágar, Faroe Islands

SELENA TAYLOR | @FINDUSLOST

(Right) The Faroe Islands are a set of eighteen scattered islands in the Atlantic Ocean. Although tourism hasn't started to influence the country like Iceland quite yet, it's only a matter of time. The natural wonders the islands possess include otherworldly landscapes and a chance to escape into an unknown territory. Pictured here is Sørvágsvatn (also known as Leitisvatn), the largest lake in the Faroe Islands.

"Seek out somewhere that you feel inspired by. Push your boundaries, but also take pleasure in the comfort of knowing many have done this before you."

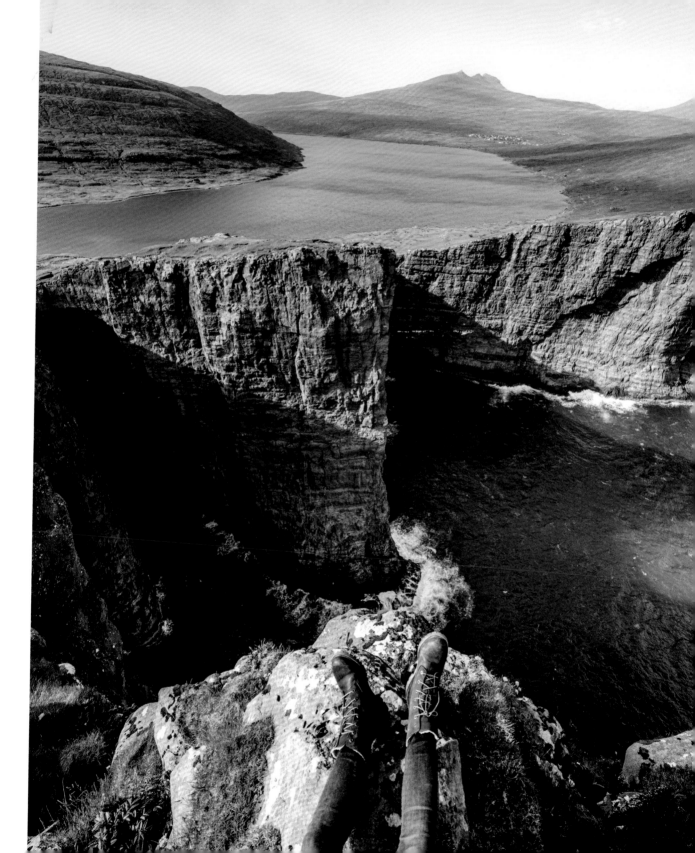

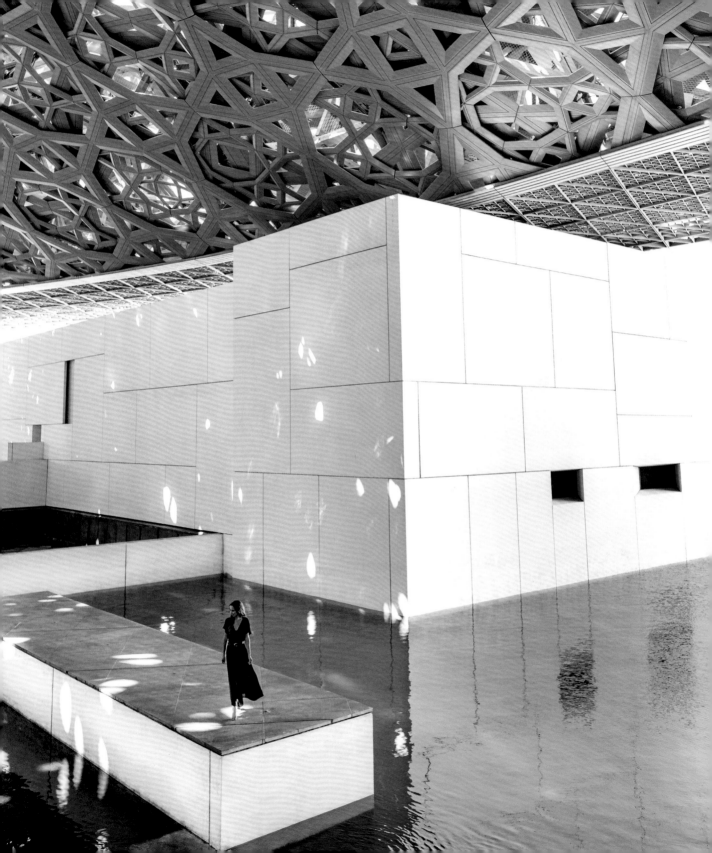

Abu Dhabi, United Arab Emirates

JESSICA SIMONSEN
@JESSICA_SIMONSEN

(Opposite) "The way the sun casts its beautiful shadows onto the floor through the ceiling of the Louvre in Abu Dhabi is simply captivating. The shadow play is inspired by the way the palm trees cast shadows in an Arabian oasis."

DAME TRAVELER PRO TIP

If you're staying in Dubai, Abu Dhabi makes for a super easy day trip, just a one-hour drive away. Be sure to reserve a whole day to explore both the interior and exterior of the Louvre's building. The inside houses art pieces from all over the world, and the outside of the building is as impressive as the many pieces of art.

Zakynthos, Greece

KATIE RITZI | @XKFLYAWAY

(Right) The view of Shipwreck Beach, also known as Navagio Beach, on Greece's island of Zakynthos can be accessed by boat including a stop at the marvelous Blue Caves.

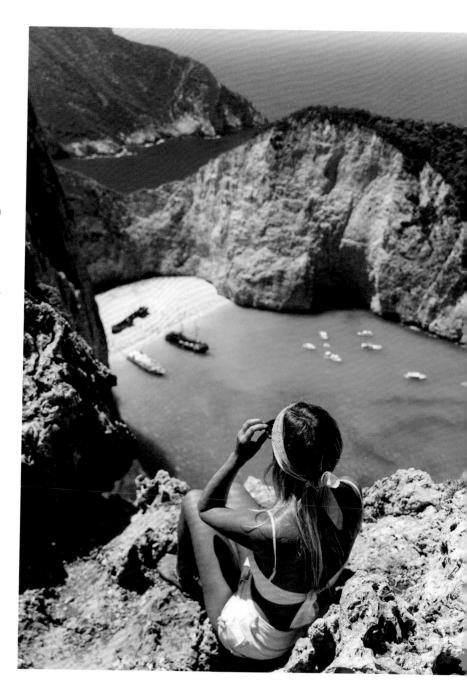

Cebu, Philippines

LOLA HUBNER | @LOLAHUBNER

(Left) Cebu, the second largest city in the Philippines, is stocked with must-do activities for travelers. However, an excellent day trip for those wishing to escape the city hustle is a two-hour drive to the Kawasan Falls. Canyoneering, swimming, and other watersports are available, including this three-stage cascading turquoise-colored waterfall at the base of the Mantalongon Mountain Range.

South Tyrol, Italy

JESSICA MEYRICK
@THEWONDERINGDREAMER

(Opposite) South Tyrol may not look like Italy at first glance. As a former Austrian territory, the Austrian influence still exists, making this breathtaking part of Italy all the more interesting since Italy's culture is so ingrained in their existence. Pragser Wildsee (or "Lago di Braies" in Italian), famous for its crystal blue waters and pristine reflections of the surrounding mountains, is best experienced at sunrise. As the morning light warms the ground, the waters gleam and you'll be able to avoid lines of other tourists.

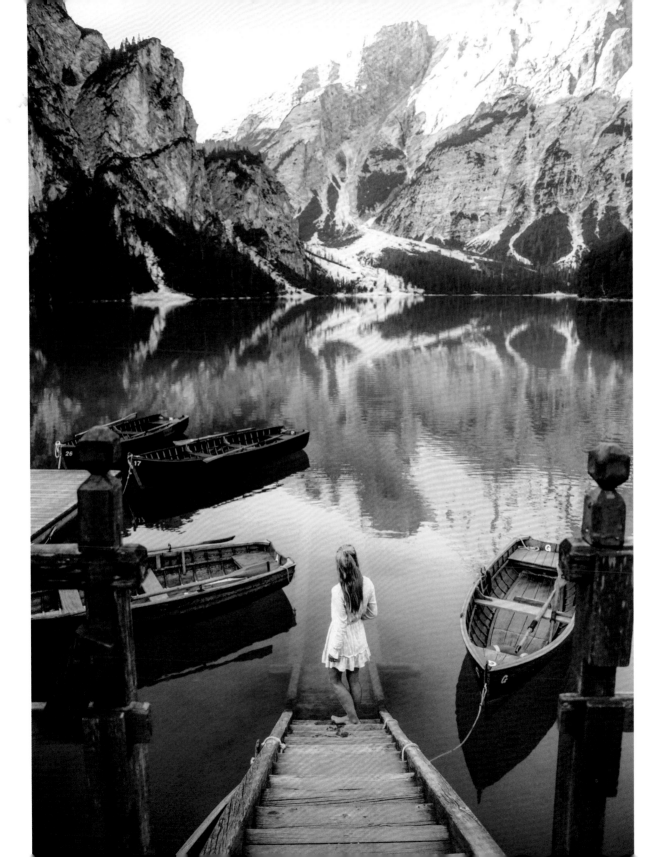

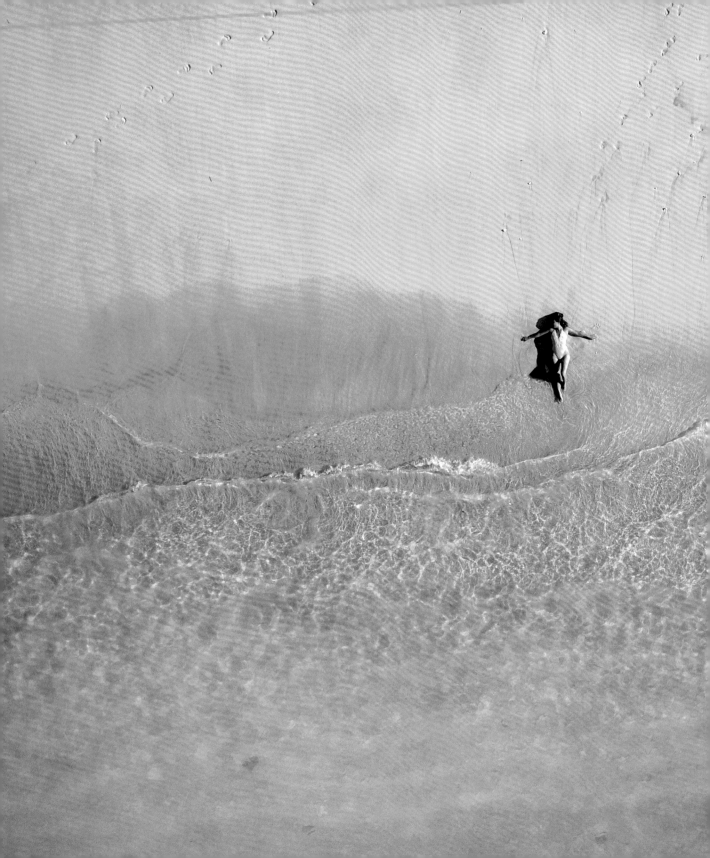

Flores, Indonesia

QUINN LUU | @QUINN.LUU

"I think oftentimes beautiful places can become overcrowded, losing a bit of their spark. When we stepped foot on Flores Island, it was not only breathtaking but perfectly untouched. Not a soul in sight. The beach is located in the Komodo National Park. To get here, fly into Labuan Bajo from Bali or by boat from Lombok. Spend the day snorkeling, stargazing, and being in awe of the red coral–tinted sand produced by microscopic *Foraminifera*."

Positano, Italy

ANA LINARES | @ANANEWYORK

Although you may think the best time to be on the Amalfi Coast is summer, with higher prices for accommodations, overly crowded beaches, and extreme heat, you'll have a much more pleasant experience during low season at the end of September or the beginning of October. The weather feels like an extension of summer, plus, harvest season begins during this time and the local wine is extra delicious!

Mallorca, Spain

JESSICA WRIGHT | @BONTRAVELER

In the south of the island of Mallorca lies the Torrente de la Cala Pi beach. Its name was inspired by the many pine trees surrounding the area. For a real adventure, you can hike from Cala Pi to the Cap Blanc.

"Embrace your time alone. Go sit at a restaurant, order a meal, and soak in the moment. It is so rewarding to see and feel a place through your own eyes and heart without any other distractions."

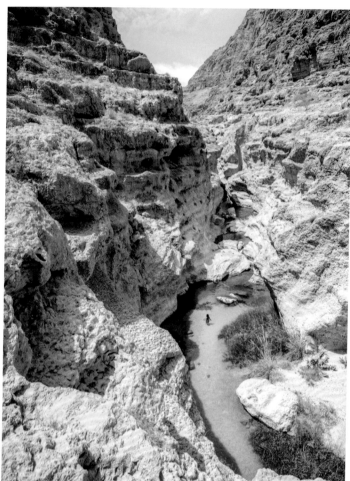

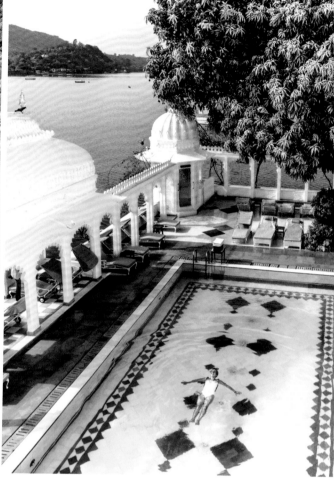

Wadi Shab, Oman

FATEN HAMOUDA | @FATEN09

Located an hour-and-a-half drive outside of Muscat in the Al Sharqiya region of eastern Oman, Wadi Shab is the perfect respite from the heat . . . but it doesn't come easy! After a strenuous forty-five-minute hike through the cascading canyons, you can finally plunge into its clear waters. Bring sunscreen, water, and a healthy dose of can-do attitude.

Udaipur, Rajasthan, India

MARIJKE JURRIAANS | @MJ.AWAY

Feel like royalty floating in the majestic pool at the Taj Lake Palace Hotel. This property is located in Udaipur, best known for its gorgeous (but artificially made) lakes. Don't miss its City Palace, Bagore Ki Haveli Mansion, and the Jag Mandir (also known as Lake Garden Palace), and schedule an early morning walk to see the waking city covered in dreamy, pastel hues.

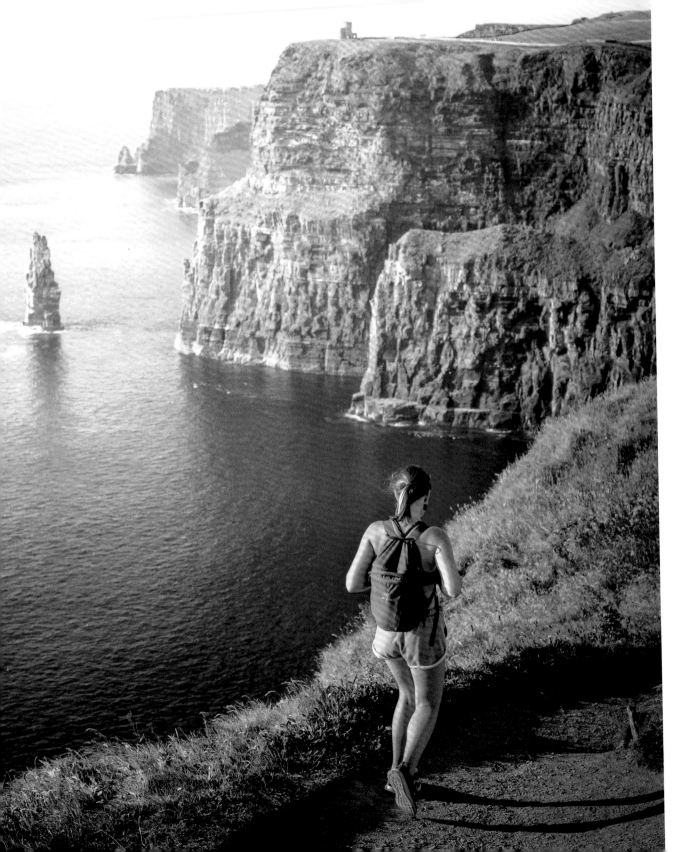

Cliffs of Moher, Ireland

MOLLY MALOTT | @GOODGOLLYMISSMOLLY16

(Opposite) "The plan was to leave our car in Doolin and hitchhike to the Cliffs of Moher trailhead at Hags Head. We accepted rides from an Alaskan family, a local Irish farmer, and an Australian tourist and finally made it. From there, we spent the day exploring the cliffs and making the eight-mile trek back to our hostel in Doolin. If you're traveling solo and don't feel like hitchhiking, there is a shuttle that goes from Hags Head to the Cliffs of Moher visitor's center, which makes it easy to drop a car at the trailhead and shuttle back when you're done with the hike."

DAME TRAVELER PRO TIP

If you're traveling with people, use the European app BlaBlaCar that matches up passengers who need long-distance rides with drivers who are already headed in that direction. It's a great way to meet people and get some local recommendations.

Budapest, Hungary

MARTYNA DAMSKA-GRZYBOWSKA
@MARTIDAMSKA

(Right) Budapest is commonly known as "the City of Spas." The warm spring waters underneath its surface make it a fantastic spot for thermal baths, and the bathing culture of Hungary is alive and well. One of the most picturesque ones is Széchenyi Thermal Bath with eighteen pools and ten saunas that are open all year round.

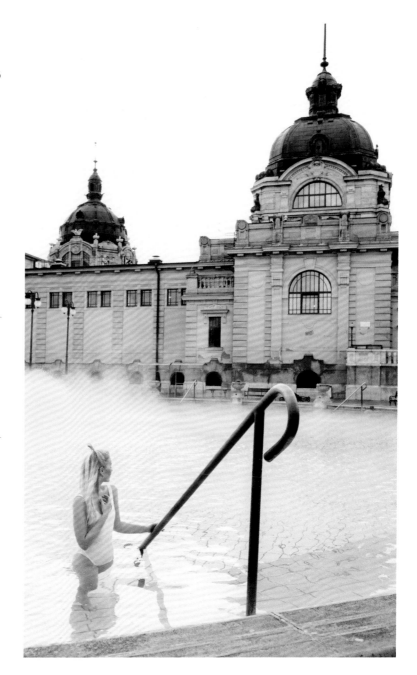

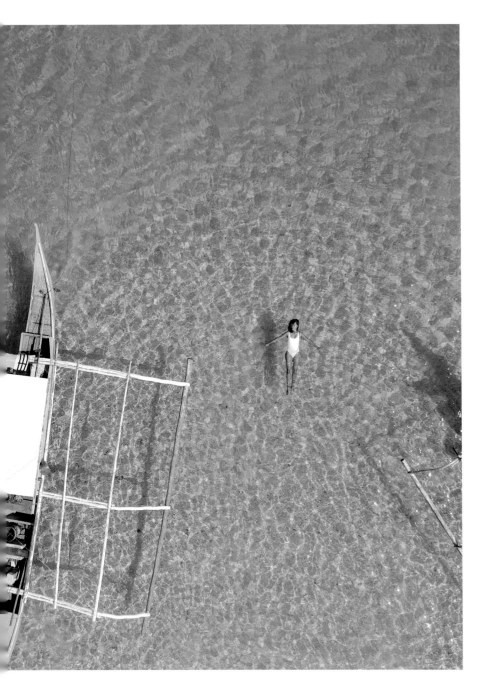

El Nido, Philippines

MAY LEONG | @HELLOMISSMAY

(Left) Even the most seasoned travelers find themselves on red-eye flights. No one really looks forward to them, but there are some tried-and-true tricks to getting through with ease. One, book the last flight out! Depart as late as possible, when you're extra tired; this way you're more likely to pass out as soon as you get to your seat. Second, know how you prefer to sleep. If you're a side sleeper, book a window seat so you'll be able to rest your head. If you're a light sleeper, avoid the back galley at all costs! However, if you know that you're a frequent bedtime bathroom visitor, save yourself the headache of climbing over strangers and book an aisle seat. Hopefully, you'll find some peace and quiet until you find yourself someplace truly tranquil, like floating in the waters of El Nido.

Gili Meno, Indonesia

TARA MICHELLE BROSE
@TARAMICHELLEBROSE

(Opposite) "The Gilis are basically the Maldives of Lombok; each of the three small islands feels like a tropical oasis with white sandy beaches and crystal clear waters. I thought the sculptures would be harder to get to and that I'd have to swim deeper in the ocean to find them, but you won't even need to dive to see it. This place is also fairly easy to get to by fast boat from Bali to Gili Air, and then a local snorkeling boat to Gili Meno."

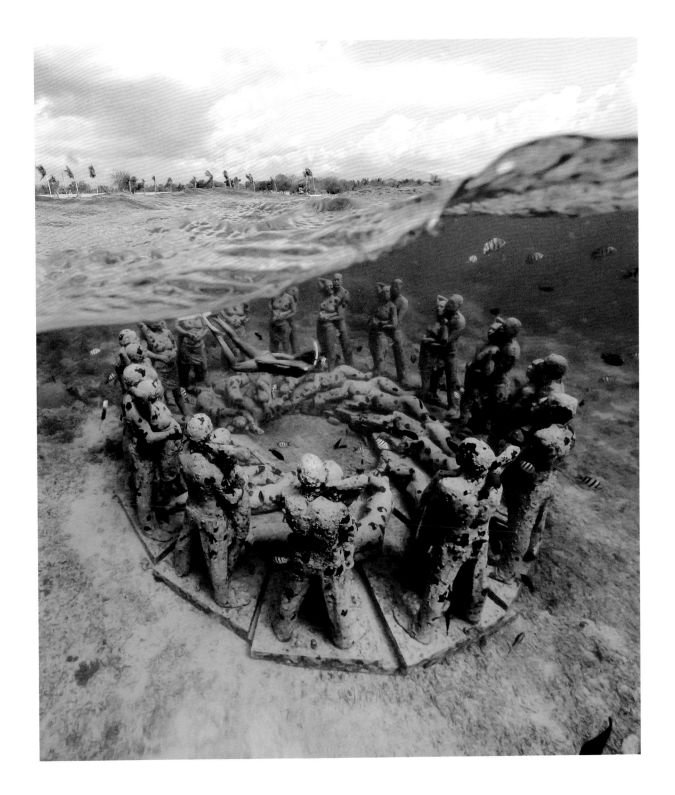

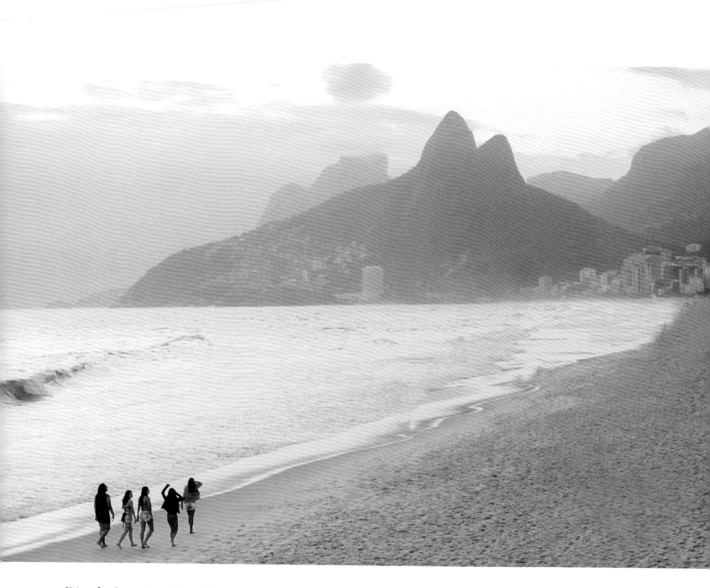

Rio de Janeiro, Brazil

SIOBHAN REID | @SIOBHANMREID
BY @NASTASIASPASSPORT

When most people think of Rio de Janeiro, they think of Copacabana Beach. But surprisingly, it's not the most polished of beach fronts. That's where Ipanema Beach comes in! Copacabana's chic neighboring beach is really the place to be, with locals dancing on the shore and many chic bars nearby.

"Philosophically, I can get behind the notion of change, as it carries with it the possibility of positive things like rebirth, progress, and evolution. But when it comes to my own life, I'm generally terrified of the prospect of change and associate it with feelings of loss, loneliness, and even regression. But when you travel, you can't help but be swept up in the inexorable rhythm of the universe. Sunrises and sunsets, the rising and falling of the tides, the brief, locking of eyes with a stranger on a train–yes, these moments are fleeting and remind you that nothing lasts forever. But they're also intoxicating and wondrous and allow you to experience change in a natural and even welcome way."

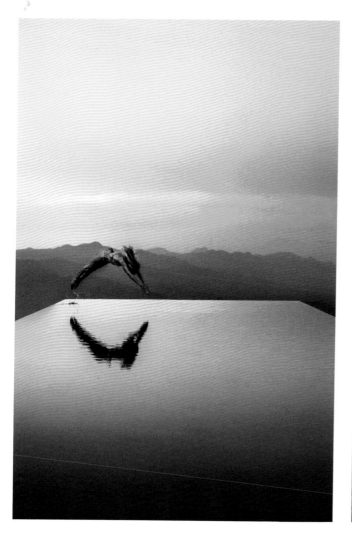

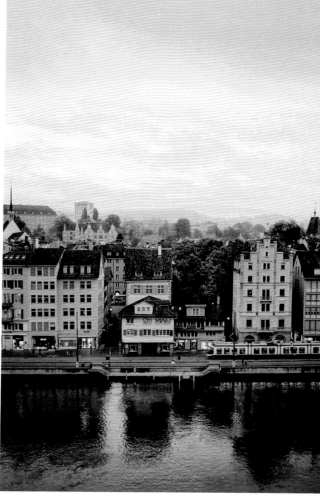

Bali, Indonesia

ANASTASIA PITTINI | @TRAVEL_LEAP

The Munduk Moding Plantation Nature Resort & Spa is set in a working coffee plantation surrounded by a jungle with several incredible natural wonders to explore, including the Munduk and Melanting waterfalls in the nearby area. With a total of nine villas, it's a relatively affordable option in Bali for those looking for luxury without breaking the bank.

Zurich, Switzerland

KAEL REBICK | @PUNKODELISH

With Zurich being surrounded by the Alps, there's really no bad angle to admire the beauty of this city. To catch this panoramic view of the city's Old Town, head up to the Lindenhof Square.

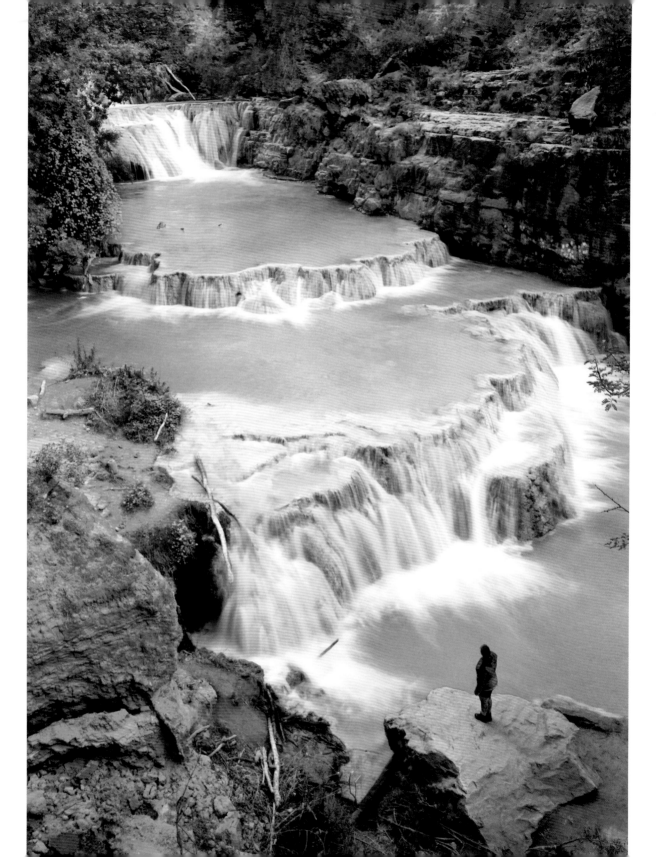

Beaver Falls, Arizona, United States

EMMA KULKARNI | @EMMAEXPEDITION

(Opposite) "The hike to breathtaking Beaver Falls is about twelve miles from the Hualapai Hilltop or eight miles from the Supai Village center. With three sets of ladders and numerous water crossings to navigate, it's definitely an adventurous hike. Nevertheless, the contrast of the vibrant turquoise waters, warm red canyon wall, and lush green foliage makes it undeniably a place that needs to be experienced in person."

Cape Town, South Africa

MARGARITA SAMSONOVA | @S_MARGA

(Right) "For the last six years, I have been volunteering in animal rescues around the world, and I lived in Cape Town briefly to work with SANCCOB to help rescue, rehabilitate, and release penguins. One of the most important rules I learned is to have as little personal contact with penguins as possible so they don't get the feeling that humans are nice creatures who bring them food. Otherwise, they won't have a chance to survive in the wild. We released eighteen of our penguins back into the wild, and it was an incredible feeling being a part of the bigger cause. As a traveler passionate about the environment, I often get to see firsthand what actually happens to our planet and how plastic and food waste affects the environment . . . so I've set out to make it my mission to become an advocate and to encourage people to care about our planet. Sustainability has given my travels purpose."

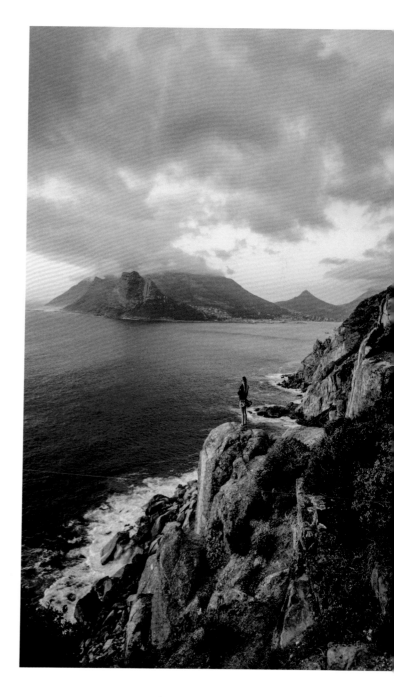

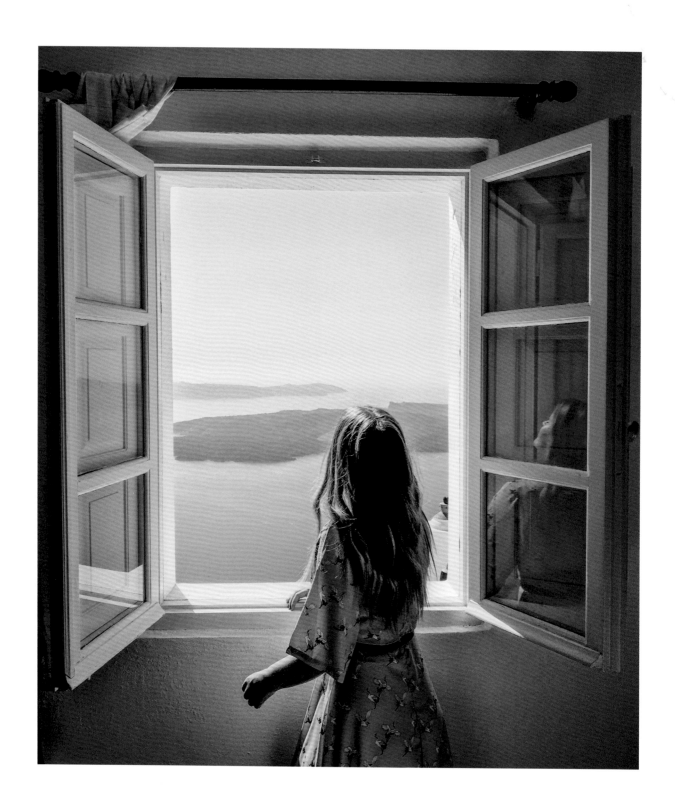

Santorini, Greece

ALISA ANTON | @ALISAANTON

(Opposite) The Altana Traditional Houses & Suites is located in Imerovigli, one of three towns in Santorini. The hotel boasts some of the best views of Greece's iconic blue waters through their rooms' wide windows. Imagine starting a few mornings of your life here! It's also on the more affordable side, relative to the many pricey resorts that exist on the island.

Perast, Montenegro

CHANEL CARTELL | @HOWFARFROMHOME

(Right) "The country of Montenegro is tiny! You could drive along the entire coastline and stop at a couple of the villages in just one day. Rent a car and explore at your own pace. The little village of Perast was such a gorgeous spot, and it seemed almost empty on the day we explored it . . . probably because everyone was admiring the views from atop the Kotor Hill nearby (a UNESCO World Heritage Site). Just proof that exploring smaller towns is sometimes the way to go."

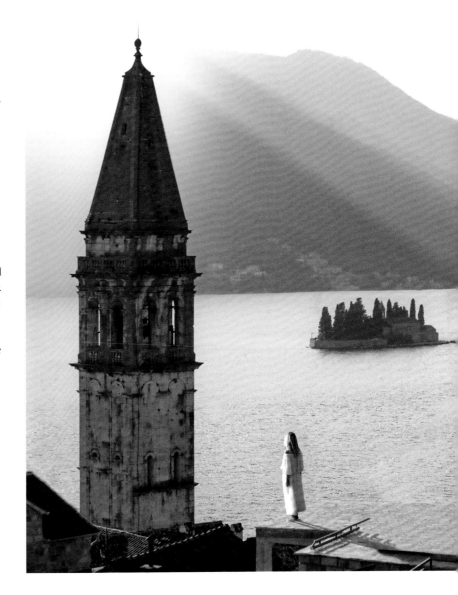

Da Nang, Vietnam

MELISSA TENG | @WITANDFOLLY

(Left) Da Nang, Vietnam, has a coastline longer than the whole of Thailand! To explore its blue, unspoiled waters, book a diving excursion to see the oceanic wildlife in its finest form.

"My life of travel has been one long, fluid, and constant moment of change. It keeps me on my toes and forces me to observe . . . even if I don't feel ready for what I see. It's made me realize how privileged I really am, and how wasteful I can be. I think, above all else, a life of travel has made me more aware; aware of others, aware of myself, and aware of my choices, choices that leave an imprint on this planet, and the power we all have to choose the type of impact we want to make on this world."

Almaty, Kazakhstan

SISSI JOHNSON | @ASKSISSI
BY DIANA KHUSSAINOVA

(Opposite) About ten miles outside of the largest city in Kazakhstan, the Big Almaty Lake is a ski resort area with snowfall from December to April. The biggest perk of this hidden gem? You can enjoy the ski area without the massive crowds of more popular resort towns, since the country is yet to be spoiled by too much tourism.

"I was amazed to find out Kazakhstan is the Brazil of the East. Indeed, it is an eclectic melting pot of cultures because of the borders it shares with Turkmenistan, Uzbekistan, Kyrgyzstan, Russia, and China. A must-do is a road trip across the Tian Shan Mountains. They are also known as 'the mountains of Heaven,' and I can personally attest to that."

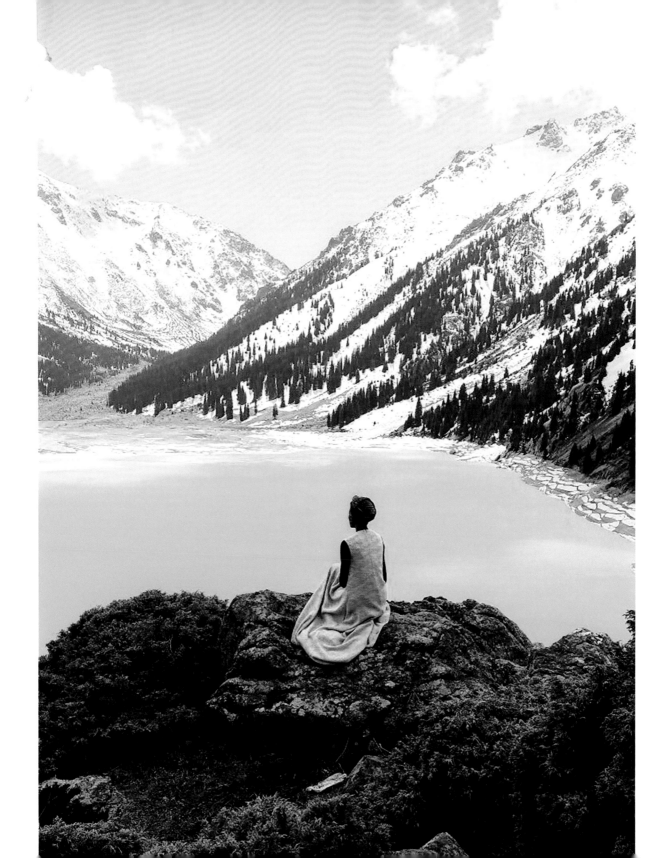

Krabi, Thailand

TANYA SHAMI | @ONEWORLDJUSTGO

(Opposite) Timing is everything when it comes to planning your trip to the Land of Smiles. Thailand has touchy weather conditions throughout the year, so it's important to research when monsoon season occurs. The country has two major rainy seasons, and depending on which coast your destination lies, it can really affect your weather! The best time to visit is during Thailand's cool and dry season between November and April. However, the western side of the country is best during the winter months and the east coast is favorable for most of the year. Lading Island is located in the southwestern portion of Thailand, where you can arrive by long-tail boat from the main island of Krabi.

Tulum, Mexico

KELSEY DENNISON | @KVDENN

(Right) Tulum once served as an ancient Mayan port city . . . but it's now become a boho-chic destination for free-spirited travelers. The town itself has a laid-back vibe that's sure to put you in a chilled-out mood, and, in between hunting for tacos and biking to its famous beaches and resorts like the Coco Tulum Hotel, you can also explore beachfront, ancient Mayan ruins.

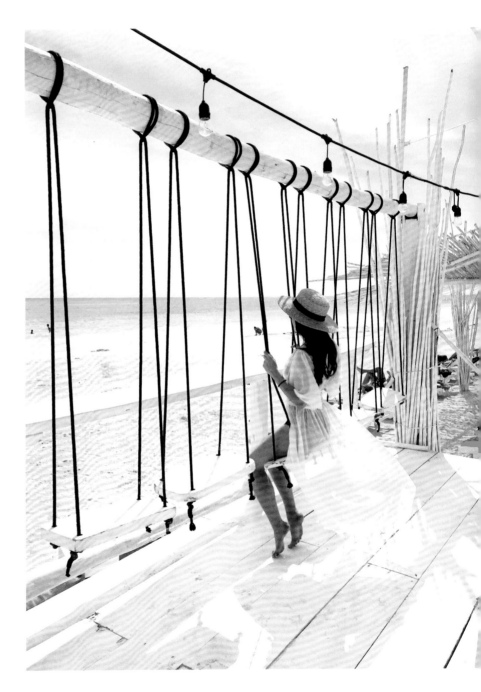

Illulisat, Greenland

SOHA ZIA | **@FAMEISFICKLEFOOD**

"I come from a very sheltered, conservative, and patriarchal culture that condemns female solo travel. The limitations of my culture, coupled with my own sense of codependency, prohibited me from traveling for a long time. I'll never forget being in my early twenties and rebelling against my family to take my first solo trip to Japan. I was absolutely terrified of being on my own, but the anticipation of a great adventure eventually dissolved the fears. I would later go on to explore five continents on my own. Traveling helped me break out of my timid, introverted nature to become a confident, self-sufficient, and adventurous woman. I've attempted some of the most dangerous hikes in the world on my own, driven through waist-deep rivers, explored the Arctic Circle, and spent nights camping on some of the highest mountain peaks in the world. I now try to encourage other females from my culture to break the mold and explore the world."

culture

Ask almost any traveler who explores with an effort to make the world a more connected, undivided place, and they'll say that one of the reasons they hop on a plane is to connect with and learn from a country's culture. Genuine and sincere interest in another country's culture and its people contributes something to the world that cannot be compared to anything else. Slow down a bit, smile, acknowledge shopkeepers and passersby, or do a homestay and have a homecooked meal with a family. Each of these small cultural travel moments goes a long way to giving purpose and perspective to your travels.

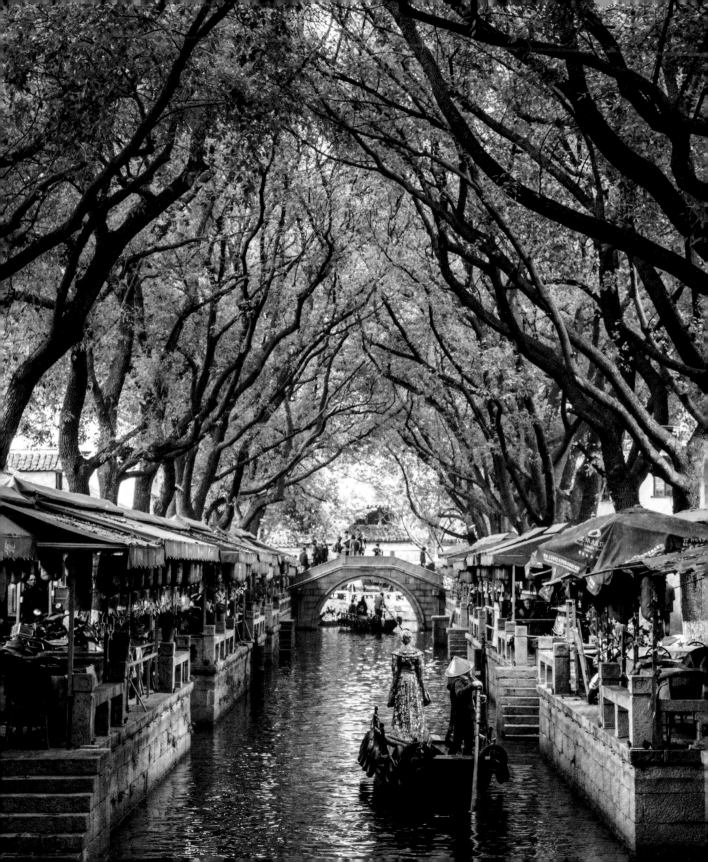

Suzhou, China

LAURA GINGERICH | @ROAMANDGOLIGHTLY
BY @NASTASIASPASSPORT

(Opposite) Tongli, just outside of Suzhou, is often called the "Venice of the East" and is lined with beautiful canals.

"I grew up hearing stories of far-off places and ancient histories from my grandmother's library. She'd tell me of dynasties and ages long gone, the art of yore, the philosophers of days gone by, and the lessons we should learn from them. I call my grandmother 'my armchair explorer' because she was a true seeker of knowledge and culture through the pages of her many, many books. She chose to learn about our planet through the words of books, and I chose to see and experience it. Every time I hop on a plane, I hope to honor her—ready to capture a story she'd be happy to read."

Meteora, Greece

MARIE STOKKA | @MARIESTOKKA

(Right) In the fourteenth century, monks established an elaborate monastic community on the giant cliffs of Meteora. As the monks settled the area, their impressive setting elevated their existence (literally and figuratively) and provided them with the isolation and peace they required. The rock formation in central Greece is home to six monasteries on top of the enormous, breathtaking pillars—isolated, mystic, and truly an inspiring pilgrimage fit for a solo trip.

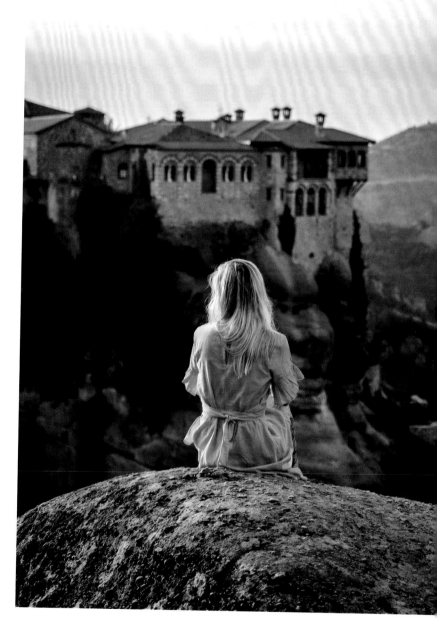

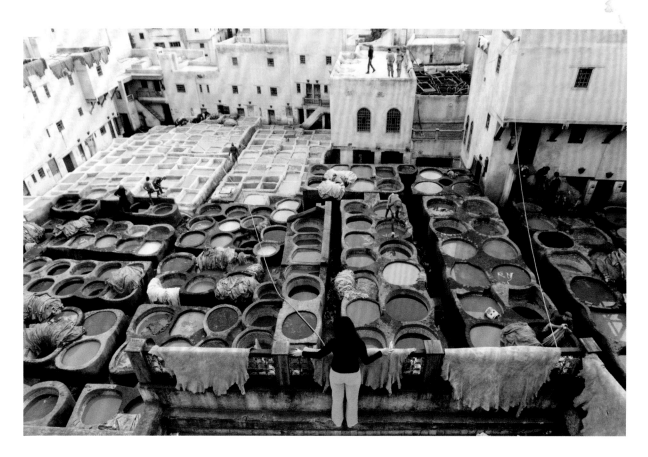

Fès, Morocco

IVETTE LEON | @ETTEVI_WANDERLUST

(Above) "The Chaouwara tanneries are one of the city's most iconic sights (and smells), offering a unique window into the pungent, natural process of producing world-class leather using methods that have changed little since medieval times. In 2015, they underwent a year-long restoration to spruce up the crumbling environs surrounding the pits, including the viewing terraces, but fear not–the tanneries' atmosphere remains intact. Try to get here in the morning when the pits are awash with colored dye."

London, England

ALEKSANDRA PANKRATOVA
@PANKRATOVA916

(Opposite) The Natural History Museum near South Kensington in London has been crowned "the cathedral to nature." But whether you love science or not, the museum is a sight to see when exploring London. If you find yourself in its main exhibit hall, soak in the soaring, enormous blue whale skeleton above you.

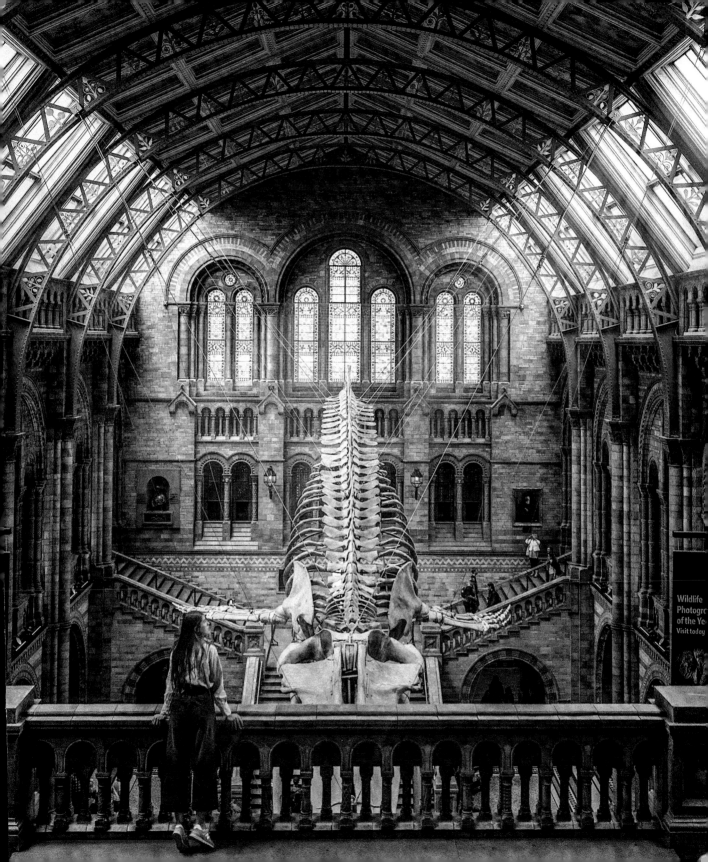

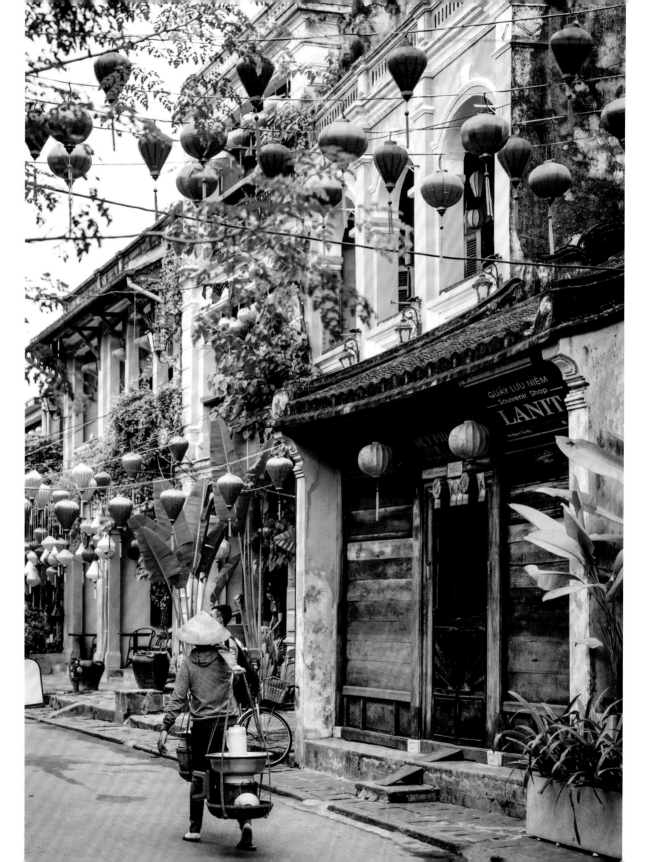

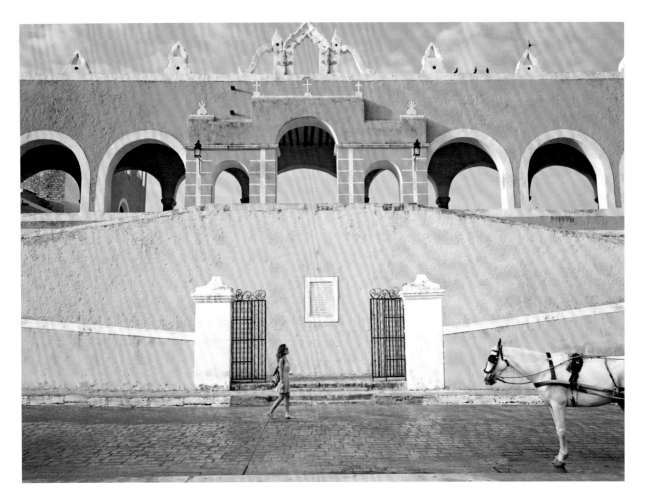

Hội An, Vietnam

JOANN PAI | @SLICEOFPAI

(Opposite) The ancient town of Hội An feels like a place where time has stood still. It's brimming with historical stories reflected through its well-preserved historic homes and the heritage museum.

DAME TRAVELER PRO TIP

Hội An is known for its tailors, so if you'd like to get something made, keep in mind that it would take two to four days. Come with ideas or allow them to inspire you!

Izamal, Mexico

BECA LILY | @BECALILY

(Above) The Yucatán region of Mexico is spectacular yet often overlooked, from the area's stunning pink lake, Las Coloradas, to the small but charming "yellow town," Izamal. The cobblestoned streets of the town are lined with mustard yellow colonial buildings and authentic restaurants and stores. Izamal is an easy drive from Cancun, so try to book a rental car to get a fuller experience.

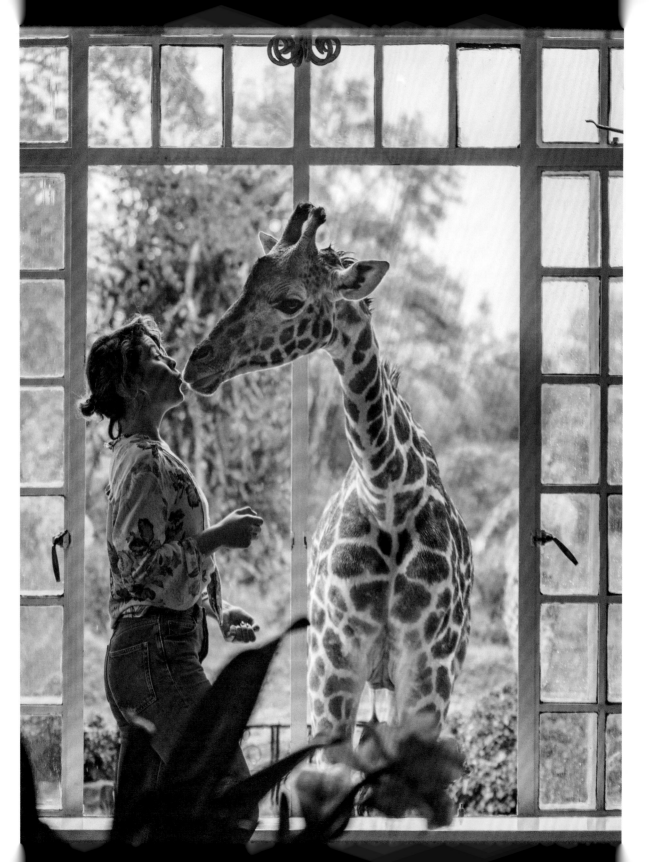

Nairobi, Kenya

CARMEN HUTER | **@CARMENHUTER**

(Opposite) The Giraffe Manor Hotel offers a boutique feel set against the lush greenery of Kenya where you can have breakfast and afternoon tea with the wild giraffes. Fly directly into Nairobi and plan a transfer to Giraffe Manor. Book your trip at least a year in advance! Safari destinations book up quickly and require extensive planning.

Nara, Japan

CAROLINE MULLER | **@VEGGIEWAYFARER**

(Right) About a half hour from Kyoto Station, you can experience the magic of Nara Park (Nara Kōen), best known for its semiwild deer who freely roam through the park grounds. Some even bow for a bite or two of food! The ideal time to see these cuties is certainly during Japan's sakura blossom season, when the cherry trees burst into life. March to April are the best times to see the whole city covered in the sakura pink petals. But with the seasons becoming more and more unpredictable these days, be sure to find a live blossom tracker online to catch them at their peak.

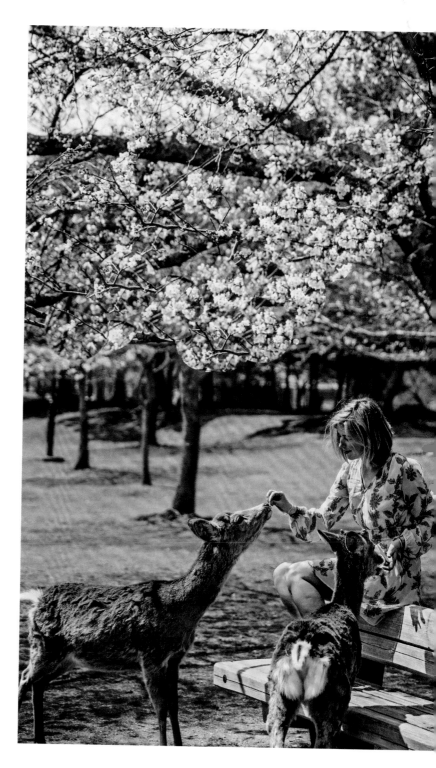

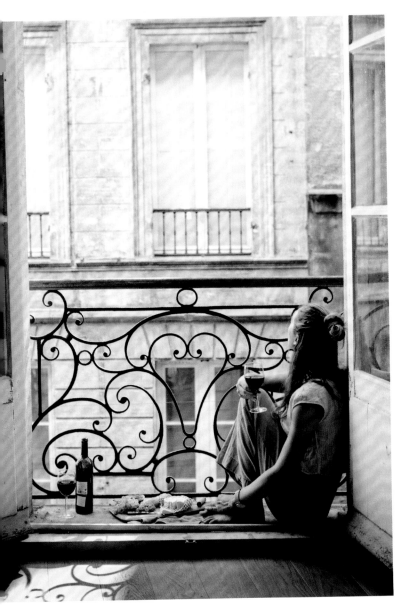

Bordeaux, France

CHLOÉ CRANE-LEROUX | @CHLOECLEROUX

(Left) "When people think of France, they rarely think of visiting the southwestern part of it. Bordeaux is surrounded by vineyards and chateaus, and the city is filled with beauty, charm, and history with homestays that look like this. After Paris, Bordeaux has the highest number of preserved historic buildings of any city in France. And, of course, Bordeaux's wine is not to be missed!"

DAME TRAVELER PRO TIP

Make a visit to Saint-Émilion, a little wine town about thirty-five minutes away from Bordeaux by train, to sip wine of the region.

Turin, Italy

CASSANDRA SANTORO | @TRAVELITALIANSTYLE

(Opposite) La Venaria Reale, a restored royal residence and gardens just outside of Turin, is one of the largest palaces in the world.

"For the past four years, I've split six months of the year in Italy and six months in New York City as a travel planner, so traveling is a reminder that you do not have to 'fit in' anywhere. I found that, as human beings, we are always trying to categorize ourselves into a type. I used to call myself a city person, a yogi, and a writer. Then this reflected the way I traveled. My goal was to find similar people while on the road. I no longer feel this way. Now, whenever I get on that plane, I am looking forward to meeting a new kind of person or discovering a new place outside of my comfort zone."

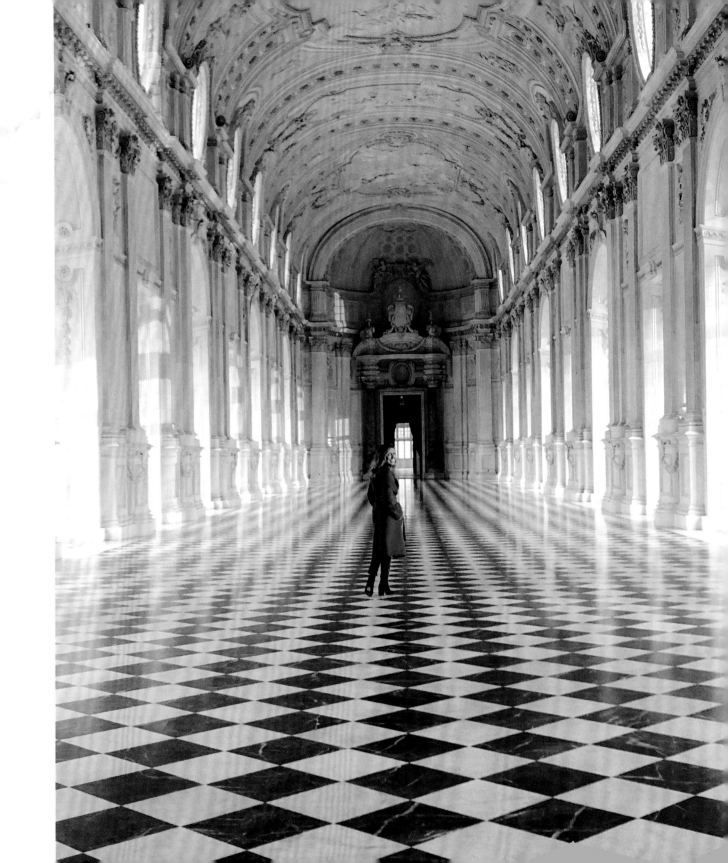

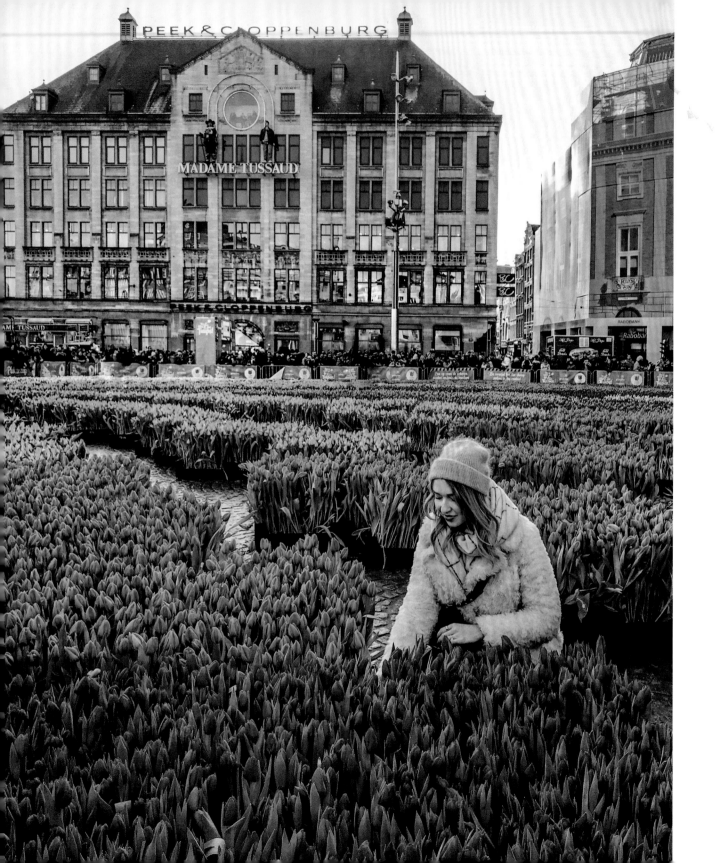

Amsterdam, Netherlands

POLINA BURASHNIKOVA | @POLABUR

(Opposite) Visit the Netherlands in January when Dutch growers share hundreds of thousands of tulips in Dam Square. Their colorful blooms and fragrance are refreshing during the chilly season, and you can even pick one to bring home for free! And the best way to get there? By bike of course! And if you plan on walking around the city instead . . . watch out, especially during rush hour. The locals take their bike riding seriously around here.

DAME TRAVELER PRO TIP

If you ever find yourself on a flight with a layover in Amsterdam (even if you have only a few hours to spare), the airport train can get you to the heart of the city center in just fifteen minutes.

Nyungwe National Park, Rwanda

MARCY YU | @MARCY_YU

(Right) The One & Only Nyungwe House is at the edge of the Nyungwe National Park, home to one of the oldest rainforests on the continent. Nyungwe House stays committed to adapting their facilities to receive tourists who are hoping to experience the magic of its flora and fauna. It's an authentic experience for any traveler who's dreamed of exploring the wild, dense forests of Rwanda.

DAME TRAVELER PRO TIP

To spot chimpanzees, head to the Nyungwe National Park. To see gorillas, Volcanoes National Park is the place to be. Both parks provide an authentic and raw experience where you explore throughout the wild forest, in a place unlike any zoo you've visited.

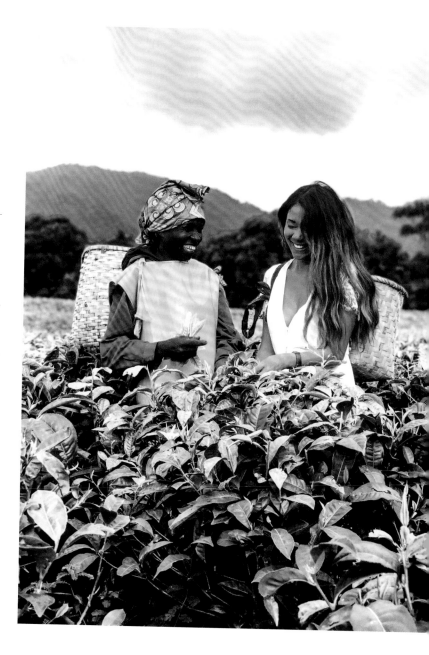

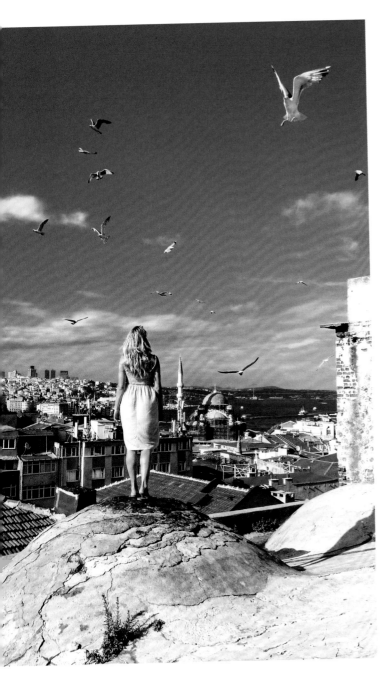

Istanbul, Turkey

ANA KOROLIJA | @_SMALLTHINGS_INLIFE_

(Left) "After two years of living in Istanbul, I said my farewell to the city by revisiting one of the hidden gems I'd found—one of the lesser-known rooftops called Kubbe Istanbul. After following locals carrying cups of Turkish tea to a door, I had been greeted by the space's manager. He'd explained that Kubbe is an art gallery, workshop space, and area to create handmade art. The view was not only special, but the beautiful moments people were having up there were even more so."

DAME TRAVELER PRO TIP

Beware of some of the Istanbul shoe cleaners—they drop their cleaning brush "by accident" and if you pick it up, they start their "act" by saying they need to thank you by cleaning your shoes. At the end they ask you for a ridiculous amount of money. It's best to avoid interacting with shoe cleaners to prevent being scammed like this!

Nice, France

BOLD BLISS | @BOLDBLISS

(Opposite) "Ochre, coral, and Tuscan red. Amber, pale citrine, and sunstone. If you've ever been to the Old Town of Nice, you'll agree that the streets seem to be drenched in precious hues: *la palette de couleurs de la Méditerranée*! After having our morning cappuccino on the Cours Saleya, we climbed toward the Castle Hill. At some point when we bumped into the walls surrounding the chateau, we turned one of many brightly painted corners and discovered a beautiful, completely deserted street winding down to the city center. Looking at the scenery, with the higher floors draped with laundry, it seemed as if we had walked into a deserted film set, transporting us back decades. Well, it turned out we actually had! We ran into a technician who told us they were filming *Un sac de billes*, based on the novel by Joseph Joffo."

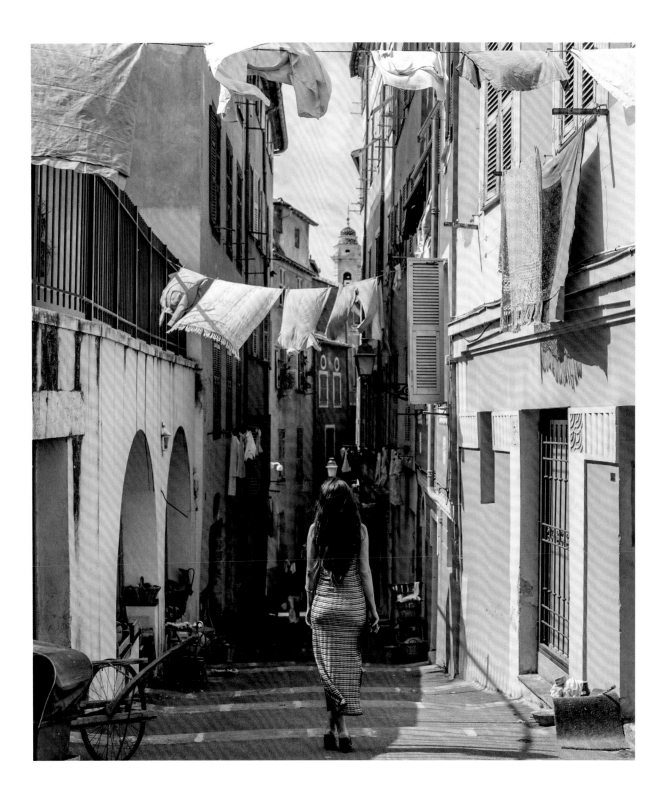

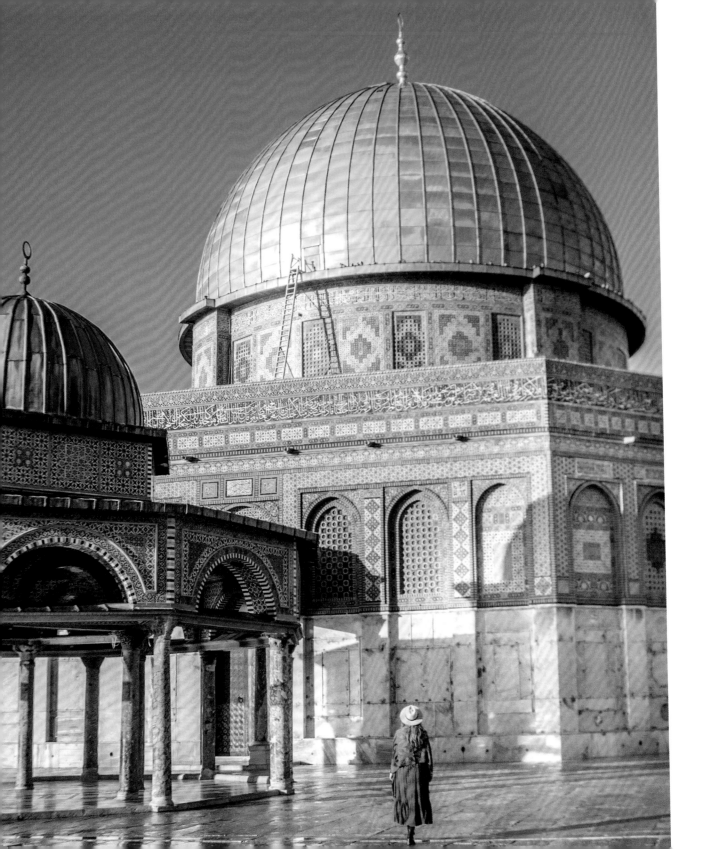

Jerusalem

CHELSIE KUMAR | @SUITCASEANDI

(Opposite) One of the most contested religious sites in the world, the Temple Mount is a place of great importance to Christianity, Judaism, and Islam. Despite their differences, all three religions agree that the site is of cultural and historical importance. The Dome of the Rock is only open to Muslim visitors, but no matter your faith, people of all faiths can take in the intense energy from the gorgeous, intricate exterior.

DAME TRAVELER PRO TIP

There is only one entrance for non-Muslims, located outside the Western Wall near Mughrabi Gate. Remember to dress conservatively (your shoulders and knees must be covered) and bring your passport to security.

Seville, Spain

ROXANNE VITNELL | @THECHRONICLESOFWANDER

(Right) The ornate Plaza de España is adorned with the most beautiful yellow, blue, and green patterned tiles from top to bottom and is surrounded by a moat around which visitors can gently row.

"Moving to Seville, Spain, is one of the most exhilarating things I have ever done, but it has also been one of the most challenging and difficult experiences. There are language barriers, cultural differences, and things I have never encountered before. I take pride in small victories, like being able to speak with the postal worker on the phone and understand him or being brave enough to try food that I'd never eat at home. I didn't go abroad to 'find myself' . . . but to merely be a better version of who I already am."

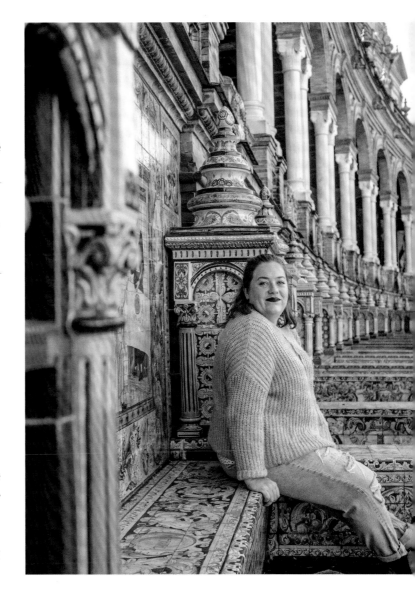

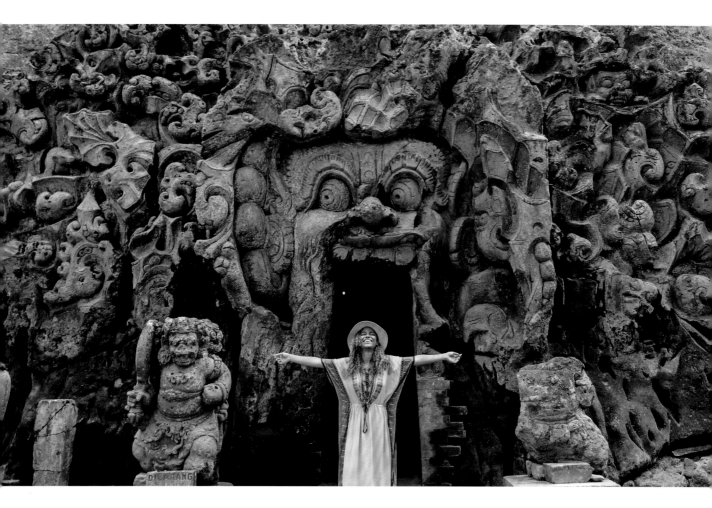

Bali, Indonesia

GENITH FUENTES | @GENITHFUENTES

(Above) Don't judge a book by its cover. While the entrance of Ubud Goa Gajah, or Elephant Cave, may look a bit menacing, the inside of the cave is thought to be a place of meditation and spiritual cleansing.

"You are going to face loneliness as a solo traveler. And sometimes it happens in the weirdest and most unexpected places. And you know what? You just have to embrace it. Accept that lonely little voice resonating in your head and gently tell it, "I got this. Don't worry." And, worst-case scenario—call home or reconnect with some pals when you have a good Wi-Fi connection."

Easter Island, Chile

TINE PETTERSON | @TINEPETTERSON

(Opposite) "Easter Island is one of the most remote inhabited places in the world and known for its almost nine hundred massive statues known as Moai. This place is called Ahu Tongariki and is the largest ceremonial platform on Easter Island with fifteen Moai. To be there was a wonderful and spiritual feeling."

DAME TRAVELER PRO TIP

To get to Easter Island, you'll need to take a flight from Santiago. But heads up—tickets can be quite expensive and the flight can be six to eight hours long. But considering how remote and special Easter Island is, it's well worth the time and cost.

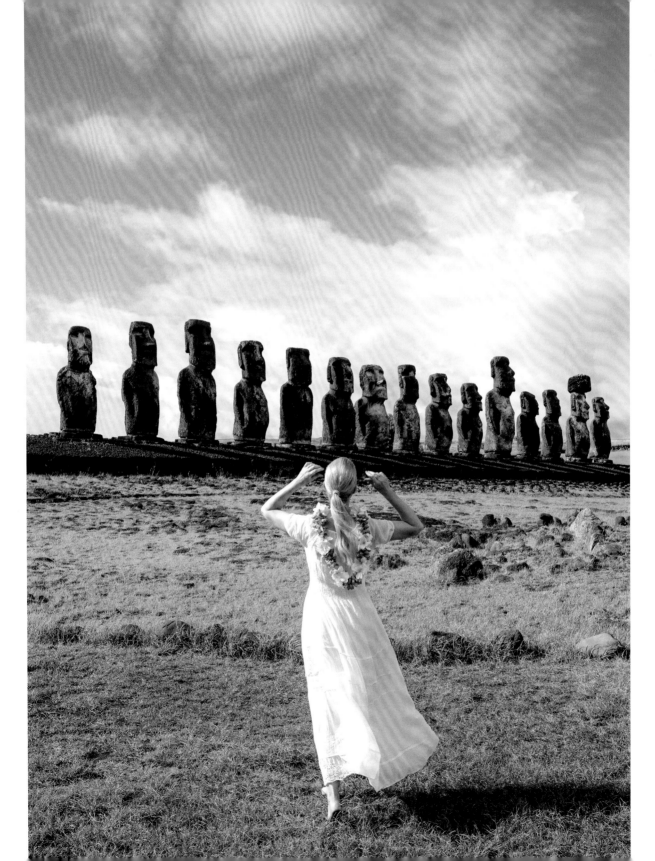

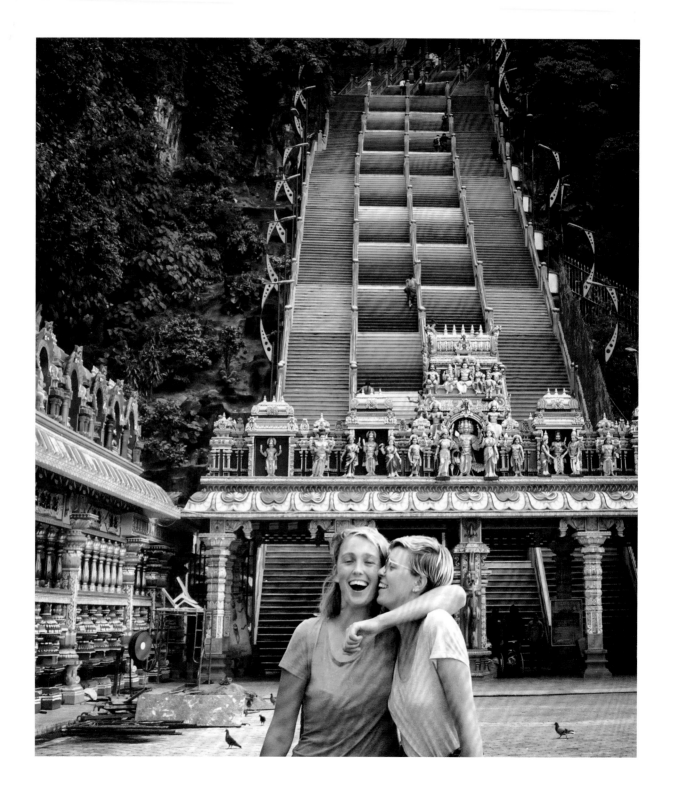

DAME TRAVELER **130**

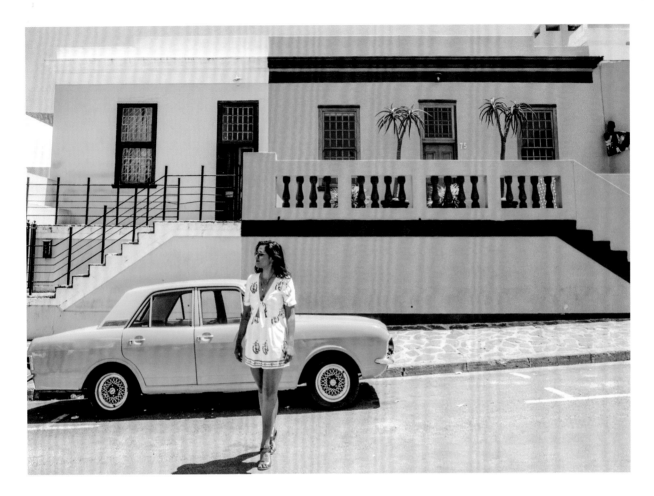

Selangor, Malaysia

ROXANNE AND MAARTJE | @ONCEUPONAJRNY

(Opposite) Rainbow bright and scaling high above, the Batu Caves of Malaysia are absolutely mesmerizing.

"We're a female couple traveling the world together. No country is off-limits for us, as we know there's an LGBTQ+ community within every country. For us, it's important to meet LGBTQ+ locals and hear their stories. At first, it wasn't our intention at all to share so much of our personal story, but along the way, we realized there are very few examples of LGBTQ+ members (especially women) traveling. We often get asked about the safety of traveling as queer women. Unfortunately, most media and the news share all the bad stuff that's happening, so it's easy to get scared and never visit places because of that. The truth is, the world is amazing, learning about different cultures is amazing, and there are so many kind people everywhere we go."

Cape Town, South Africa

NIKKI LAZARAN | @NIKKTHEQUICK

(Above) "Bo Kaap, translating to 'Above the Cape' in Afrikaans, is a brightly colored neighborhood in Cape Town, South Africa, with picturesque houses dating back to the 1700s. It was made a Muslim-only neighborhood under the apartheid government in the 1950s, and it still retains a large Muslim population today. While we mostly encounter its image today in gorgeous travel photos, learning about the history of the neighborhood reminded me of why I love to travel—it connects me to communities I would not have otherwise encountered and exposes me to our global human history, both the beautiful and calamitous."

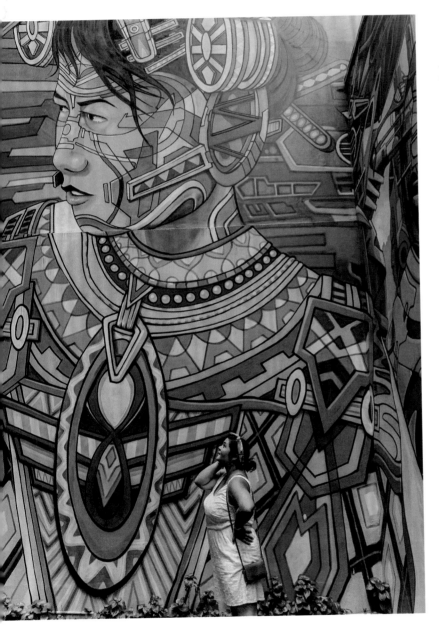

Kampong Glam, Singapore

BIANCA KARINA | @BIANCAKARINA__

(Left) "This mural can be found on the backside of Haji Lane's Piedra Negra restaurant, behind a shroud of trees. Most people will wander down Haji Lane to see the Aztec wall art by Didier 'Jaba' Mathieu, not realizing there's another mural hidden away from the main shopping street. The Kampong Glam neighborhood has become quite the bohemian center in Singapore, as the rest of the country has rapidly modernized. These murals are a huge statement considering all graffiti is punishable by law and the arts aren't prominent in the university system in Singapore."

Shanghai, China

KATERINA PADRON | @LIFE_IN_TOKYO

(Opposite) "Walking through the Yu Garden of Shanghai is like walking through living Chinese poetry."

DAME TRAVELER PRO TIP

No visit to Shanghai is complete without visiting the Yu Garden and taking a tea break at the Huxinting Teahouse. Reaching it by a zig-zag walking path is said to ward off evil spirits according to a Chinese myth.

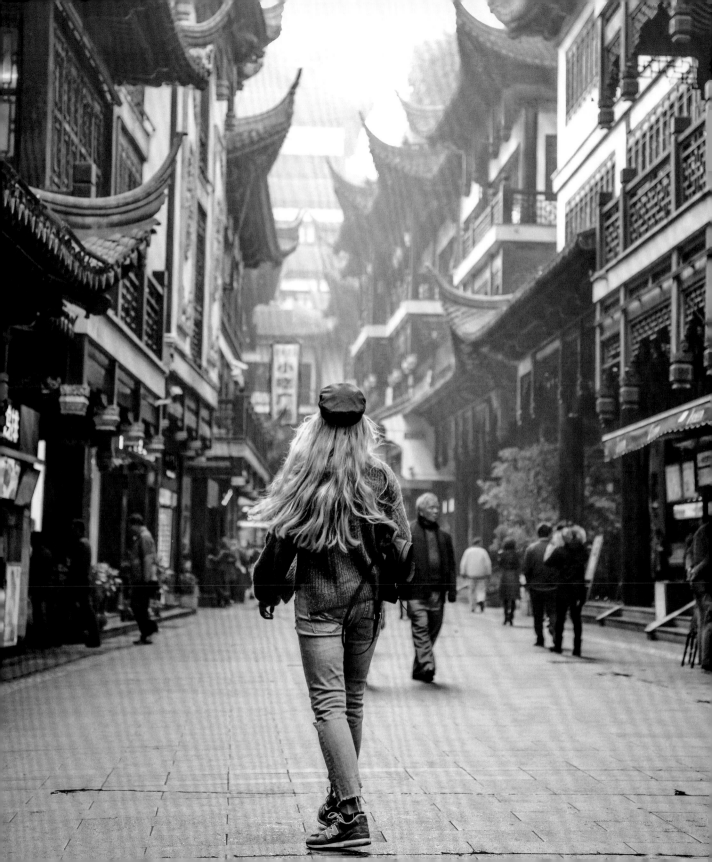

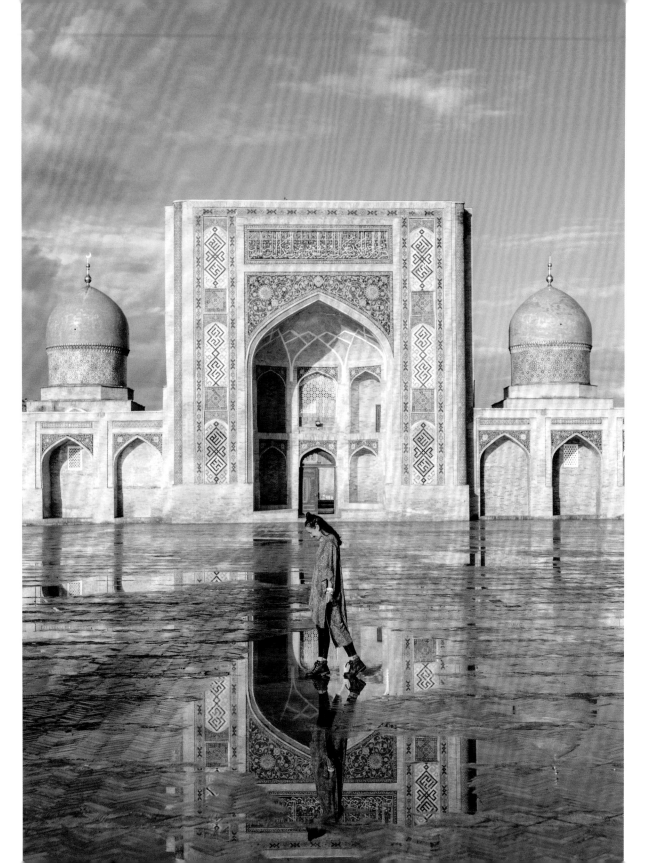

Tashkent, Uzbekistan

SINDHYA SHOPTAUGH | @WHYWESEEK

(Opposite) "This moment was captured at Barak-Khan madrassa around 7:30 a.m. after the rain had stopped and the sun broke through the clouds. Being the center of the Silk Road between the Mediterranean and China, Uzbekistan represents the beginnings of trade, both in goods and ideas. It's a land that's been ruled by many leaders, from Genghis Khan to Amir Timur to Gorbachev. The architecture is exquisite and, in my opinion, sheds a positive light on Islamic culture, which is necessary in today's world. Other major 'must-sees' throughout the country are Tashkent, Samarkand, Bukhara, and Khiva."

Kabul, Afghanistan

ALEXANDRA REYNOLDS
@LOSTWITHPURPOSE

(Right) Sakhi Shrine is located in the Karte Sakhi neighborhood of Kabul, Afghanistan. Its beauty and resiliency shines as an example of the Afghan people. While exploring its detailed turquoise walls, you'll find many Shia families picnicking and children playing on its marbled floors.

"Life on the road helped me realize that I am strong. I have confidence in myself. I can survive whatever life throws at me. If I can find my way onto a bus in a terminal overflowing with vehicles and bodies and signs I can't read, in Pakistan, I can find my way anywhere. If I can find the courage to punch a man in the face for drunkenly assaulting me on the beaches of India, I can hold my own against men around the world. If I can find friends in Kabul, hitch a ride in the Caucasus, dodge traffic in Dhaka, or survive sickness in the Himalayas, I can—and will—pursue my dreams no matter where my travels take me."

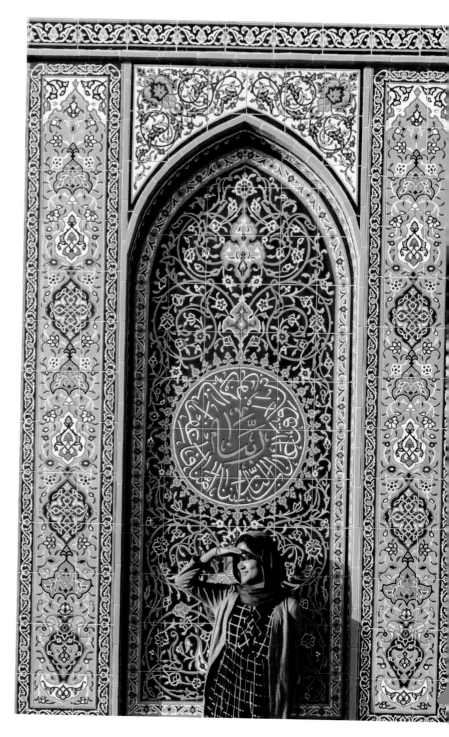

Puerto Vallarta, Jalisco, Mexico

JANE KO | @ATASTEOFKOKO
BY HALEY PLOTKIN
@READYSETJETSET

"Mexico is one of the most vibrant places on earth, and the beautiful Mexican seaside resort town of Puerto Vallarta can attest to that. This is the kind of place most people go to for an all-inclusive vacation. My advice would be to make sure you *don't* just stay at your resort the whole time you're there. Get out and explore the city! You'll find colorful corners like this, street art, local food stands, and more."

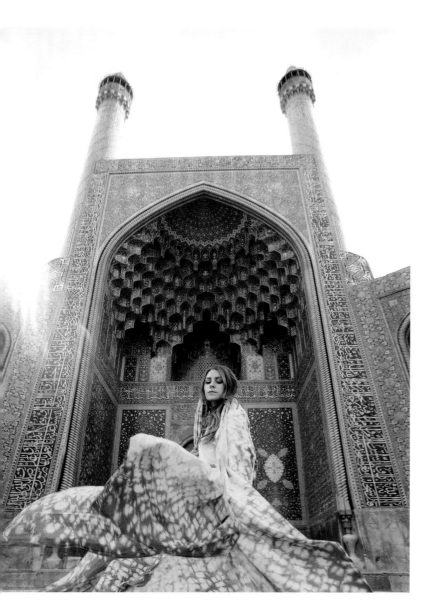

Esfahan, Iran

SARA MELOTTI | @SARAMELOTTI_

(Left) "Travel changed everything for me. Before I started traveling, I was a fashion photographer living in New York City. Then one day I realized my work was contributing to setting a very unrealistic beauty standard that made too many women, including myself, feel inadequate. I quit the fashion industry and started traveling for a personal project I created, Quest for Beauty, to photograph women in their raw elements and to ask them what beauty means to them. The project led me to Iran, Ethiopia, Vietnam, Cuba, and beyond, as well as to Brooklyn, where I met Nastasia. I reached out to her to share her story with the world and to take her portrait, and we went on to become friends and to eventually travel together."

Koslanda, Sri Lanka

LARA KAMNIK | @YOUR_PASSPORT

(Opposite) "Visiting small villages like this one at the Living Heritage Koslanda—and meeting some of the friendliest locals who were passing days praying for keeping what they have (rather than pleading for what they have not)—not only surprised me but gave me a whole new perspective on life. Find a secret hideaway like this to give yourself a chance to self-reflect and recharge. Sri Lanka is, by far, one of the best destinations for meditation or yoga, nestled in the jungle with beautiful sounds and scents."

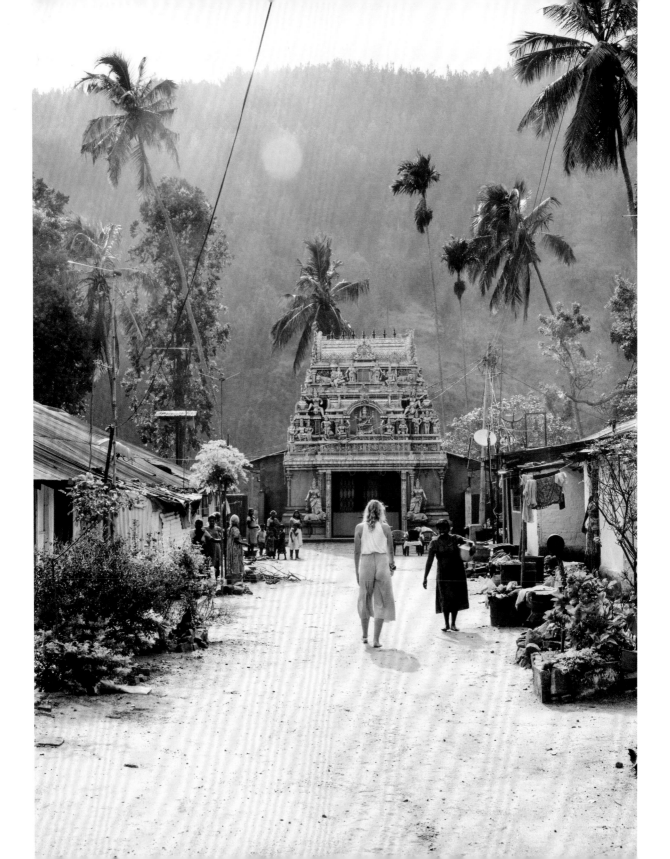

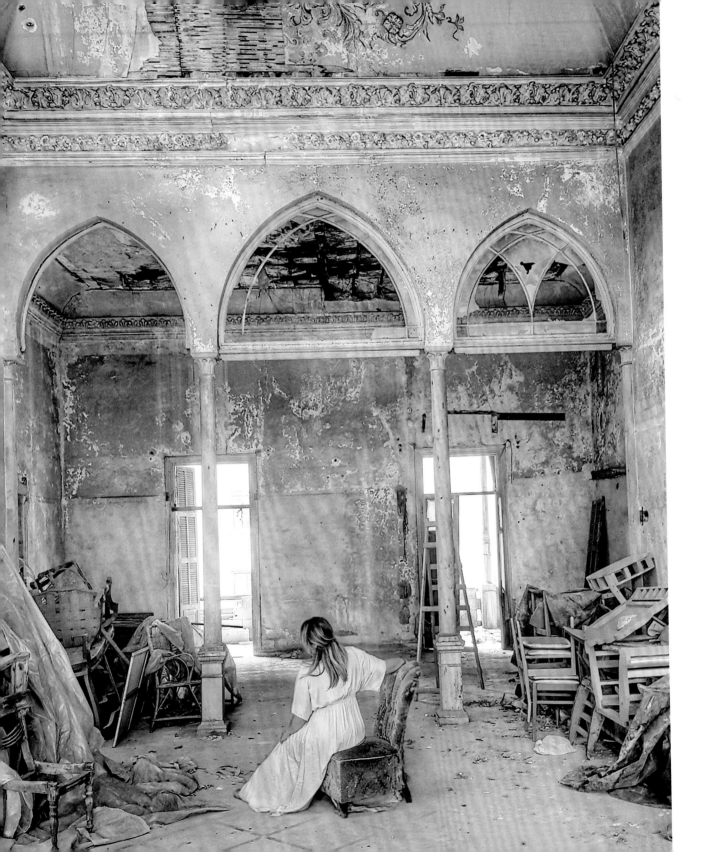

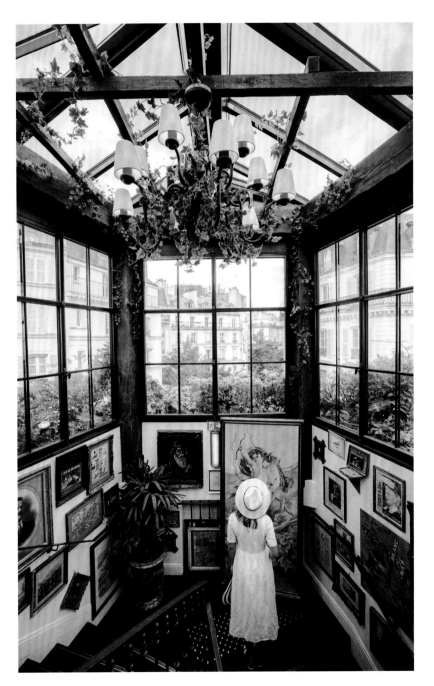

Beirut, Lebanon

DIALA SHUHAIBER
@FRAMEWITHAVIEW

(Opposite) This abandoned villa in the Basta area of Beirut is one of many reminders of the city's war-torn history, but it is also a reflection of the country's resilience and beauty. While travelers should do their research before packing their bags and heading to Lebanon, the country has taken a turn and has experienced peace, especially within the last couple of years, and your senses will be completely overwhelmed and charmed by all that it has to offer. The people of Lebanon are some of the warmest individuals around, so strike up a conversation and make friends! There's nothing like seeing a country through a local's eyes.

Paris, France

STEPHANIE STERJOVSKI JOLLY
@STEPHSTERJOVSKI
BY @NASTASIASPASSPORT

(Left) With tons of overpriced restaurants bent on tricking tourists, it can be overwhelming to decide where to eat in Paris. But you're safe at Pink Mamma in Paris's hip Pigalle district. Pink Mamma is four stories tall with a different vibe on each floor. There's also a secret speakeasy underground!

Hong Kong

FARRAH ZAK | @_BYFARRAH

(Right) "For a more peaceful experience while visiting the bustling city of Hong Kong, take the MTR train to Diamond Hill MTR Station. Within a few blocks sits the serene and ancient Nan Lian Garden. After sipping on tea, stroll through the classical Tang Dynasty–style landscaped gardens filled with hills, water features, and wooden structures. It's so tranquil and unbelievably flawless–a sense of calm in the middle of Hong Kong, where every rock, plant, body of water, and timber structure is specifically placed. It's feng shui on another level."

Pattaya, Thailand

CYNTHIA CORONA | @CYNCYNTI

(Opposite) The Sanctuary of Truth is a relatively new religious construction in Pattaya, Thailand. Initiated in 1981 and set to finish in 2050, this temple is actually built using ancient wood-carving and wood-joining techniques unique to the earliest Thai buildings. It represents images from the Buddhist and Hindu mythologies of many countries to showcase the human relationship with the universe and a shared goal of living toward utopia. Although Pattaya is best known for its beaches, be sure to also explore its Mini Siam—a miniaturized replica of famous structures from the country—as well as its floating markets, where vendors sell their goods from their boats on the water.

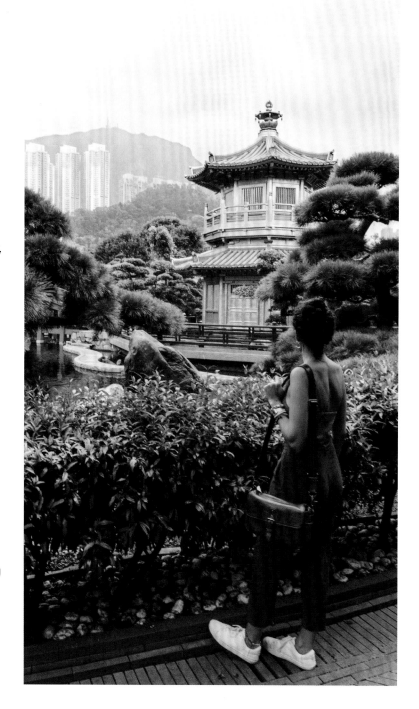

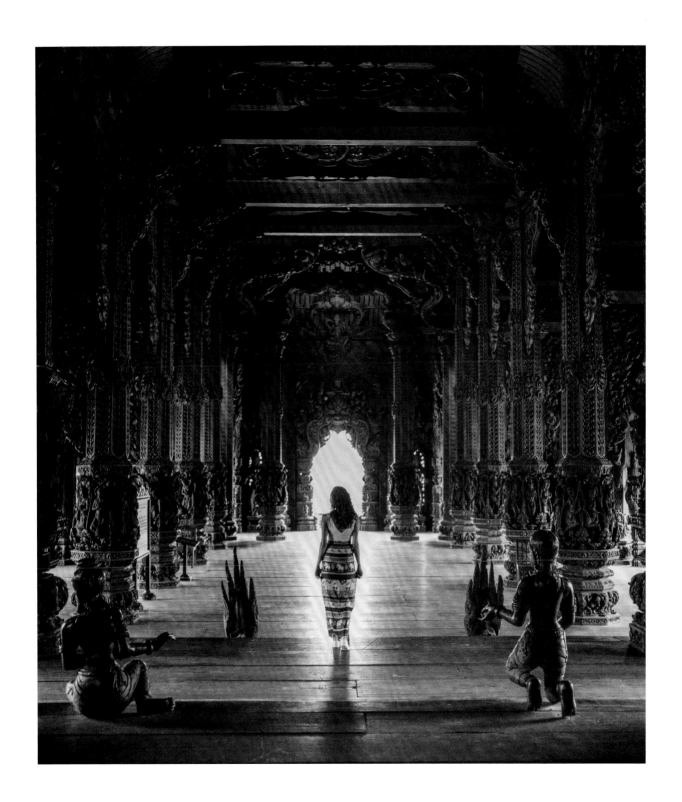

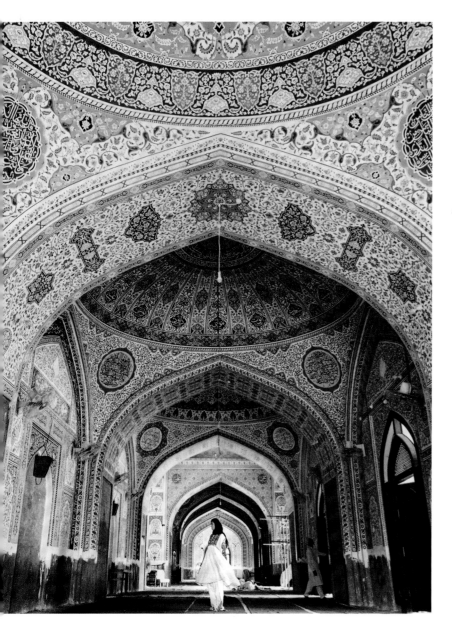

Multan, Pakistan

MINAHIL BUKHARI | @LANDANDMARKS

(Left) The political climate of Pakistan has changed dramatically in recent years, allowing for more tourism and safer conditions for explorers. Multan is known as the city of Sufi saints, and the city houses many other beautifully ancient and important sites, like the Shahi Eid Gah Mosque.

"An important part of travel is to be sensitive to the specific region's customs and culture, so the experience of cities like Multan is much better if travelers blend into the crowds. Dressing accordingly, learning a few local phrases, and perhaps traveling with another person or two makes for a much safer experience."

St. John's, Newfoundland

DANIELA AMYOT
@DANIELA_AROUNDTHEWORLD

(Opposite) "St. John's is the only 'big' city in Newfoundland, so it's certainly very different from the other cities on the island. Newfoundlanders are very proud of their culture, and the city is so rich in history that you can really feel it when walking around in the different neighborhoods. So, discover the city by foot! St. John's abounds with colorful houses and cafés to discover, like these in the Battery neighborhood."

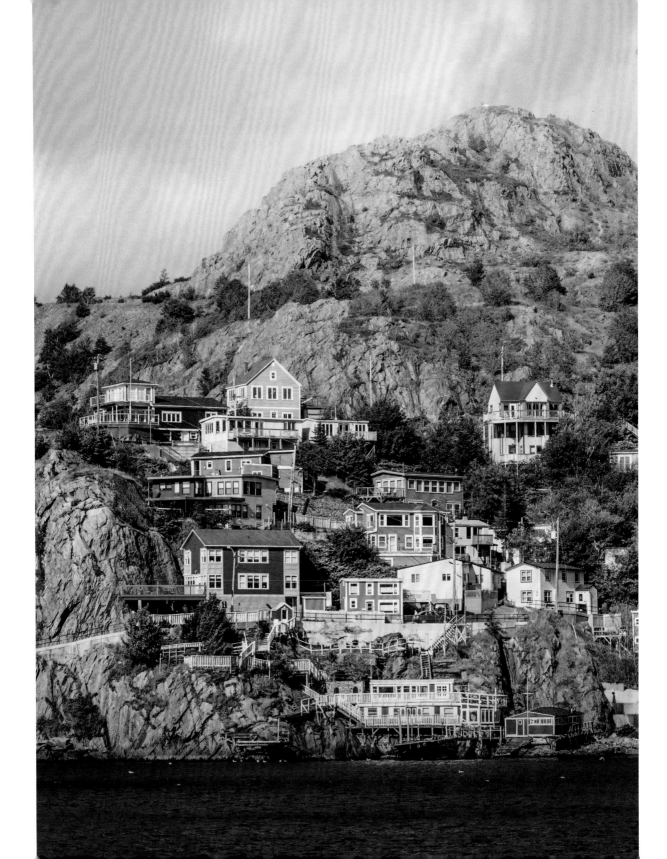

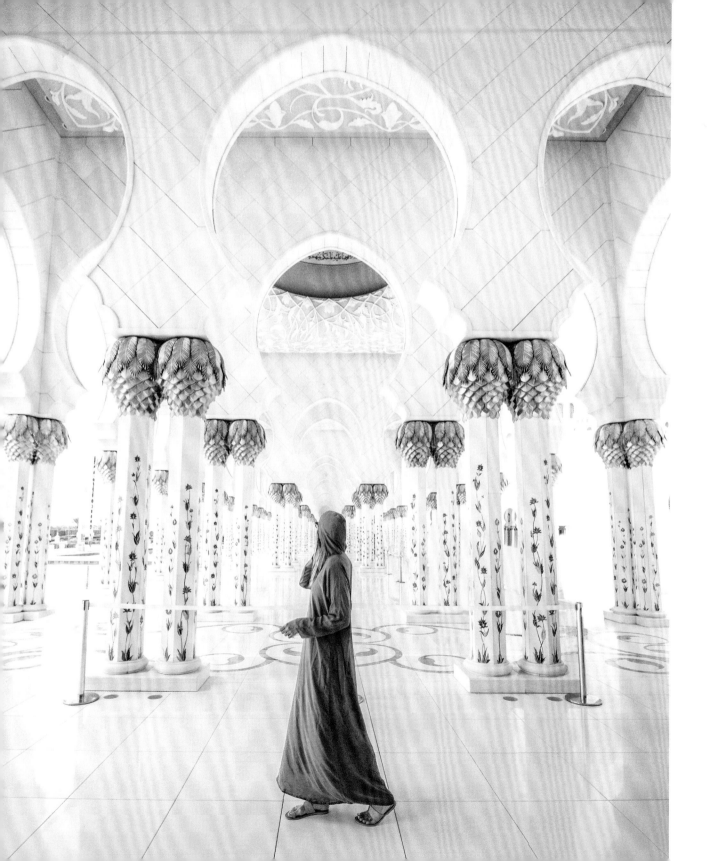

Abu Dhabi, United Arab Emirates

DIANA MILLOS | @DIANAMIAUS

(Opposite) As one of the world's largest mosques, the Sheikh Zayed Grand Mosque is visited by millions of visitors per year. The mosque has an open-door policy, inviting people from all over the world into the splendor of this incredible architectural place of worship.

DAME TRAVELER PRO TIP

The mosque has strict rules regarding behavior and dress. You must be fully covered upon entering the mosque. But in case you didn't pack appropriately, there are *abayas* (traditional coverings) available at the entrance for you to borrow. Keep in mind that this is a religious site, and avoid disturbing or photographing women, children, or people in prayer without their permission. Displays of affection are forbidden.

Agra, India

JESSICA COBBS | @FROONTHEGO

(Right) "As a curly-haired Black woman, it was hard for me not to draw attention to myself in a place like the Taj Mahal in India (where I stuck out like a sore thumb). Travel has been my best teacher. Not only have I learned some memorable life lessons, I've become braver, more humble, and socially aware. I'm able to tell some of the most amusing stories–because traveling while Black is either eye-opening, frustrating, or funny."

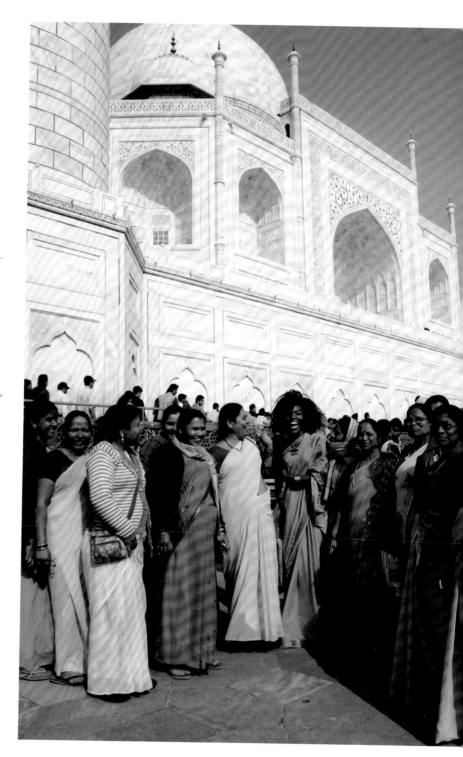

Izmir, Turkey

STEPHANIE BUELNA | @STEPHBETRAVEL

Ephesus, an ancient Greek city near Izmir, is home to the Temple of Artemis and the Virgin Mary House where Mother Mary spent the last years of her life.

"Travel is an investment in bettering yourself. Travel has made me humble. It's put life into perspective when I'm small and Mother Nature is so big. Travel pairs me with patience, when I worry about now, but see ruins withstand centuries."

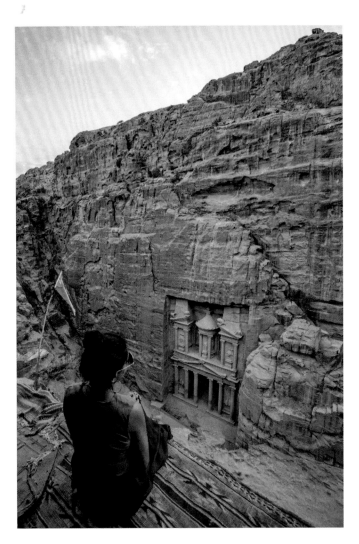

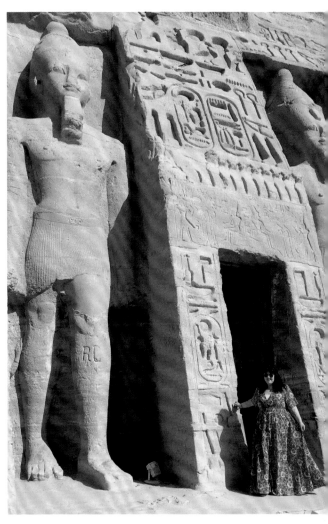

Petra, Jordan

SABINA KHILNANI | @SABINAK617 BY @NASTASIASPASSPORT

Petra, the Rose City, is one of the Seven Wonders of the World. It feels like a scene from *Indiana Jones*, especially as visitors enter through the Siq, a massive split rock canal leading into its center. Follow the Al-Khubtha trail, a steep, one-hour hike, to see one of the best views in Petra.

"When you and your family are transferred from the US to a tiny town in the middle of Brittany, France, at the age of two, travel is more a way of life than an adventure or vacation. Visiting museums, chateaus, and new cities every weekend fostered an adventurous spirit within me."

Abu Simbel, Nubia, Egypt

SHERI MATTHEWS | @SHERRYIVY_

"We spent two nights on a *felucca* (a traditional Egyptian sailboat that is essentially a floating mattress and tent) sailing down the Nile, and it was the highlight of the whole trip. We sunbathed on the banks of the river, stargazed on the roof of the *felucca*, and saw a shooting star and danced around an open campfire as the crew played local, traditional music."

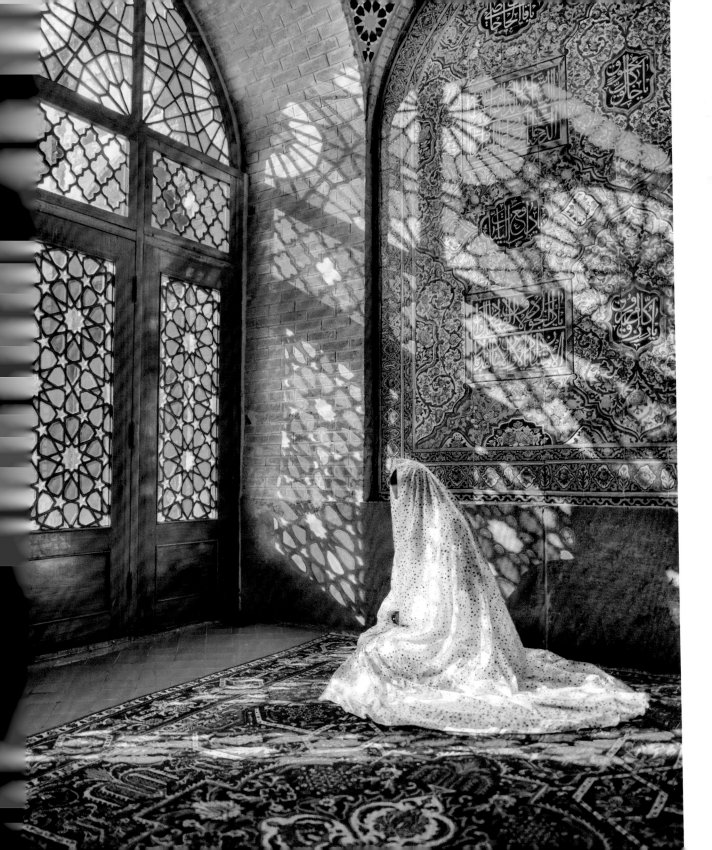

Shiraz, Iran

AYDA IZADPANAH
@AYDA_JUNE

(Opposite) Nasir al-Mulk Mosque (also called the Pink Mosque) is a traditional house of worship in Shiraz, Iran. Its stained-glass windows create a magnificent kaleidoscope effect when the sun shines through.

Mumbai, India

LINDSAY SILBERMAN | @LINDSAYSILB

(Above) "My first visit to India happened to fall during Holi, the ancient Hindu festival that marks the beginning of spring. There was a palpable energy throughout Mumbai in the days and hours leading up to the event. Live music, local food, and a seemingly infinite array of vibrant powder to toss around at one another! It was a gorgeous sunny day, with just enough wind to make the powdered paint float through the air like confetti. It's a day I will never forget."

Morondava, Madagascar

PAULA HERNANDEZ | @UNVIAJEDE2

(Left) "Connecting and assisting local communities is what I longed to do. The greatest adventure of my life began when I decided to volunteer in Africa, which enabled me to connect with many beautiful people. Undoubtedly, the Baobabs Avenue in Madagascar is one of the most unique places in the world! It was quite the experience to be standing among the oldest trees in the whole continent of Africa. Having dreamed of being in this place, it felt very much like an out-of-body experience seeing them in real life."

Jaipur, India

SUKAINA RAJABALI | @SUKAINARAJABALI

(Opposite) "The City Palace is a beautiful fairytale with the most intricate architecture. The allure really lies in its vivid colors. Here, you will see ladies in the brightest canary yellow saris cleaning the never-ending courtyards with their local hay brooms. Every now and then, you will come across a security guard dressed in impeccable white with a colorful red turban. Rajputs equated color with hospitality and, ever since the Maharaja brushed the city pink in preparation for the Prince of Wales in the late 1800s, Jaipur's obsession with color has remained.

"Being a hijabi woman who dresses modestly, I want to reach out to my fellow women who are also hijabi and tell them to leave all their misconceptions behind. Don't worry about what anyone will think of you, that you will be stared at or ostracized. Don't think your hijab will stop you from doing anything or going anywhere. Be free, be independent, be adventurous, be playful, live your dream. Wear the hijab proudly while traveling, like a crown."

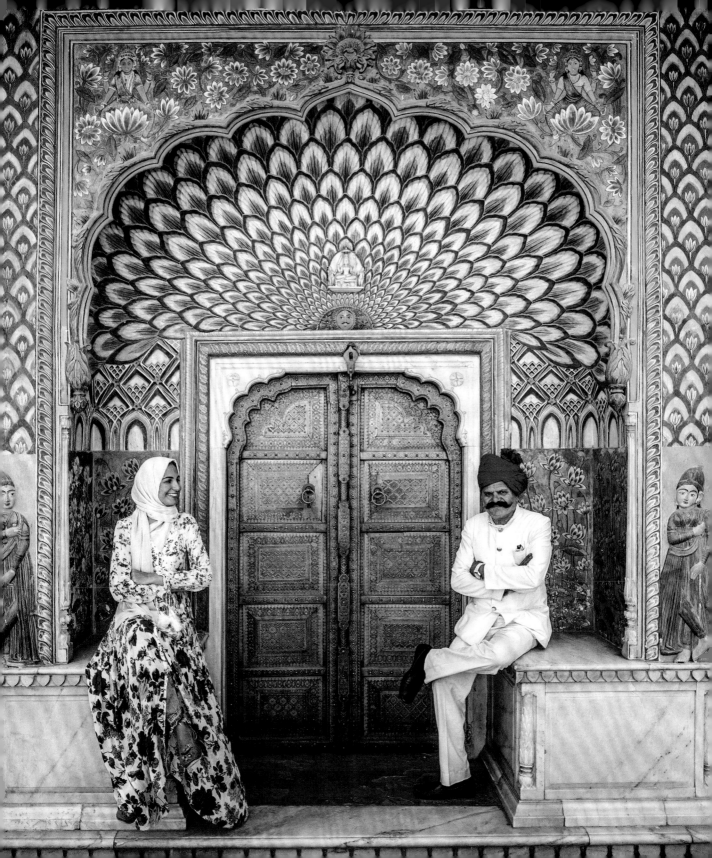

Göreme, Cappadocia, Turkey

CAMILLA TOIVONEN
@CAMILLAMILJA

(Opposite) The shopping in Göreme is an experience in and of itself. Every inch of the towering twenty-foot-high showroom at the Galerie Ikman shop is covered in an eclectic mix of textural patterns and bright, vividly colored carpets. If you ever find yourself in Göreme, stop by and maybe even have chai with the shop owner.

Marrakech, Morocco

HERMON AND HERODA BERHANE
@BEING__HER

(Right) The Medina of Marrakech is one of the biggest shopping markets, full of pottery as well as spices, textiles, and local crafts.

"We were born and raised in Eritrea, East Africa, where we both became mysteriously deaf at the young age of seven. When we feel limited, that's when we decide to push our boundaries. Being deaf may be difficult, but being scared is the real barrier. As deaf travelers, we want to share the barriers we face every day. There are many misconceptions about disabilities, so we advocate for diversity in all aspects of life and we feel women of color especially need inspiration to travel and experience new countries and cultures. We aim to inspire diversity and inclusion for all girls and women, which will enable them to gain the confidence to see the world too."

Freudenberg, North Rhine-Westphalia, Germany

JOHANNA HÄUSLER | @BEAUTELICIEUSE

(Above) Freudenberg, Germany's fairytale village is just an hour outside of Cologne, and makes for the perfect day trip to witness the satisfyingly stacked homes. To get this exact panoramic view of the town, you'll find a staircase right next to the fire department's parking lot that leads you up the hill to this view.

"I gave birth to a little girl last year and didn't know how she would like traveling. I was so afraid motherhood would change my passion for travel. But that's not the case. Traveling with her is different, but possible, and still so satisfying. I get to see the world through her eyes and enjoy the little things I've never noticed before."

Xijiang, Guizhou, China

STEFANIE WICH-HERRLEIN | @SMILE4TRAVEL

(Opposite) "While traveling through this unique part of China, the remarkable houses with their wooden facades built along the riverbank and on the slopes of the karst mountains of eastern Guizhou fascinated me tremendously. In these villages, the lives of the locals are still dedicated to the traditions and customs of the Miao minority people, who have been living in these mountains for thousands of years. Despite tourism picking up, traveling to this province gives you an idea of the Chinese ancient way of living far outside of the uber-modern, mega cities."

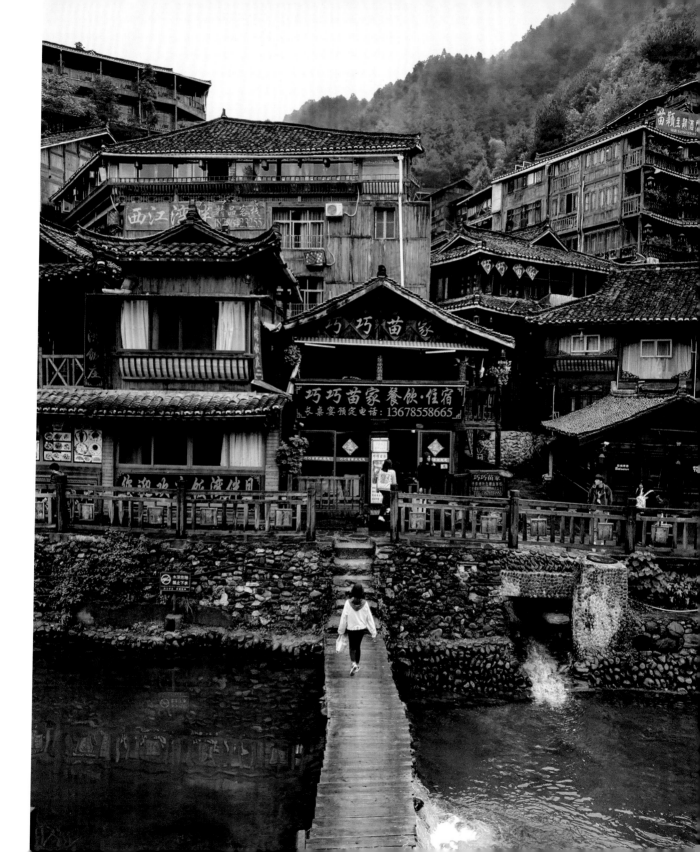

nature

Whether climbing to mountain peaks to catch the sunrise or frolicking through wildflower fields, there's something special about connecting with nature. Marveling at the natural wonders of the world and the grandeur of it all slows time down and puts things into perspective. It's a different kind of travel but one to be experienced and savored mindfully and sustainably.

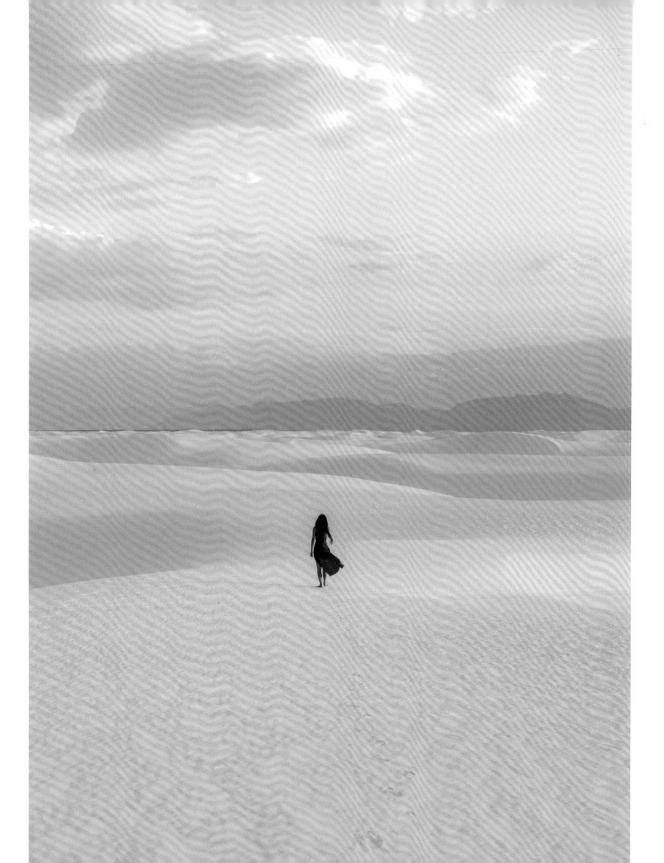

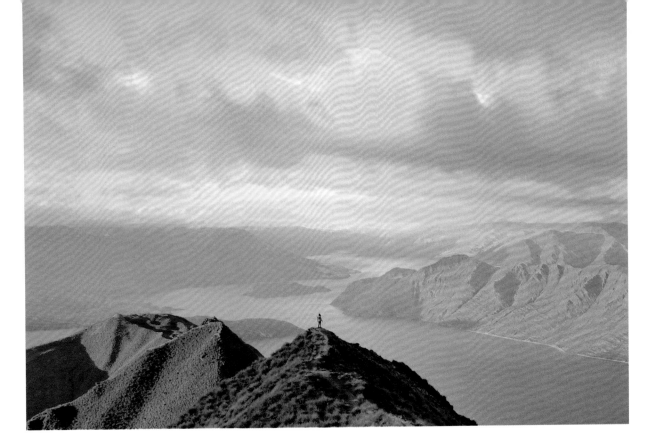

White Sands National Monument, New Mexico, United States

RAY YUN GOU | @RAYYWANDERS

(Opposite) The largest internally drained valley field in the whole planet is located in the northern end of the Chihuahuan Desert in New Mexico. White Sands National Monument spans 115 square miles and actually moves 30 feet northeast per year! If you plan on visiting, avoid coming during midday. The lighting is too harsh (making for overblown pictures and very, very strained eyesight). Instead, come around golden hour or blue hour, right before and after sunset, to see the white sands change into a kaleidoscope of muted colors.

South Island, New Zealand

WILLABELLE ONG | @WILLAMAZING

(Above) The 5,177-feet-above-sea-level hike to Roy's Peak offers splendid views of Lake Wanaka, the town of Wanaka, and sometimes dramatic clouds hovering over the beauty of the sweeping wild landscape.

Anchorage, Alaska

ERIN SULLIVAN | @ERINOUTDOORS

(Right) Alaska's sparse and wild landscape is truly unlike any other place in the world. From its stretches of miles of forests, glaciers like Knik Glacier, and towering mountains, Alaska is best visited during the summer (from May to September), when its hours of daylight are longer.

"One big lesson I have learned (and am always working on) is to listen more intentionally. Travel will expose you to some really powerful stories—spoken and unspoken. You can hear these best when you are tuned in and paying attention."

Diamond Beach, Iceland

MARINA COMES | @MARINACOMES

(Opposite) When visiting Iceland, visit a not-so-ordinary beach—Diamond Beach—where you'll encounter large chunks of ice that have broken off from the Jokulsarlon Glacier and have washed up on shore. The contrast of the black sand and ice is incredibly striking, especially from the perspective of a drone!

Lisse, Netherlands

KATIE GIORGADZE | @KATIE.ONE

(Opposite) "These tulip fields are mainly concentrated around the Keukenhof Park in the small city of Lisse. There are different flower fields in Lisse, but the most visited are fields of tulips, daffodils, and hyacinths. The exact dates for the blooms vary from year to year, but they usually happen in April."

DAME TRAVELER PRO TIP

There's no direct bus or train from the Amsterdam city center to Lisse's Keukenhof Park, but there is an express bus from the Schiphol Airport during peak blossom season.

Portland, Oregon

NABINA NAZAR | @BHOOPADAM

(Right) The fall foliage of the Boardman Tree Farm in Oregon is a 2½ hour drive from the city of Portland. If you're hoping to catch the colors at their peak, you can track the foliage on Oregon Fall Foliage's website.

"Growing up in an orthodox Muslim family, I wasn't allowed to go anywhere alone. The only time I traveled was when my father used to take my family on vacations together. We used to take small road trips around the touristy places of South India, and I would wait for them with great anticipation. It wasn't easy for me to travel alone at first; I had to fight for it and push myself out of the room at times. To the women reading this—keep dreaming, be brave, work hard. No person should have a limit or boundaries drawn for them."

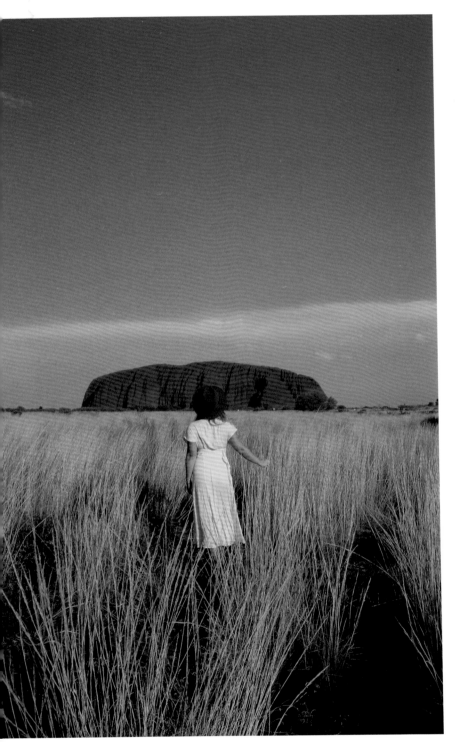

Yulara, Australia

LIZA HERLANDS | @LIZAHERLANDS_

(Left) If you're hoping to view the sacred site of Uluru in Kata Tjuta National Park, you might have missed your opportunity. This massive rock has been the place for many Aboriginal ceremonial events over ten thousand years, but visitors are banned starting in 2020.

"There is more out there than what you had initially planned for yourself. There are other ways of living and ways to feel alive than to work behind a desk and work for vacation. There are so many worlds out there with so much history. It's our job to experience, share, and preserve it."

Deadvlei, Namibia

ANNE CUI | @ANNEPARAVION

(Opposite) Once inside of the Namib-Naukluft National Park in Namibia, drive a 4x4 vehicle toward Sossusvlei. There, you'll find a designated shuttle area that can take you to the Deadvlei parking lot. From the parking lot, it will take another hike in the dunes before reaching the gorgeous clay pan of Deadvlei. Or, if you're feeling adventurous, you can drive the last leg on your own. Just be prepared for lots of off-roading!

"Surreal and spectacular, the landscape of Deadvlei reminded me of a Salvador Dalí painting. There is a peacefulness and stillness to the area that I didn't expect."

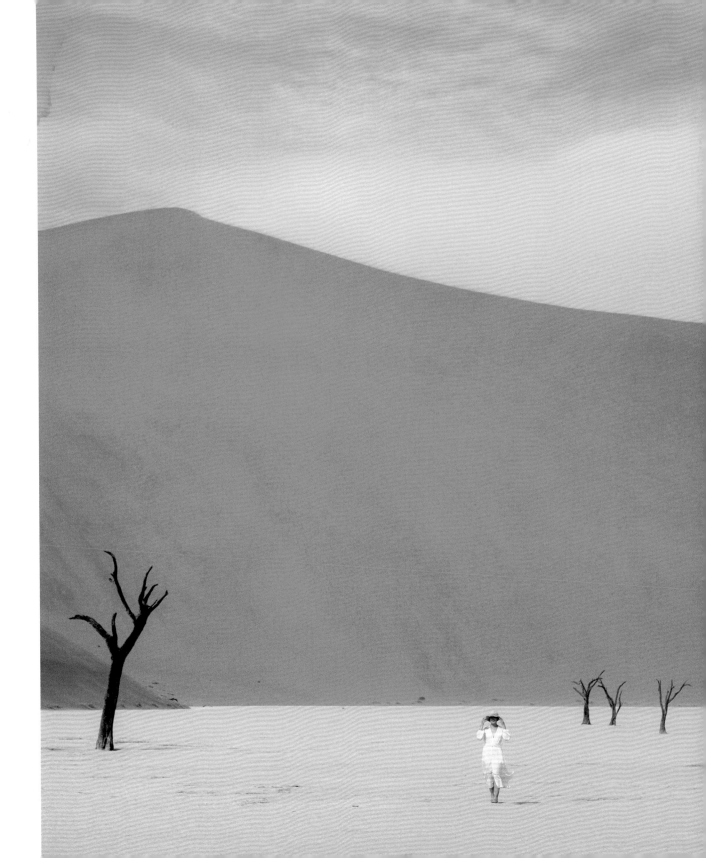

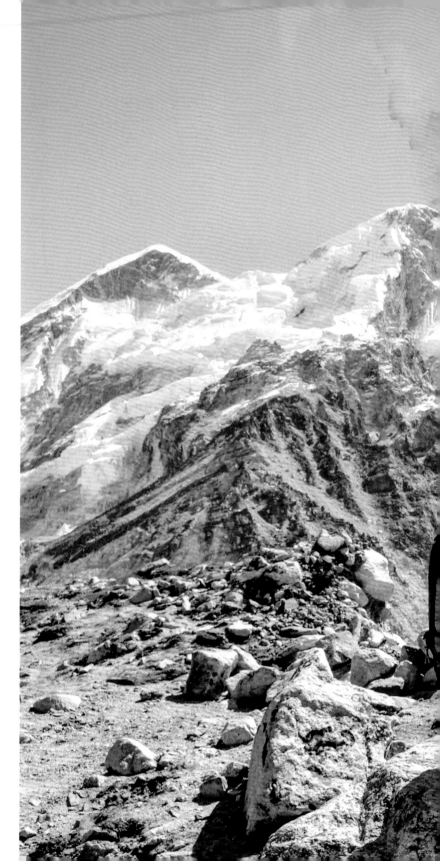

Mount Everest, Nepal

NATASHA HOLLAND
@LIFEINMINIATUREPICTURES

"There is no vehicle access to Mount Everest's base camp. Supplies are usually taken to the towns and villages along the way by Sherpas or porters with the help of animals. And by the time you reach it, the donkeys and dzos (cow-yak hybrids) of the lower altitude have long disappeared. Yaks that usually cannot live below ten thousand feet are practically the only animal you'll see for four days. These moments only add to the feelings of remoteness as you finally make your way there.

"Travel respectfully. Be respectful of people, local traditions, way of life, religion, culture, and the environment. Take the time to find out about any cultural no-nos before you arrive somewhere. Remember that you are a guest in another country and culture and be prepared to adapt and appreciate the environment you are in. Take the time to interact with and learn from those around you–this is what travel is about."

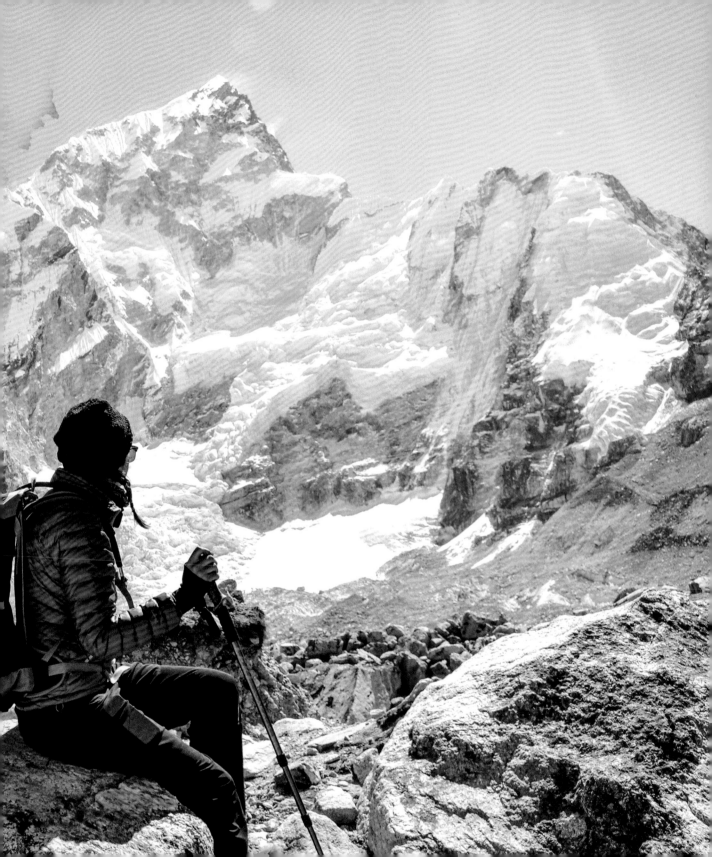

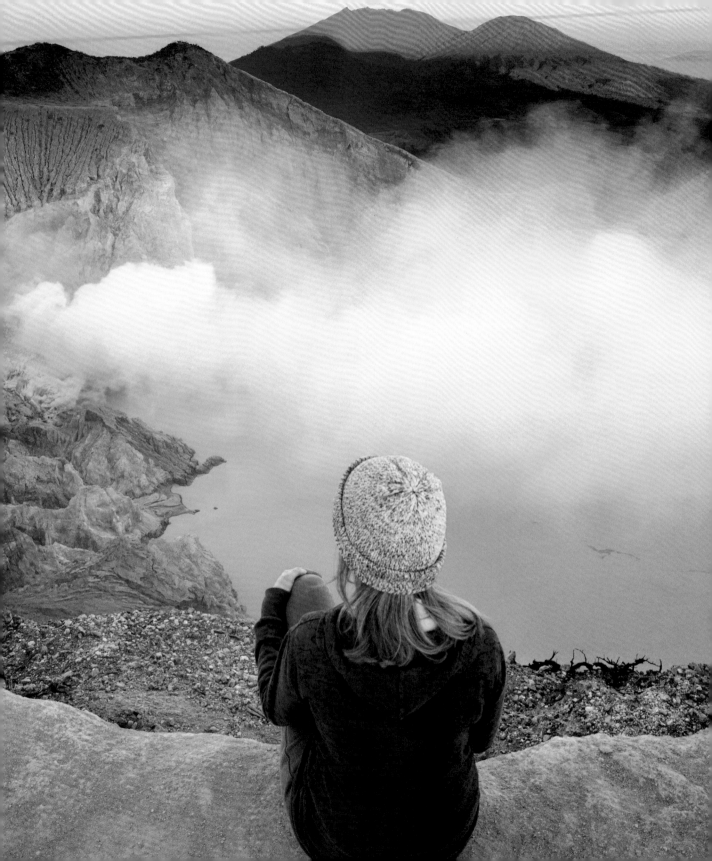

Java Island, Indonesia

NIKA PENSEK | @ANDSHEXPLORES

(Opposite) To get to this dramatic view requires a bit of effort. The two-hour hike to reach the rim of the crater is followed by a forty-five-minute hike down to the bank of the crater. But the journey is worth it because the Ijen Crater is the only place in the world (other than Iceland) where you can witness a sulfuric blue flame.

"When I was a little girl, I used to think that an apartment in a small town in Slovenia would be the only place that I could ever call home. Then I moved to the capital and made it my home. Shortly after, I studied in Paris and made it my home. I started traveling the world and now every hotel room feels like home. Hiking in the middle of nowhere in Indonesia feels like home. Even my most visited airport lounge in Bangkok feels like home. Travel has helped me appreciate that 'home' isn't necessarily a place, but a feeling."

Los Glaciares National Park, Argentina

BREE ROSE | @EYEOFSHE

(Right) The glacier can be viewed from a distant boardwalk, but making the hike is worth it. It's exhilarating and surreal to stand on the glacier. Be sure to wear sunglasses as the reflection off the ice can be very bright.

"As I stood there on Perito Moreno Glacier, I could hear the thundering sound of cracks breaking in the ice. Their resounding echoes still play in my head. Here, the elements were tumultuous, and so wild. I was surprised by the massiveness and length of the glacier and all of the jagged peaks created by wind and ice."

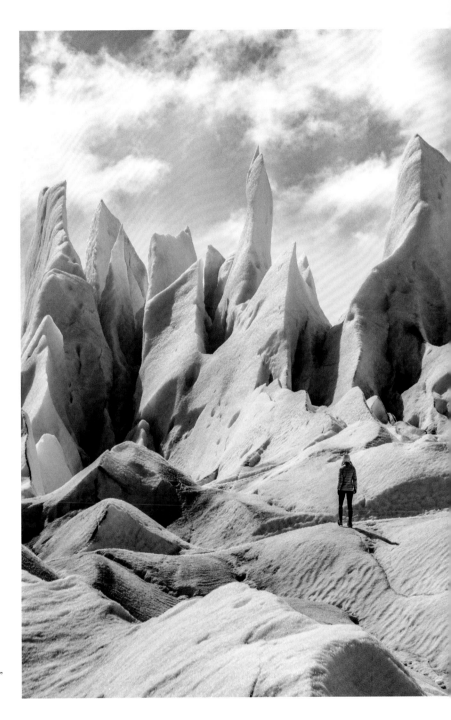

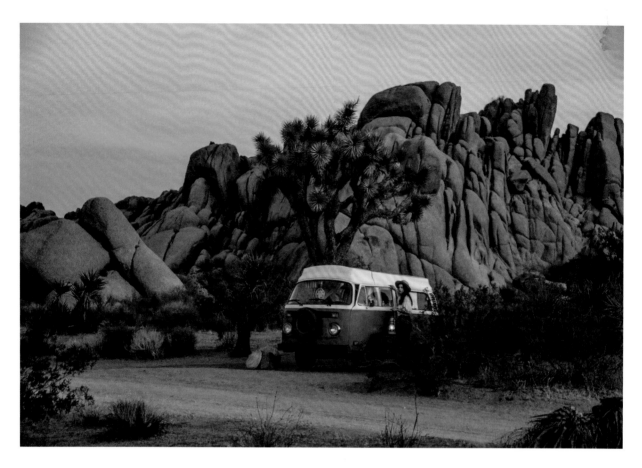

Joshua Tree National Park, California, United States

KIM FINLEY | @THENOMADICPEOPLE

(Above) "Calm, peaceful, and raw. Whether you are out exploring the vast landscape during a warm sunny day or looking up at a bright canopy of stars, the peace and tranquility evoked by the atmosphere of Joshua Tree National Park in the southeastern part of California is unparalleled. We drove to Joshua Tree National Park in our old blue 1978 VW bus as one of our many stops during our road trip along the West Coast."

DAME TRAVELER PRO TIP
Every year between March and May, the desert wildflowers bloom, putting on a brilliant display of colors like nowhere else.

Valensole, France

KRISTINA MAKEEVA | @HOBOPEEBA

(Opposite) The lavender fields of Provence have become quite famous for their sweeping purple hues and fragrant slopes of budding flowers. The Valensole Plateau is certainly the most photographed, especially near the Lavandes Angelvin shop along Route de Manosque. The fields can be quite overrun with tourists as the hours pass, so go earlier or later in the day.

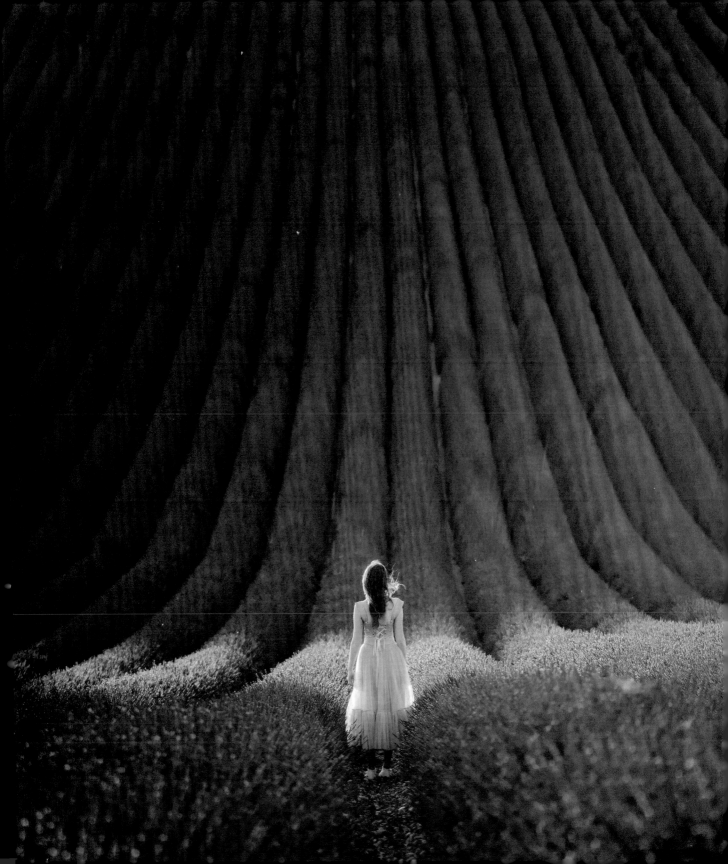

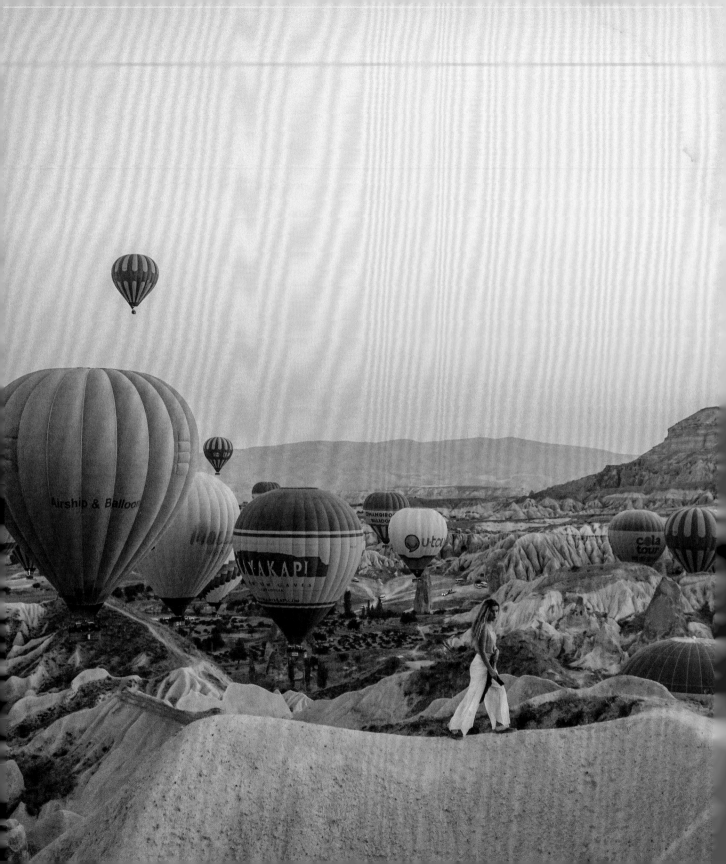

Cappadocia, Turkey

SARAH WYSEL | @SMWYSEL

(Opposite) Hot-air balloons, fairy chimneys, cave hotels, and a moonlike landscape . . . what more do you need to add Cappadocia to your bucket list? The best months to visit for pleasant weather, smaller crowds, and to increase your chances of catching a hot-air balloon ride are April, May, September, and October. If you opt to pass on the hot-air balloon ride, the view of them flying into the sky from Sunset Point in Göreme is still pretty spectacular. Other must-visit sights include Göreme Open Air Museum, Pasabagi Valley, and Uchisar Castle.

DAME TRAVELER PRO TIP

Stay at the Cappadocia Cave Suites Hotel and snag a room with a balcony overlooking the sunrise and balloons to enhance your experience even more.

Bagan, Myanmar

JESSICA LU | @JESSOMEWHERE

(Right) Old Bagan is an enchanting destination with over two thousand Buddhist temples dotting its lush land. Although walking its grounds is incredible, it's best explored by renting an electric bike (e-bike), which seats up to two people. Be mindful that it's prohibited to climb some of the temples ever since the 1975 earthquake that made many of the temples and stupas (dome-shaped shrines) quite fragile. Bagan is famous for hot-air balloon rides at sunrise, which gives travelers the unique opportunity to see the expansive grounds below.

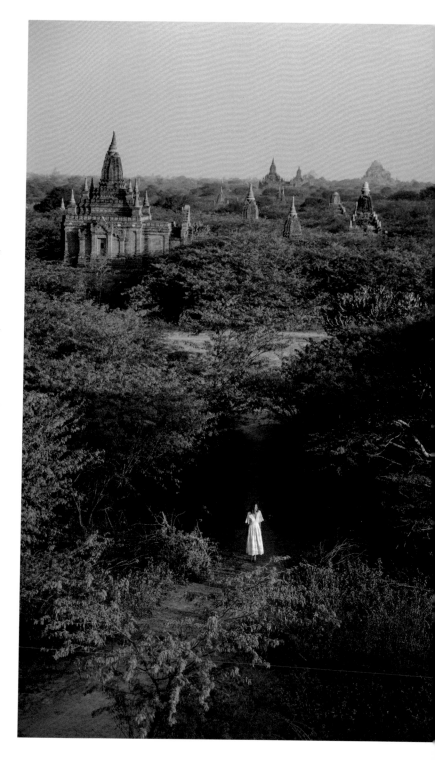

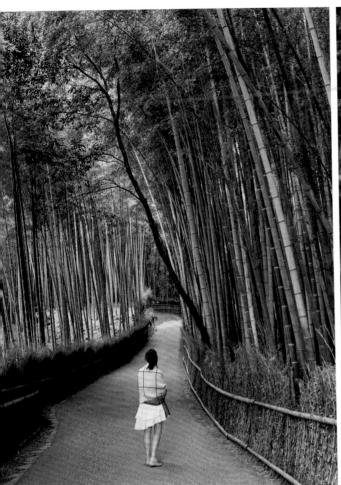

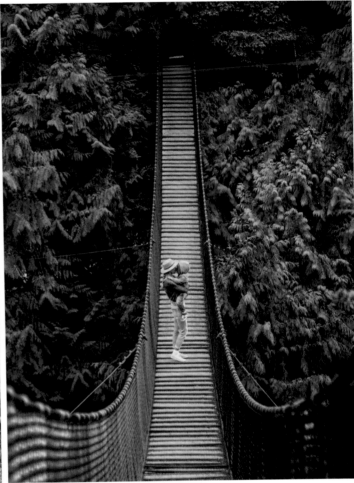

Kyoto, Japan

EMMA KATE CODRINGTON | @EMMAKATECO

Osaka is a great starting point for a variety of day trips. With cities such as Kyoto, Kobe, Nara, and Hiroshima about two hours away by train, seeing the best of Japan has never been easier. If your journey leads you to peaceful Kyoto, head to the Arashiyama Bamboo Grove to be surrounded by soaring bamboo forests that are perfectly arranged along the walking path.

"There's a word in German, *fernweh*, that there is no precise translation for in English. Loosely, it means 'farsickness'–or feeling homesick for a place you've never been–and I feel it perpetually."

Vancouver, British Columbia, Canada

GRACE KOELMA | @DARELIST.FAMILY

Vancouver is so much more than an up-and-coming city in the Pacific Northwest. Lovers of the outdoors will enjoy exploring its outlying forests and parks, filled with hiking paths and mountains within driving distance of the city. The Lynn Canyon Suspension Bridge offers beautiful views of the canyon's rapids and waterfalls. Go early and you just might have it all to yourself.

"Wouldn't it be strange to live in a house your whole life and only explore one room? The more I travel, the more I see that borders are merely bureaucratic legalities, and we often extend those into societal prejudices and fears about other cultures as a way to keep us 'in' and them 'out.'"

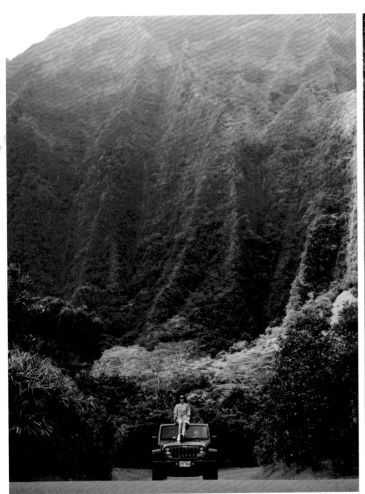

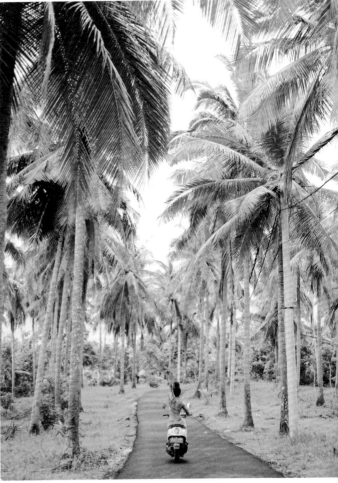

Oahu, Hawaii, United States

JENNY GAO | @OTHERWORLD.LY

"The entrance to the Ho'omaluhia Botanical Garden is framed by dramatic mountains, which disappear into low-lying clouds, causing a dynamic ever-changing landscape that is worth slowing down and taking it all in. To get here, take a scenic drive up the valleys of Oahu on the 61 from Waikiki."

Nusa Penida Island, Indonesia

MARY MOON | @MARYMOON_IPHOTO

As Bali's tourism has increased over the years, there are fewer and fewer islands that have preserved all their natural allure. Nusa Penida Island happens to be one of those places. It is the largest of Indonesia's eastern islands, and you can reach its shores via boat from Sanur, Kusamba, and Padangbai.

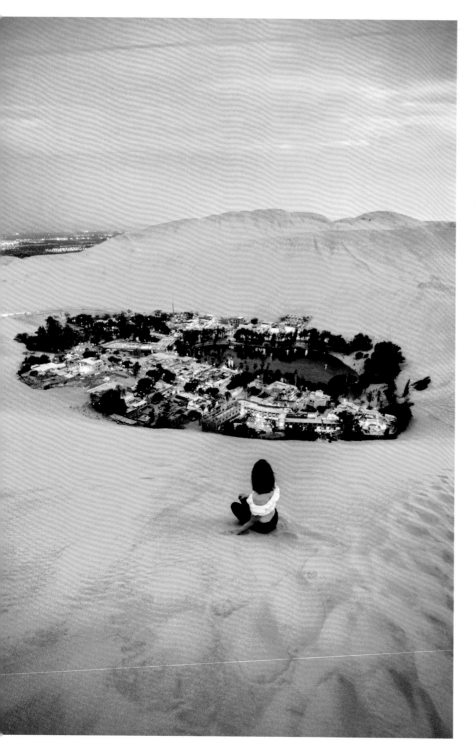

Ica, Peru

KIMBERLY HALVERSON | @STUDIOKH

(Left) Riding dune buggies and sandboarding are just some activities you can do outside of Huacachina. This desert oasis near Ica centers around its lagoon amidst the vast sands.

"It's normal to cry–that just means you're doing it right. It took me years of traveling to understand that it demands both courage and vulnerability to immerse yourself in another culture, especially as a woman, and especially alone. Be proud of the process! More than anything, it's made me realize that traveling is a mind-set and not simply a verb. It's enabled me to see my own home through a lens of adventure, understanding that distance isn't always necessary for curiosity to bloom."

Antelope Canyon, Arizona, United States

ASHLEY CROMPTON
@ASHLEY_CROMPTON

(Opposite) In today's modern world, traveling without digital conveniences may seem like a backward way of maneuvering around the globe. But with the continuing rise of digital detoxes, traveling disconnected is a true challenge for the mind. Our strong desire to constantly be entertained by our screens is a crutch worth overcoming. Reconnect with yourself and feel closer to nature and your surrounding environment, as when in the special presence of the Antelope Canyon.

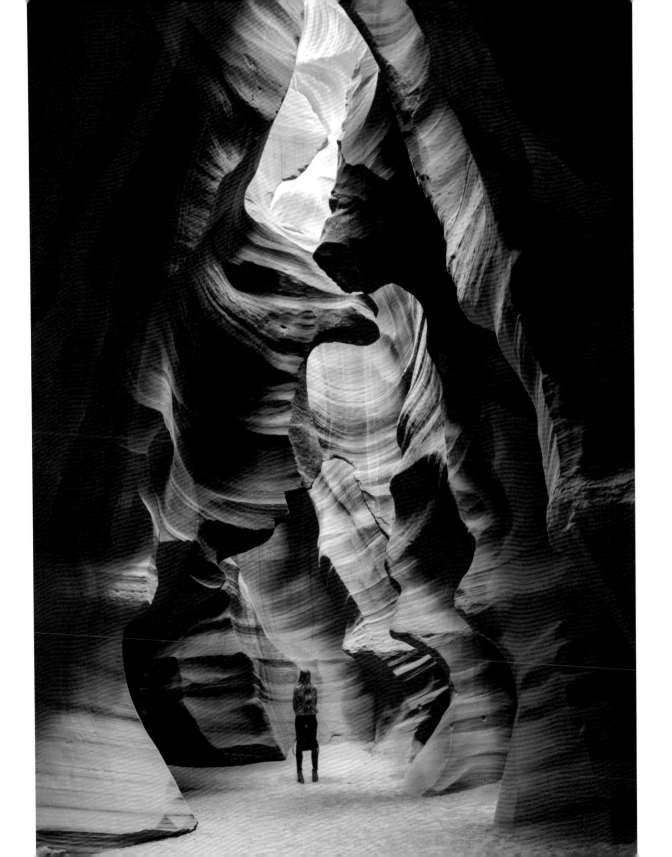

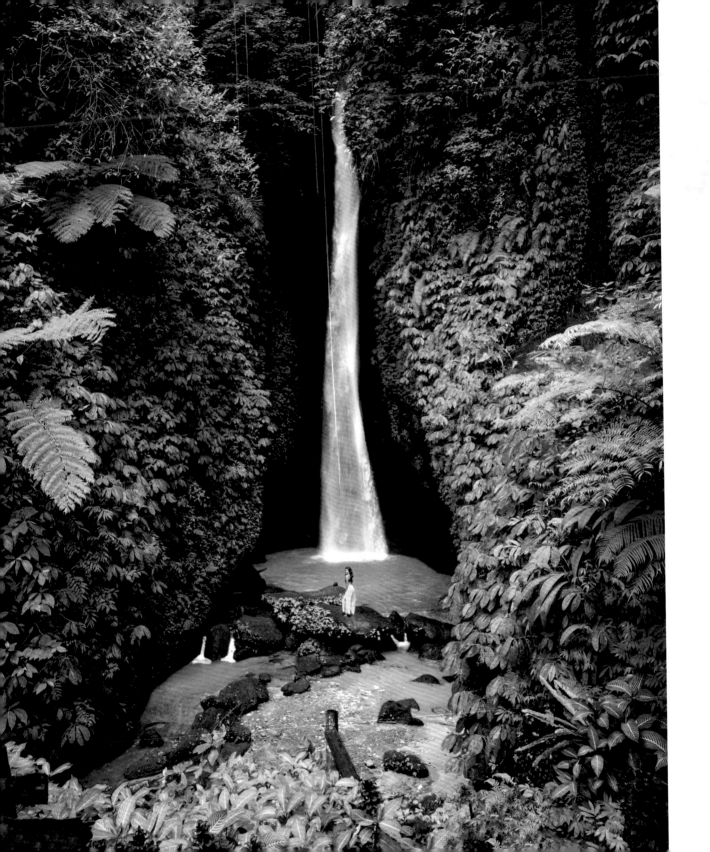

Bali, Indonesia

VANESSA HENNING | @__VAILY__

(Opposite) A masterpiece of nature, Leke Leke Waterfall's pure waters, surrounded by lush ferns and ivy, is located about an hour away from Ubud. While exploring the wild jungles of Indonesia, you'll find yourself in an almost completely secluded paradise. The walk to the falls is an easier trek than you may think, with bamboo bridges along the path that leads to its crashing waters.

Boseong-gun, South Korea

TARYN ASHLEIGH ELLIOTT @TEA_FOR_TARYN

(Right) "Having lived in Seoul for a year among the neon lights and dizzying skyscrapers, I was surprised by the sheer wonder of the natural beauty that Boseong had to offer. Nothing prepared me for the mesmerizing, rolling green hills that stretched as far as the eye could see. The culmination of humans and nature working in perfect harmony is truly a sight to behold. With its cool, fragrant air and not a skyscraper in sight, it is the ideal destination for those looking to escape the hustle and bustle of the capital."

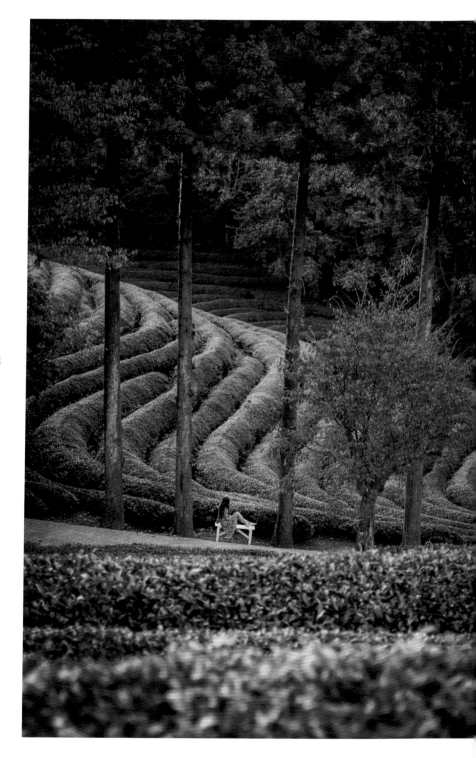

Saint-Jean-Cap-Ferrat, France

DIANA FUNG | @INBETWEENPICS

Villa Ephrussi de Rothschild has an exterior almost
as exuberantly beautiful as its interior. The Italian-style
palazzo facade is made up of four parts, all inspired
by various styles of European art, and its blooming
flowers in midsummer are not to be missed!

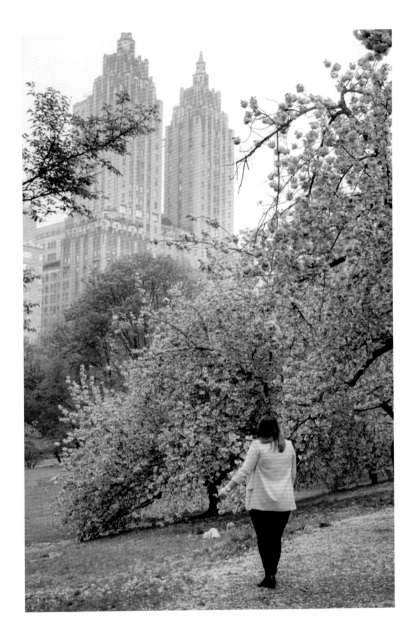

New York City, United States

CLAUDIA ZÚÑIGA | @MY.BUCKETLIST.JOURNEYS

Every spring, New Yorkers and tourists alike enjoy a very short window of time when the city is covered in vibrant cherry blossoms. One of the best places to witness the highest concentration of blooms is the Jacqueline Kennedy Onassis Reservoir, where the flowers perfectly frame the iconic San Remo towers in the distance.

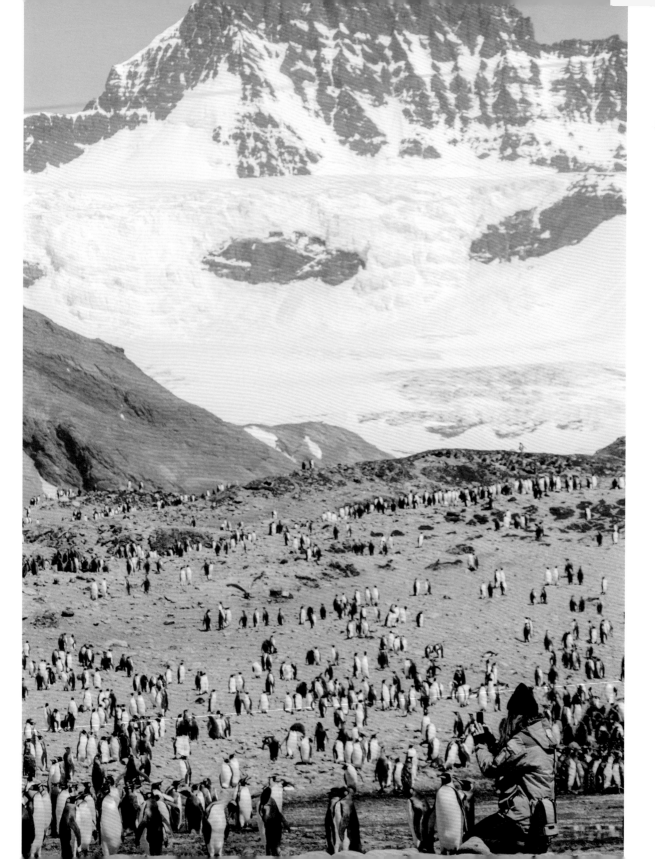

South Georgia, Antarctica

KYLIE TRISHA CHENN | @KYTRISHA

(Opposite) "Keep the Antarctic on your bucket list, even though it is far and can be expensive. It is well worth it! The sheer amount of wildlife on the Falkland Islands is incredible. Every day we saw so many penguins, seals, albatrosses, and whales. Don't miss South Georgia Island, located northeast of the Antarctic peninsula. There isn't another place in the world that has incredible wildlife populations on that scale. In general, the Antarctic is quite a safe place. . . . Just make sure to bring your motion sickness medication and be prepared for some big waves (it's an adventure)!"

Hallstatt, Austria

GRACE CHEN | @SKIPWITHGRACE

(Right) "Hallstatt has maintained its medieval charm, and the small village overlooks Lake Hallstatt. Spend a couple of days exploring the old alleyways and admire the historic Austrian architecture. I visited during the Christmas season, and the town was decorated with charming lights and a Christmas tree. Take a cable car up to the Skywalk viewpoint for sunrise views over Lake Hallstatt and then visit the salt mines afterward. Cars are not allowed inside the town, but hotels can arrange transport of your luggage."

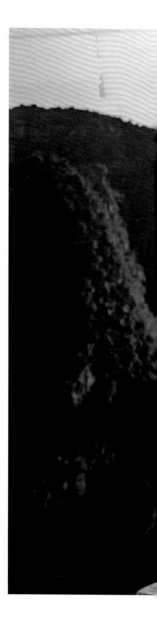

Monument Valley, Arizona, United States

HANNAH JANOE | @HANNAHJANOE

"The landscape in Monument Valley reminds you that nature has a way of carving out some of the most beautiful sights that humans aren't capable of building. The buttes that jet out of the valley floor, like many things in nature, have a way of reminding you how small you are."

DAME TRAVELER PRO TIP
Stay at the View Hotel
for exactly what it says:
the best views of the valley
right from your room.

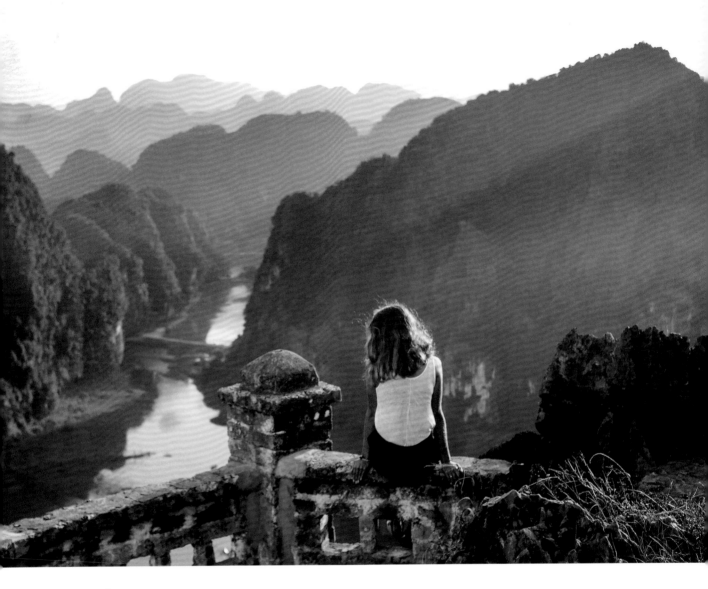

Ninh Bình, Vietnam

DIANA FAJARDO-WLOCH | @LOSTITALIANOS

The Hang Mua Caves are beautiful during golden hour. To get a more in-depth experience of exploring the country, look into renting a scooter to see its smaller towns and epic vistas.

"Travel is the best method I know for slowing down time. I honestly feel that it has added years to my life. When I am back home, working at the office, caught up in my cozy routine, all days look similar and they feel infinite. But then looking back, I wonder where the months went. When I travel, it is exactly the opposite. Every day, I get to see, feel, experience something for the first time . . . so days go by really quickly. But then looking back, I am transported back to those moments immediately."

Ravello, Italy

CARLY NOGAWSKI | @LIGHT.TRAVELS

(Right) When visiting the Amalfi Coast, many travelers overlook the town of Ravello since it's a bit hidden in the mountaintop of the coast as opposed to right on the beachfront, like Positano and Amalfi. This hidden gem is covered in gardens, and boasts some of the most beautiful views of the sea. Spend the afternoon getting lost in both the Villa Rufolo and Villa Cimbrone Gardens. And then have one of the best pizzas in all of the Campania region at Mimi.

London, England

OLGA CHAGUNAVA | @LIOLALIOLA

(Opposite) Should you find yourself in London on a rainy day (chances are high!), head over to Kew Gardens' Palm House, which is home to over fifty-thousand living plants and is a UNESCO World Heritage Site. As the world's largest Victorian glasshouse, filled with plants from all over the world's temperate areas—from Africa, New Zealand, Asia, Pacific Islands, and more—this conservatory is the perfect stop to take in the fresh air between tube stations and afternoon tea.

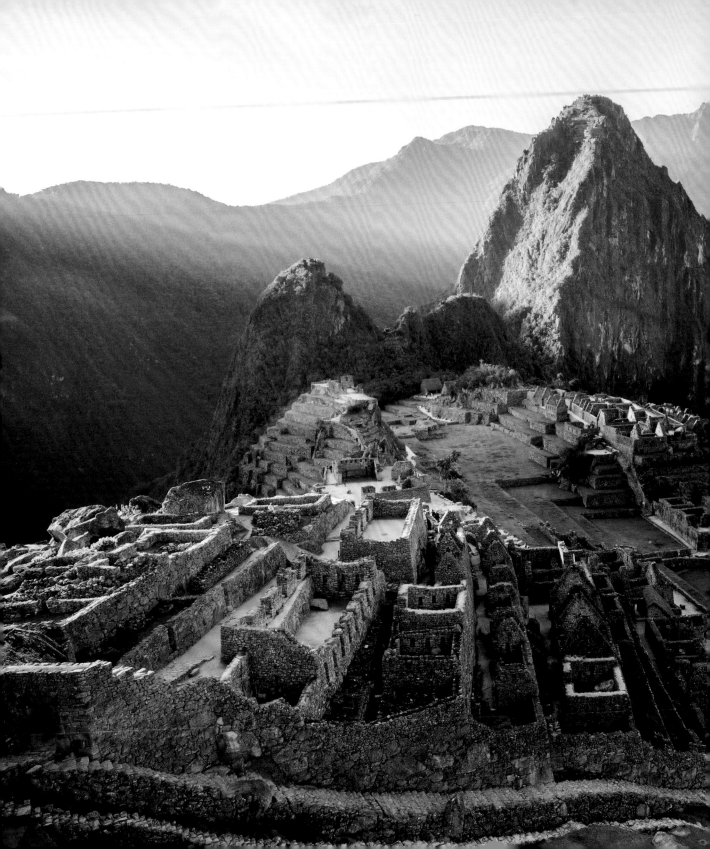

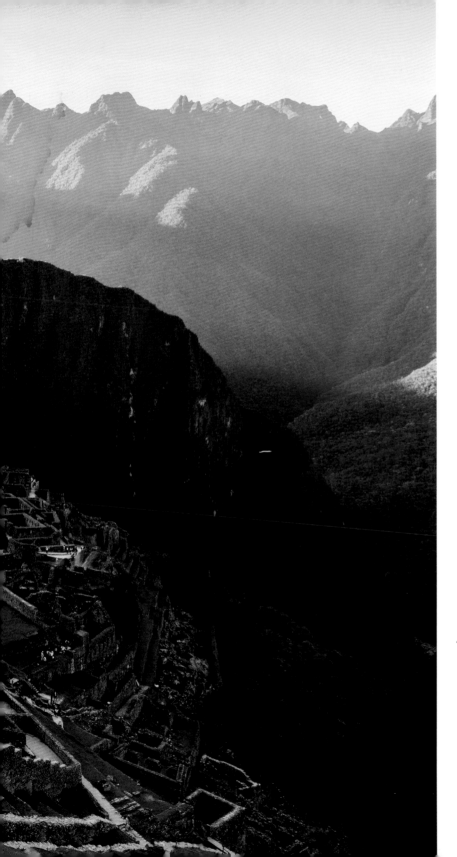

Machu Picchu, Peru
MELISSA FINDLEY
@MELISSAFINDLEY

"I live a life on the road, a life that encompasses travel and exploring new places with my camera in hand. As a professional photographer, I have an insatiable urge to showcase the beautiful diversity of our planet. I love using photography to connect others with the natural world and find the peace that comes from spending time in the wilderness."

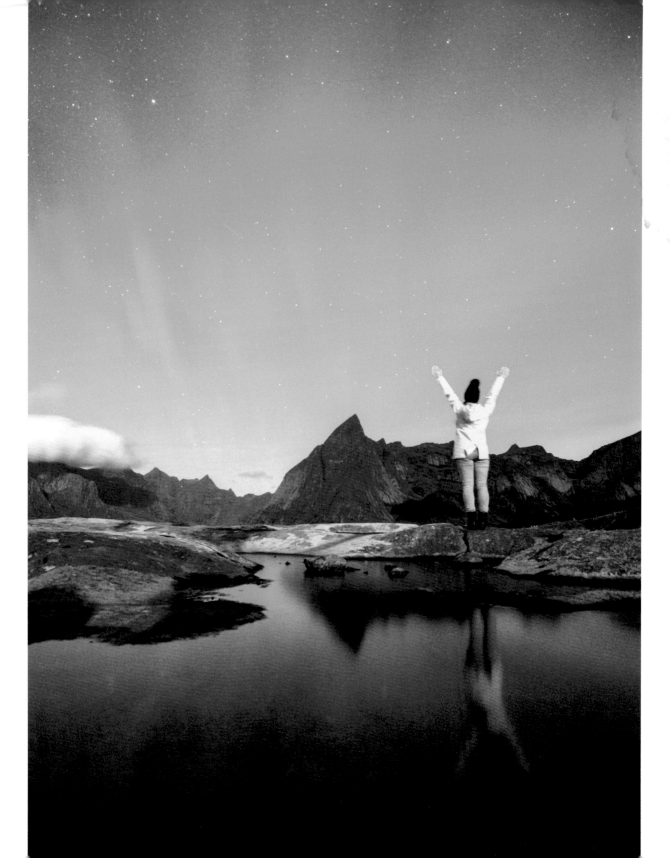

Hamnoy, Lofoten Islands, Norway

BELLA BUCCHIOTTI
@BELLABUCCHIOTTI

(Opposite) Although many travelers plan their entire Scandinavian itinerary around seeing the northern lights, it's actually quite tricky to track down. The Arctic Circle starting from Oslo or Bergen is quite the journey at over a sixteen-hour drive, but you're most likely to see the dancing lights if you go as far north as you can. The best months to see the aurora borealis are in late September, October, February, and March. And remember, the northern lights certainly don't run on a regular schedule, so be sure to schedule extra time for yourself should the lights not appear on your first few nights. Patience is a virtue, especially for this wondrous occurrence!

Mason, Ohio, United States

ALISON PETERS | **@PETERSAE0911**

(Right) The sunflower fields at Cottell Park just outside of Cincinnati, Ohio, are filled with giant blooms that turn their faces as the sun goes from east to west in the sky.

"My best advice to a woman about to take her first trip is not to lean too much on Google Maps to get around. Pretend it doesn't exist. Get to know your new, temporary home by studying the area beforehand. That way, when you arrive, you already have a sense of place and direction. To get the most of your travels, and to keep your head out of your phone, let yourself get a little lost, within reason. You'll absorb more of the destination and feel more like a local this way."

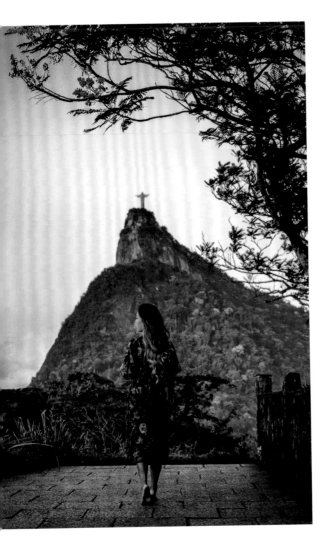

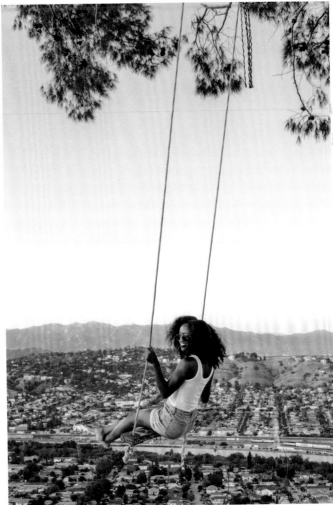

Rio de Janeiro, Brazil

KRYSTINE SAZALI | **@KRYSTINESC**

"Rio is a very high-energy city, and finding somewhere calm to enjoy the sunrise was a nice change of pace. The Mirante Dona Marta viewpoint is the perfect spot to view the best of Rio de Janeiro. You have panoramic views of the city right in front of you. In the northeast you will see the central city, to the east you'll see Sugarloaf Mountain (perfect for sunrise), to the south you'll see Copacabana Beach, Ipanema, and Two Brothers Mountain, and to the west you'll see the beautiful Christ the Redeemer."

Los Angeles, California, United States

FRANCESCA MURRAY | **@ONEGRLONEWORLD**

"The Secret Swing in Elysian Park is a great place to scope out a scenic view of Los Angeles and the surrounding mountains. Avoid going alone and try to leave before sundown because the park has some sketchy characters at night. Park hours are generally from 8 a.m. to 9 p.m., but the sun sets much earlier in the winter. The hike is only about five minutes long, but it's a steep and slippery climb. Bring a sturdy pair of sneakers. Walking barefoot once you reach the swing is also a risk as there are fire ants roaming about."

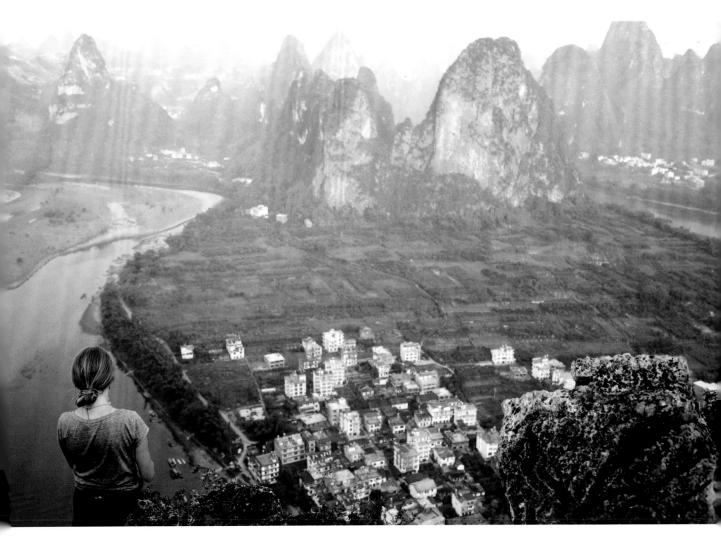

Yangshuo, Guangxi, China

CHRISTINA HOLLAND | @CHRISTINAEMHOLLAND

"Guangxi is a place depicted time and time again through traditional paintings and modern photographs. The karst mountains jutting out of the Li River are even plastered on the back of China's twenty-yuan note, convincing people of the region's familiarity even if they have yet to actually visit. That being said, nothing can prepare you for what it feels like to personally experience the destination, any destination, in all of its glory. Everything becomes distorted–the sights, the sounds, the smells–through your own, unique lens, creating an element of surprise despite how many times you may have heard or read about a place. A secret is shared between you, the traveler, and it, the place traveled to–a place that other people will undoubtedly see and experience, but one that no one will get to know in quite the same way you do."

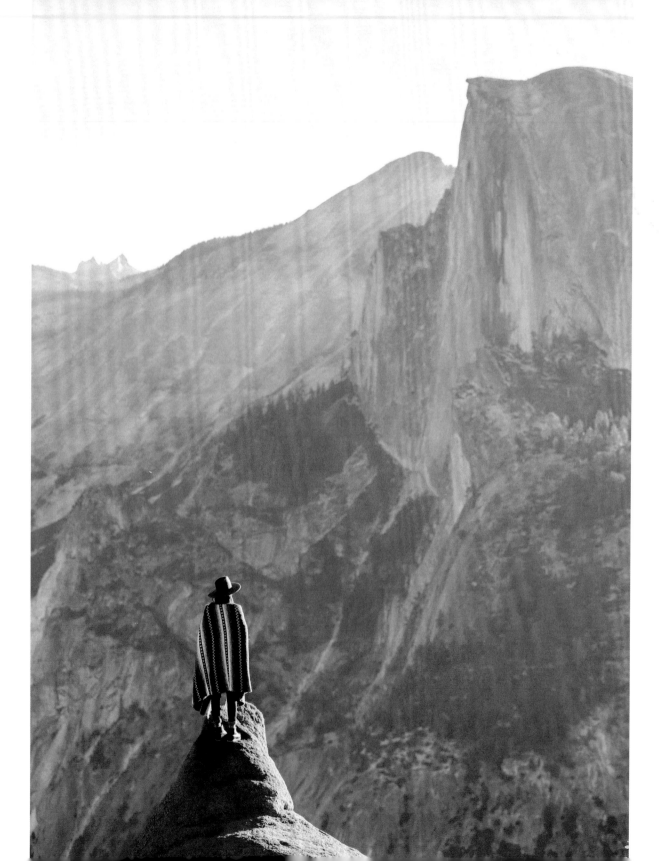

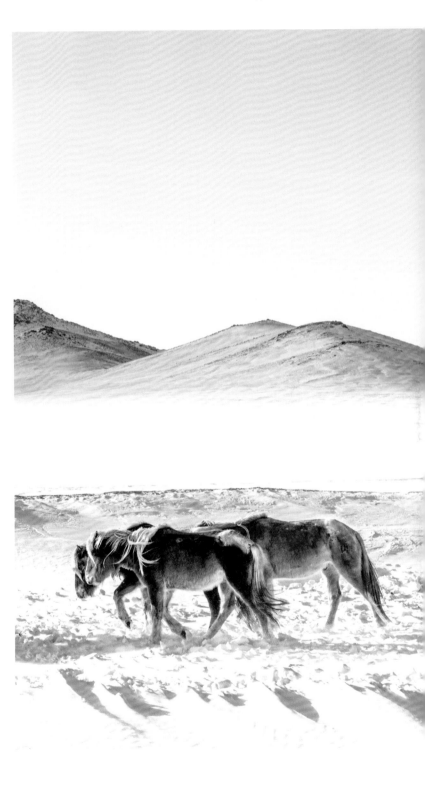

Yosemite National Park, California, United States

CANDIDA WOHLGEMUTH | @CANDIDA

(Opposite) Yosemite National Park with a view of Half Dome.

"I grew up with a mother that dreamed of traveling the world as a little girl. She grew up in Guatemala and didn't get the chance to when she was young, but once she was married and had four kids, she made it her mission to have her children live the dream she always wanted. She took us everywhere: Egypt, Israel, China, Turkey, Greece, and Guatemala to name a few. When you travel, the purpose of the day is to just live it. This is the purpose of all our days, but travel really brings this to the forefront."

Lake Khuvsgul, Mongolia

YULIA DENISYUK | @INSEARCHOFPERFECT

(Right) "I was on assignment to Mongolia's northern region to capture the beauty of the frozen Lake Khuvsgul. Leaving the capital, Ulaanbaatar, behind, we set our course north toward the lake, passing otherworldly steppe landscapes and scattered herds of horses along the way. It was early March, and the temperatures were unforgiving. With the winds blowing at forty miles per hour, my eyes instantly watered and the tears froze as my fingers refused to move swiftly and press the right button. Capturing this moment was a challenge, albeit a satisfying one!"

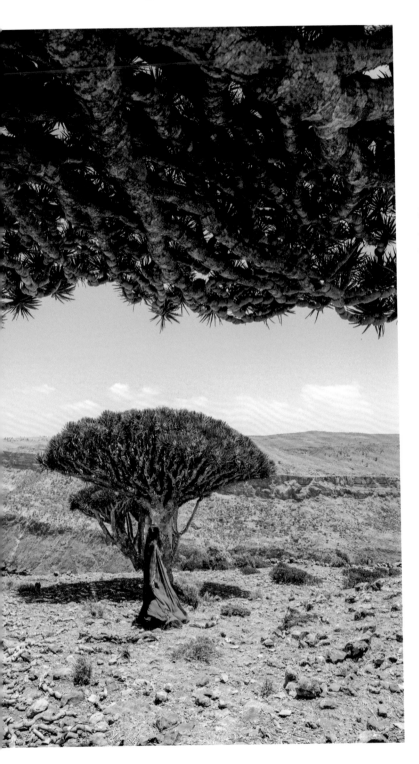

Socotra Island, Yemen

AMINA HAFIED | **@2ALGERIANSTRAVEL**

(Left) "The secret that makes Socotra a paradise is its unique environment and the culture of its local people. My days were a full immersion in nature, sea, and mountains. I could have seriously spent my entire trip just admiring the dragon trees, as seen from the Diksam Plateau, which don't grow anywhere else in the world. Socotra is truly a destination unlike any other. . . . It felt almost as if I was on another planet altogether. It's just that bizarre, that stunning, that unbelievably remote of a destination."

Bay of Fires, Tasmania, Australia

ELLIE GREEN | **@THEGINGERWANDERLUST**

(Opposite) The Bay of Fires in Tasmania is a windswept, unique location best known for its orange-covered rocks. To find this hidden (yet very picturesque) spot, head to the Skeleton Bay Reserve, where you will find this unique tree growing from the lichen-covered rocks!

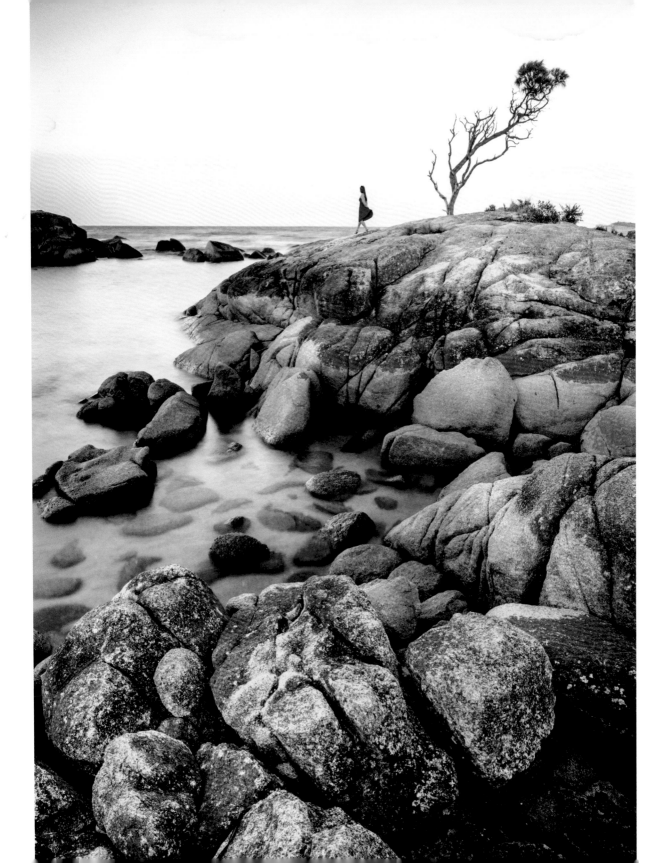

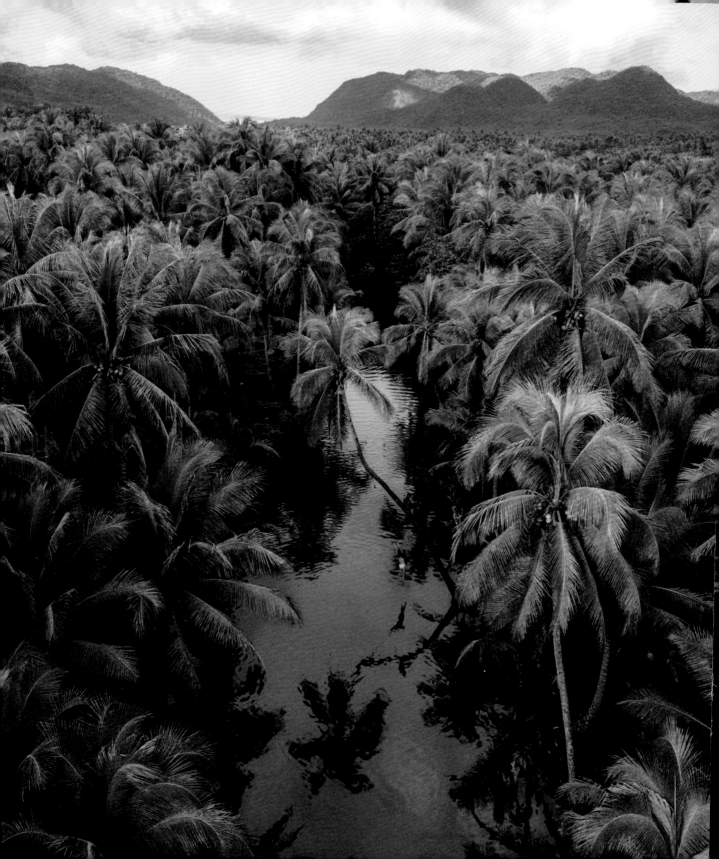

Siargao Island, Philippines

JESSICA JOHNSTON | @BACKPACKWITHME

(Opposite) "General Luna is quite developed with tons of chic cafés and restaurants catering to foreigners, but once you venture outside the area, you see the undeveloped side of the island . . . which is another level of beauty. You can see natural rock pools that are a rich turquoise color, palm tree forests as far as the eye can see, hidden lagoons only accessible by boat, and sunsets that are beyond words. This untouched side of the island gives you the raw Philippines experience."

DAME TRAVELER PRO TIP

Join a boat tour over to the Guyam, Daku, and Naked Islands. Not only are they breathtaking, but it's also a great way to meet new people if you're traveling solo.

Lago di Sorapis, Italy

ANDREA AFFINATI | @ANDREA_AFFINATI

(Right) "Lake Sorapis is hidden at almost two thousand meters high, completely enclosed by mountains in northern Italy. Therefore, it can only be reached by hiking. The recommended trail begins at Passo Tre Croci, and it took me almost three hours to get to the top. Needless to say, I'm not a professional hiker, but I'm comfortable with a challenge and it was incredibly nice to disconnect for a moment and get in touch with nature!"

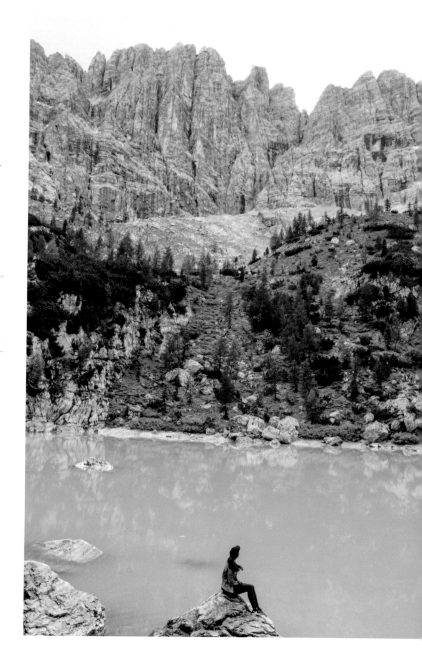

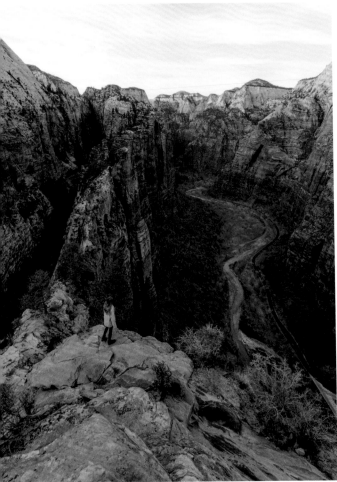

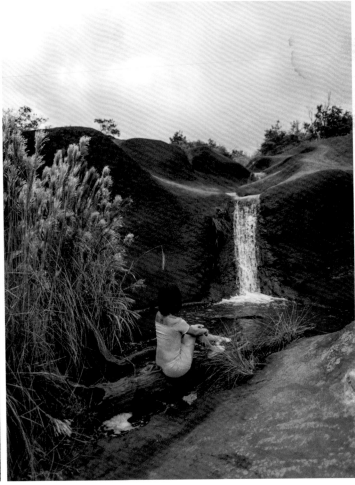

Zion National Park, Utah, United States

KELSEY JOHNSON | @HEYKELSEYJ

This 360-degree view of the incredible Zion Canyon at nearly six thousand feet shows its striking landscape of serrated mountain rocks and will leave you awed and inspired if you decide to make the climb to the top.

DAME TRAVELER PRO TIP
Beware of visiting during the months of July through September as it is flash flood season.

Kauai, Hawaii, United States

LISA LINH | @BYLISALINH

Waimea Canyon State Park's red sand landscape is a rare treat. Very few places in the world feature such a color! A few miles from this location is Waimea Canyon, "the Grand Canyon of the Pacific." Be sure to research its many vantage points and vistas to catch a glimpse.

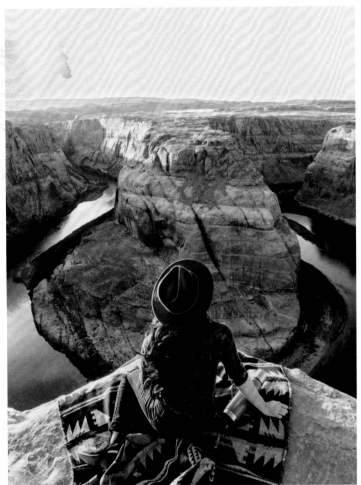

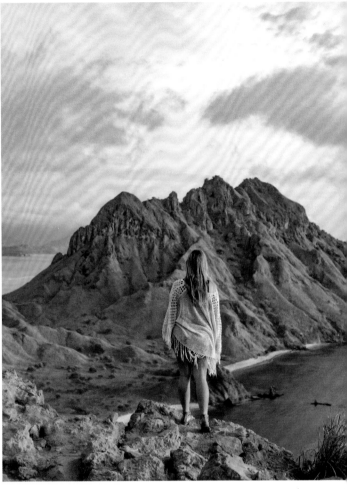

Horseshoe Bend, Arizona, United States

ANNA NGUYEN | @THETRAVELLINGYPSY

The dramatic curvature of the Colorado River at Arizona's Horseshoe Bend is certainly one of the United States' most remarkable natural sights to see, with its red rock landscape juxtaposed with the thousand-foot pedestal it surrounds. Careful though—there aren't any supports or railings for explorers to depend on when taking this one in. So, be cautious at the edge of its steep cliffs!

Padar Island, Indonesia

AMBER JOHNSON | @LOHA.AMBER

Padar is home to the mysterious Komodo dragons, many species of sharks, whales, and green turtles. Situated in the middle of Komodo and Rinca Islands, Padar Island is the largest island of Komodo National Park. Its three bays are famously each a different color: pink, white, and black sand. The hike to the peak of Padar is a quick, yet challenging trek (much of it is uphill and steep) . . . but that shouldn't stop you from seeing this *Jurassic Park*-esque scene in all its glory.

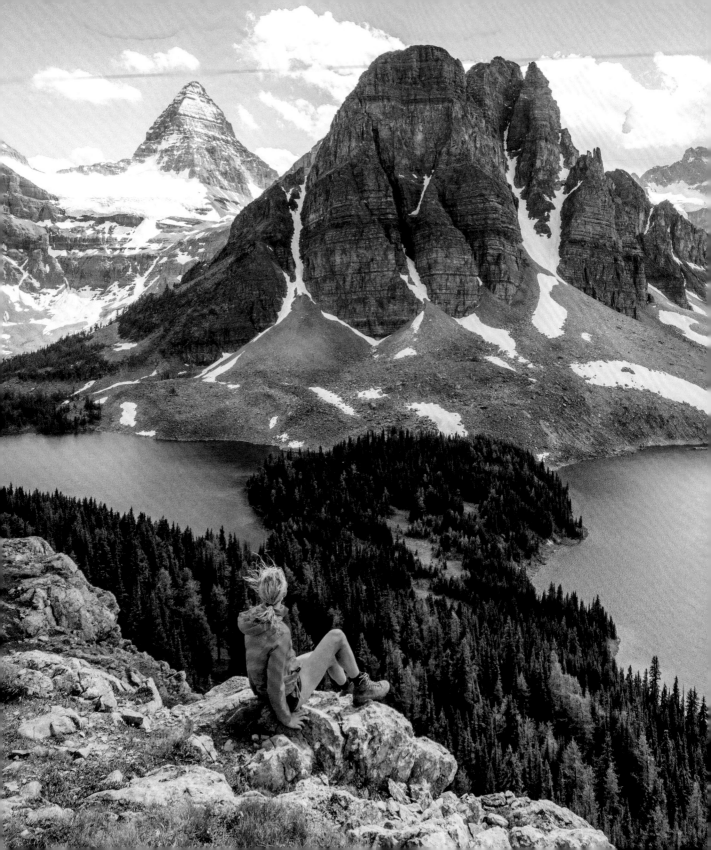

Mount Assiniboine
Provincial Park,
British Columbia, Canada

ANANYA RAY | @ANANYA.RAY

(Opposite) "We hiked over sixteen miles
to reach our campsite in the Mount
Assiniboine Provincial Park, where we found
ourselves at the base of its epic mountain.
Called the 'Matterhorn of Canada,' Mount
Assiniboine is located on the Great Divide,
the border between British Columbia and
Alberta in the Canadian Rockies."

Edmonton, Alberta, Canada

CORRINE THIESSEN | @CORRINE_T

(Right) Alberta's Ice Castles park is actually a
human-made attraction also located in six other
cities of North America. Filled with fountains, lit
sculptures, thrones, and tunnels, the experience of
weaving through the icicle-laden structure is wild.

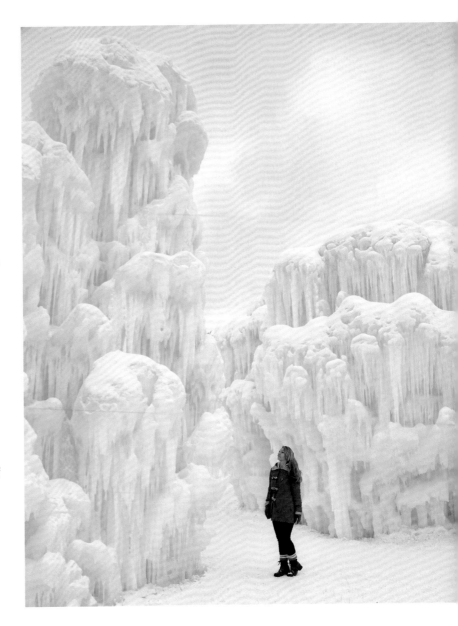

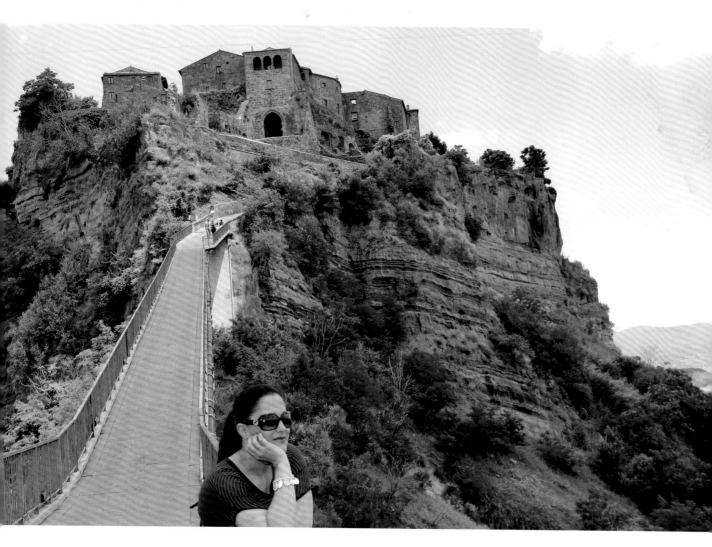

Civita di Bagnoregio, Italy

GG BENITEZ | @GGBENITEZPRINC

The town of Civita di Bagnoregio is just an hour's drive north of Rome and can only be reached by walking along a narrow pedestrian passageway.

"I wasn't able to go on my school's class trip to Italy, but I vowed to make it to the country one day. I went through many personal struggles until I finally reached a place in my midtwenties where I could afford such a trip. I had an Italian American best friend who was from Sicily, and I persuaded her to embark upon an exploration of Italy, including visiting her relatives. Those were some of the most impactful days of my life and awoke inside of me an insatiable desire to go back time and time again to Italy. Every time I do, it's a completely different experience."

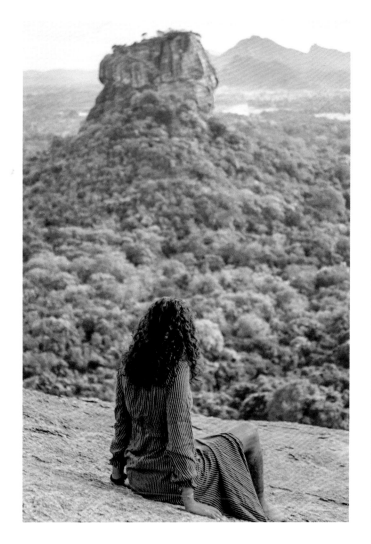

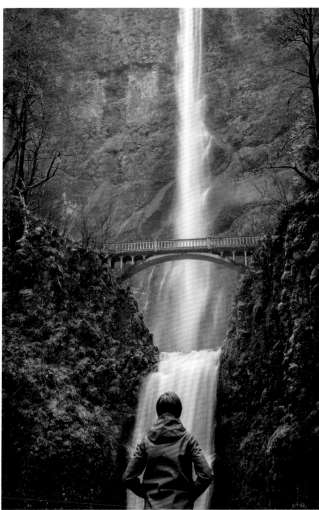

Sigiriya, Sri Lanka
GIULIA DE JESUS | @_DGTRAVEL_

This enormous, ancient Lion Rock fortress features a palace
and a lion-shaped gateway at the top . . . but to reach this
world wonder, you'll have to climb over 1,200 steps! The trek
is well worth it as the views are stunning, and you'll come
across ancient Sigiriya frescoes along the way.

DAME TRAVELER PRO TIP
To catch this view of Sigiriya Rock, hike up
to the Pidurangala Rock as an alternative.

Multnomah Falls, Oregon, United States
MELISSA D. JONES | @ROUXROAMER

"A short drive outside of Portland, Oregon, Multnomah
Falls is quite a sight to behold with its iconic bridge.
This location can be extremely busy in the summer
and a solitary, meditative experience in the winter.
I recommend that folks take the time to do the entire
hike. It's steep but there are some other waterfall
gems waiting to be discovered with just a little work."

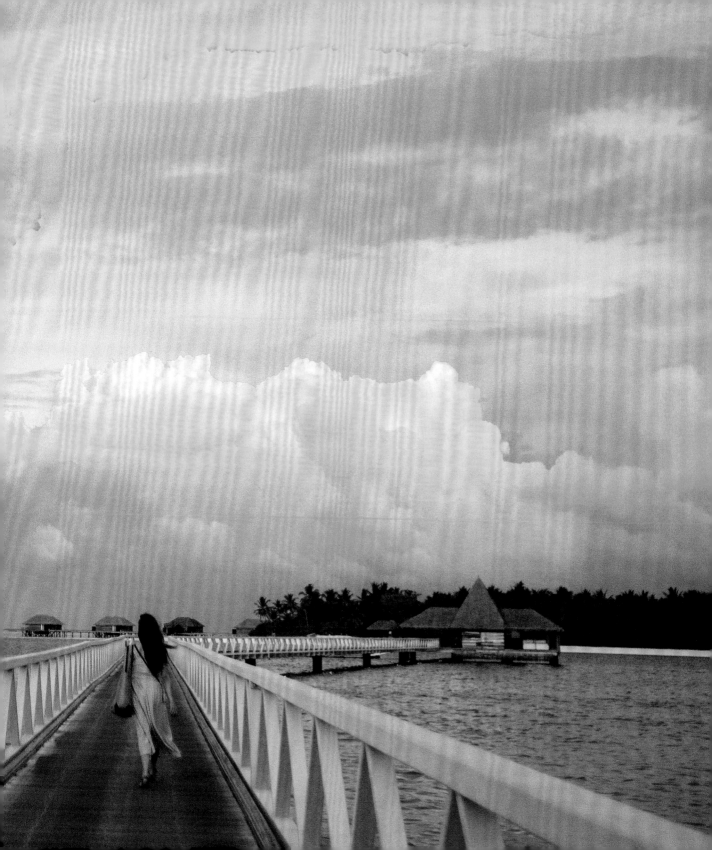

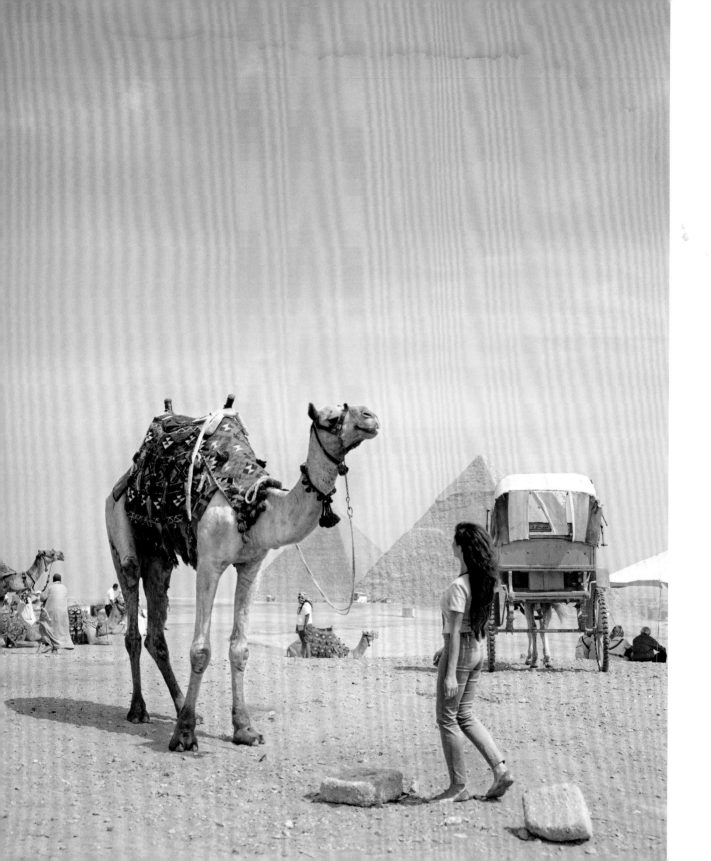

acknowledgments

I would have never gotten this far in my life without the supportive people right there by my side who have believed in me and who have helped me get to where I am today. This book would not be complete without sincere gratitude to each and every one of you who played a role, no matter how big or small. I wish I had room to list every single person's name, but you know who you are and I appreciate you!

To Jesus Christ my Lord for holding my hand from the day I took my first breath on earth to the days when I felt your presence as I cried in an empty church to the happiest days of my life. Thank You for being my main source of hope and strength. I am forever grateful and in awe of every blessing You've given me.

To the editor-in-chief of Dame Traveler, Laura Jean, for your positive spirit, loyalty, and sincere belief in the Dame Traveler movement and for all of your hard work in helping me bring this project to life. I'm not sure I could have pulled it off without you!

To my friends and family for your unconditional love, support, and patience with my decision to live an unordinary life and for accepting it. Mom, Dad, Sasha, Robert, Johnny, I love and appreciate you from my whole heart.

To my aunts Nadwa and Najla, I am thankful to have grown up around such strong examples of women who live life on your own terms, which inspired me to do the same with mine. You played a huge role in inspiring me to tap into my own courage within, and I might never have moved away or traveled the world if it weren't for you two.

To my Persian cat, Buddy, I would have not survived the long days and nights in front of the laptop without your cuddles and purrs!

To the contributors of this book, thank you for agreeing to be included in this special project and for trusting and supporting my vision for it. Your stunning photography and beautiful words will live on in the eyes of readers for years to come, and I'm honored to feature your work in a tangible form outside of the digital world.

To my fellow women and to my Dame Traveler community, thank you for resonating with my message from day one. Dame Traveler was inspired by you, and it would not exist if it weren't for you, so it will always exist to celebrate you and all of the incredible things you do.

And last but definitely not least, to the wonderful team that made this book possible: my literary agent, Myrsini Stephanides, executive editor Lisa Westmoreland, creative director Kelly Booth, VP of marketing Windy Dorresteyn, editor Shaida Boroumand, and production manager Serena Sigona. Thank you for this incredible opportunity and for helping me bring this longtime dream of mine to life.

Thank you.

PREVIOUS SPREAD

Conrad Maldives Rangali Island

NASTASIA YAKOUB
@NASTASIASPASSPORT WITH
SARAH NATASHA HOROWITZ
@SARAHNATASHA

OPPOSITE

Cairo, Egypt

NASTASIA YAKOUB
@NASTASIASPASSPORT

contributors

Agata Wagemaker
Aleksandra Pankratova
Alexandra Reynolds
Alexandra Rozhkova
Alisa Anton
Alison Peters
Amber Johnson
Amelie Giada
Amina Hafied
Ana Korolija
Ana Linares
Ananya Ray
Anastasia Ezhova
Anastasia Pittini
Andrea Affinati
Angela Giakas
Anna Galu
Anna Hammerschmidt
Anna Nguyen
Anne Cui
Annette Richmond
Айгуль Вишня
Ashley Hutchinson
Ashley Crompton
Ayda Izadpanah
Beca Lily
Bella Bucchiotti
Bettina Halas
Bianca Karina
Bold Bliss
Bree Rose
Callie Thorpe
Camilla Mount
Camilla Toivonen
Candida Wohlgemuth
Carla Vianna
Carley Rudd
Carly Nogawski
Carmen Huter
Caroline Muller
Cassandra Santoro
Chanel Cartell

Chelsie Kumar
Chiara Barrasso
Chloé Crane-Leroux
Christina Holland
Ciara Johnson
Claudia Zúñiga
Connie Cao
Corrine Thiessen
Cynthia Andrew
Cynthia Corona
Dana Givens
Danielle Greentree
Daniela Amyot
Davina Tan
Devon Costantine
Diala Shuhaiber
Diana De Lorenzi
Diana Fajardo-Wloch
Diana Fung
Diana Khussainova
Diana Millos
Dulce Ruby
Elke Frotscher
Ellie Green
Emma Kate Codrington
Emma Kulkarni
Erin Sullivan
Fanny Texier
Farrah Zak
Faten Hamouda
Federica Di Nardo
Francesca Murray
Genith Fuentes
G G Benitez
Giulia De Jesus
Grace Chen
Grace Koelma
Grasella Dayot
Haley Plotkin
HaNa Yu
Hannah Janoe
Helena Bradbury

Helene Sula
Hermon and Heroda Berhane
Huda Bin Redha
Ivette Leon
Jana Bogena
Jane Ko
Jelena Bogicevic
Jenny Checo
Jenny Feng
Jenny Gao
Jessica Cobbs
Jessica Johnston
Jessica Lu
Jessica Meyrick
Jessica Simonsen
Jessica Wright
Jiayi Wang
Jo Hyun
Joann Pai
Johanna Häusler
Kael Rebick
Katerina Padron
Katie Giorgadze
Katie Ritzi
Kelly Neill
Kelsey Dennison
Kelsey Hamel
Kelsey Johnson
Kim Finley
Kim Van Weering
Kimberly Halverson
Kristina Makeeva
Krystine Sazali
Kylie Trisha Chenn
Lara Kamnik
Laura Fleischer
Laura Gingerich
Laura Grier
Leyla Kazim
Leyla Tran
Lindsay Silberman
Linh Tran

Lisa Linh
Lisa Michele Burns
Liza Herlands
Lola Hubner
Luciana Terroni
Maartje Hensen
Marcy Yu
Margarita Samsonova
Mari Bareksten
Marie Stokka
Marijke Jurriaans
Marina Comes
Marissa Anwar
Martyna Damska-Grzybowska
Mary Moon
May Leong
Meagan Lindsey Bourne
Melissa D. Jones
Melissa Findley
Melissa Male
Melissa Teng
Mendy Waits
Michelle Catherine
Michelle Juergen
Michelle Teuscher
Minahil Bukhari
Molly Malott
Nabina Nazar
Natalie Raymond
Natasha Holland
Nathalie Aron
Nika Pensek
Nikki Lazaran
Noella Ehikwe
Olga Chagunava
Onyi Moss
Ophélie Moris
Paula Hernandez
Pippa Marffy
Polina Burashnikova
Quinn Luu
Radha Engling

Ray Yun Gou
Rosanna Cordoba Hutchinson
Roxanne Vitnell
Roxanne Weijer
Sabina Khilnani
Samantha O'Brochta
Sara Melotti
Sarah Wysel
Sarah Natasha Horowitz
Sasha Shaffou
Selena Taylor
Shade Bakare
Shaikha Alkhayyal
Sharon Yap
Sheri Matthews
Sierra Dehmler
Sindhya Shoptaugh
Siobhan Reid
Sissi Johnson
Soha Zia
Stefanie Wich-Herrlein
Stella Yan
Stephanie Buelna
Stephanie Sterjovski Jolly
Sukainaw Rajabali
Tanya Shami
Tara Michelle Brose
Taryn Ashleigh Elliott
Taylor O'Sullivan
Teresa Miranda
Tezza Barton
Tiffany Wynns
Tine Petterson
Ty Allen
Vanessa Henning
Viktoria Steinhaus
Willabelle Ong
Yulia Denisyuk

Additional Photo Credits: Paul Hughson/Magasinet Reiselyst (page 68), Ryan Bowen (page 77), Brook Sabin (page 79), Theis Olsen (page 86), Stevo Dirnberger/How Far From Home (page 103), Jens Herrmann/@envy4lens (page 142), Colin Rupp (page 179), and Bernardo Salce (page 195).

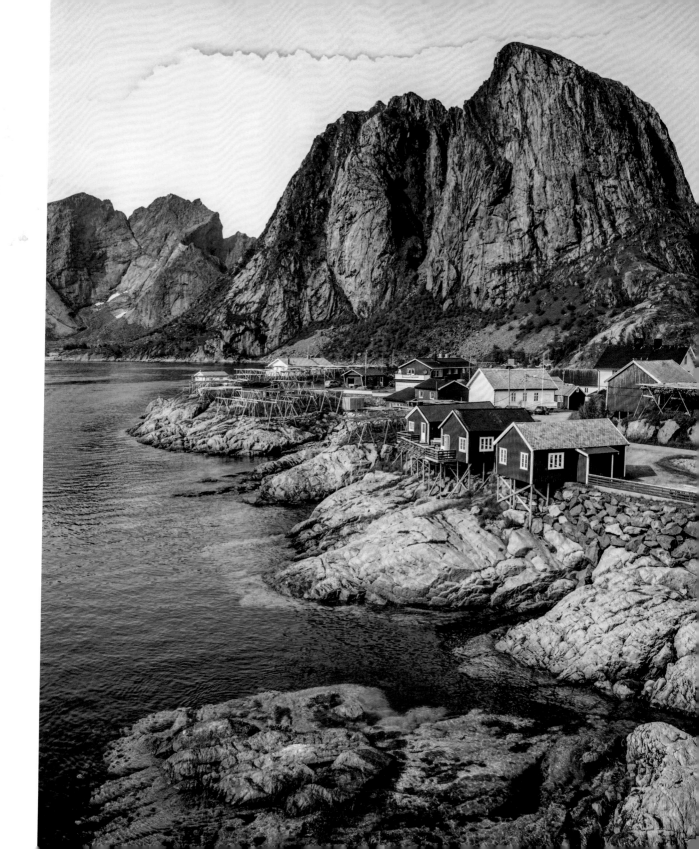

about the author

Nastasia Yakoub is a former registered nurse turned full-time traveler, entrepreneur, and photographer who strives to inspire and empower women. She founded Dame Traveler–the first female travel community on Instagram. Nastasia's mission stems from her desire to break the mold. Defying cultural norms, she went from being totally sheltered from the world, simply because of her gender, to traveling to more than sixty-five countries, many of which were solo adventures. She lives in New York City.

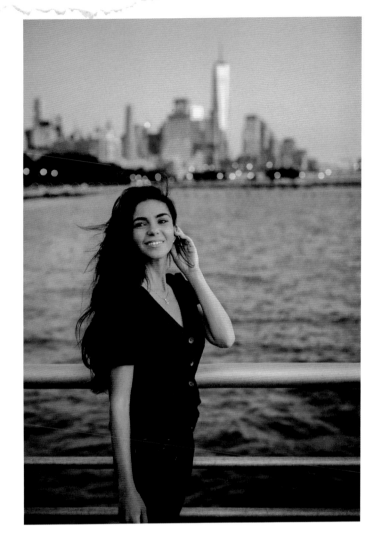

Published in the United States by Ten Speed Press,
an imprint of Random House, a division of
Penguin Random House LLC, New York.

www.crownpublishing.com
www.tenspeed.com

Ten Speed Press and the Ten Speed Press
colophon are registered trademarks
of Penguin Random House LLC.

Some of the photographs in this work were
originally published on the Dame Traveler Instagram
account and/or on the travelers' individual social
media accounts.

The following photographs copyright
Nastasia Yakoub | @nastasiaspassport:

Front Cover: Bagan, Myanmar.
Spine: Marrakech, Morocco (with Fanny Texier).
Back Cover: St. Moritz, Switzerland (with Elke Frotscher).
Page I: Cartagena, Colombia.
Page II: Singapore.
Page IV, top: Saint-Paul de Vence, France; Uxmal,
Mexico; Brooklyn, New York, United States
(with Sara Melotti). Bottom: Amalfi Coast, Italy;
Miyajima, Japan (with HaNa Yu); Ravello, Italy.

Library of Congress Cataloging-in-Publication Data
is on file with the publisher.

Hardcover ISBN: 978-1-9848-5791-0
eBook ISBN: 978-1-9848-5792-7

Printed in China

Design by Kelly Booth

10 9 8 7 6 5 4 3 2 1

First Edition